Smashing Statues

Smashing Statues

THE RISE AND FALL OF AMERICA'S PUBLIC MONUMENTS

ERIN L. THOMPSON

W. W. NORTON & COMPANY
Independent Publishers Since 1923

For information about permission to reproduce selections from this book, write to Permissions,
W. W. Norton & Company, Inc., 500 Fifth Avenue, New York, NY 10110

For information about special discounts for bulk purchases, please contact
W. W. Norton Special Sales at specialsales@wwnorton.com or 800-233-4830

Manufacturing by Lakeside Book Company
Book design by Chris Welch
Production manager: Lauren Abbate

Library of Congress Cataloging-in-Publication Data

Names: Thompson, Erin L., author.
Title: Smashing statues : the rise and fall of America's public monuments / Erin L. Thompson.
Other titles: Rise and fall of America's public monuments
Description: First edition. | New York : W. W. Norton & Company, [2022] |
Includes bibliographical references and index.
Identifiers: LCCN 2021041567 | ISBN 9780393867671 (hardcover) | ISBN 9780393867688 (epub)
Subjects: LCSH: Monuments—United States. | Memorialization—United States. | Collective memory—
United States. | Monuments—United States—Public opinion. | Public opinion—United States.
Classification: LCC E159 .T39 2022 | DDC 725/.940973—dc23
LC record available at https://lccn.loc.gov/2021041567

W. W. Norton & Company, Inc., 500 Fifth Avenue, New York, N.Y. 10110
www.wwnorton.com

W. W. Norton & Company Ltd., 15 Carlisle Street, London W1D 3BS

1 2 3 4 5 6 7 8 9 0

For Stella

People who imagine that history flatters them
(as it does, indeed, since they wrote it)
are impaled on their history like a butterfly on a pin . . .

—James Baldwin, "The White Man's Guilt" (1965)

CONTENTS

INTRODUCTION

P hilip Reed's eyes watered from the smoke and the stench of the horse dung. His back ached from carrying fuel and stooping to tend the low fire. It was late November 1860. Reed had been working seven days a week for nearly five months. He could not relax his vigilance over the drying mold.

In a few days, four thousand pounds of molten metal would be poured hissing into this mold, which had been shaped from a mixture of sand and dung.[1] If Reed did his job perfectly, the mold would break apart when the metal cooled to reveal the bronze torso of a woman, the folds of her robe pulled tight across her breasts.

If Reed failed—if the mold overdried into brittleness or retained pockets of moisture—it could explode. Red-hot bronze would shoot through the bodies of the fashionable ladies and gentlemen who were coming to the foundry, a few miles outside Washington, DC, to witness the casting of a section of what would become a nearly twenty-foot-tall allegorical statue of Freedom destined to top the dome of the United States Capitol Building.[2]

When *Freedom* was finally hoisted into place in December 1863, it was hailed as a symbol of the universal liberty the Emancipation Proclamation had declared in January of that year. More than 150 years later, many avowed white supremacists undertook a deadly invasion of the Capitol Building to dispute the results of the presidential election.

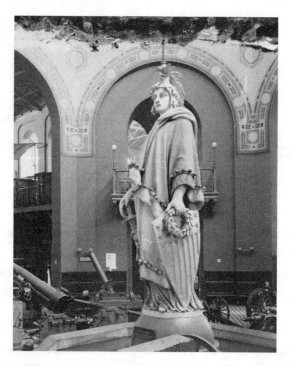

Plaster model used by Philip Reed and Clark Mills to cast the bronze statue of *Freedom* installed on the U.S. Capitol Building in 1863. *Library of Congress, Prints & Photographs Division, photograph by Harris & Ewing, LC-H25-3200-A.*

You might think that a symbol of the liberty America is supposed to offer to all would have dissuaded or at least shamed them. Looking more deeply into *Freedom*'s history reveals why the monument instead inspired them. It is a white supremacist vision of freedom.

The federal government had hired the sculptor Clark Mills to cast *Freedom*. The government paid the wages of Mills's workmen too. Reed's rate was $1.25 per day, a quarter more than any of the other laborers. But he kept only the money he earned on Sundays. Mills took the rest. Reed, the man who played such an important role in creating *Freedom*, was not free.

Reed was born into slavery in South Carolina. Mills purchased him

in Charleston "when he was quite a youth," as the sculptor recalled, sensing "his evident talent" for sculpture.³ Reed helped Mills cast the very first bronze monument ever made in America, a statue of President Jackson that still stands just north of the White House. Jackson waves his hat from the back of a rearing horse. He seems precariously balanced, as if he would bob like a dashboard ornament if you flipped his nose.⁴

The charismatic Mills won this commission even though he had never even seen a monumental bronze sculpture, much less made one.⁵ He moved north to work on it, meaning that Reed would have lost contact with everyone he had ever known. In Washington, Reed worked hard in a profession that is hazardous enough when everyone knows what they are doing, which was definitely not the case in Mills's foundry.

When, after many disastrous failures, the Jackson monument was at last unveiled, it made Mills famous. It was so popular that replicas went up in Nashville, Jacksonville, and New Orleans. Mills received many new commissions, including the one for *Freedom*. He purchased an estate, where he built a new foundry and a crenellated octagonal workshop. Visitors marveled at his "kennels of ferocious bull-dogs" and the elk he had procured as a model for a sculpture and kept as a pet.⁶ Mills made other purchases with his new wealth: four human beings. They joined Reed and another woman Mills already owned.⁷

On that day in November 1860, Reed's molds held. In all, he worked for more than a year, with only a handful of days off, to complete *Freedom*.⁸ Few of those who see her on the Capitol Building know she was made by a slave owner and one of the men he enslaved. Slavery shaped everything about her.

Debates over slavery were already raging in 1854, when the artist Thomas Crawford was commissioned to make the plaster model Mills would use to cast *Freedom*. Jefferson Davis rejected Crawford's initial design. The future president of the Confederacy was then the secretary of war, charged with overseeing the expansion and decoration of the Capitol Building. Davis made sure none of the new sculptures

or paintings for the building criticized the slavery he so vehemently supported.[9]

Davis scrutinized artists' sketches for a slouchy hat with a bulbous tip, known as the pileus or liberty cap. It had symbolized freedom since antiquity, when Romans gave it to newly freed people during emancipation ceremonies. Davis rejected any design that included the liberty cap, which he claimed was "inappropriate to the people who are born free." He told Crawford, who had sketched *Freedom* wearing a liberty cap, to replace it with a helmet showing "her cause triumphant."[10]

Why was Davis afraid of a hat? He knew the liberty cap symbolized not just freedom but, more specifically, emancipation—the process of becoming free. Davis did not want official federal art to give anyone the idea that people currently enslaved in America could one day become free. He wanted freedom to be reserved for people like him—people who had never been enslaved. Crawford obeyed, designing headgear for *Freedom* that looks more suited to a Vegas showgirl than a warrior, with a starry headband topped with feathers sprouting from a popeyed eagle.

Reed probably knew nothing about Davis's millinery-related paranoia, but as he made *Freedom*, he would have vividly understood the conflict at the heart of America—the conflict between freedom for all and freedom for some. Reed had never been free, but one of the other people Mills owned had been, if only for a few days. In November 1859, when Crawford's plaster model of *Freedom* was on display in Washington but before Mills's foundry had begun work on its casting, a Boston abolitionist newspaper reported the arrest of a white man "who had with him a wagon and provisions, and was accompanied by a colored man and woman, supposed to be *en route* for a free state." The paper describes the woman as "a slave of Clark Mills of Washington."[11]

This was probably Ann Ross, described by Mills as "mullatto [sic] color, about five feet seven inches high, rather slim make."[12] She must have planned carefully in order to make contact with a white man willing to pretend to be her owner and successfully reunite with her

husband. She was captured only a few miles from the border of Pennsylvania, a free state. As Reed helped create a statue of a white woman who symbolized triumphant freedom only for those Americans who had never been enslaved, he lived with a Black woman who had fought for her freedom and lost.

Work on the casting of *Freedom* stopped when the Civil War broke out, but Lincoln himself ordered it resumed. "If people see the Capitol going on," Lincoln reasoned, "it is a sign we intend the Union shall go on."[13] When Lincoln signed the District of Columbia Emancipation Act on April 16, 1862, Reed was finally a free man. He was forty-two years old. In June, he married and also collected $41.25 from the federal government for working thirty-three Sundays "keeping up fires" under *Freedom*'s drying molds.[14] Meanwhile, Mills petitioned the government to be reimbursed for the $1,500 loss Reed's emancipation meant for him.[15]

Someone wrote "Philip Reid his mark" around the *X* that Reed signed on the receipt for his $41.25. Mills also used this spelling, but in all subsequent records, Reed's name is spelled with two *e*'s. Perhaps this is a historical accident, but I have retained this spelling in case it was his preference. The 1870 census lists him as a plasterer.[16] He died in 1892, having lived in Washington for the rest of his life, and was buried in a cemetery within sight of the Capitol Building.[17]

Reed was a crucial part of the birth of American public monuments. The circumstances of this birth have much to tell us about why some of these monuments are falling today. In May 2020, George Floyd, an unarmed Black man, suffocated when a Minneapolis police officer knelt on his neck for nine and a half minutes. Within a few days, millions were protesting police brutality in hundreds of American cities.[18] Around 170 public monuments fell or were removed in the year after these protests began.[19] The fate of monuments could not be more contentious.

Why were protesters taking to the streets to shout "I can't breathe"

giving a second thought to people who had been dead for centuries instead of days? Why would anyone risk imprisonment to tear down a hunk of marble to which only pigeons seemed to pay attention? Why were other people forming armed patrols and even shooting protesters to defend these statues?

President Trump weighed in, threatening harsh punishments for those who "indiscriminately destroy anything that honors our past" and claiming that protests against statues seek to "erase" history.[20] But monuments aren't history lessons—they're pledges of allegiance. As the story of *Freedom* reminds us, monuments are created and controlled by powerful people to advance their own interests. Monuments present a specific version of history, without room for doubts or questions.

This book examines public monuments. Memorials mourn those who have suffered, while monuments honor those who have succeeded. Both call attention to history in order to shape the future. Memorials point out things that should never happen again, while monuments spotlight people whose lives and deeds viewers are supposed to emulate.[21]

Our monuments both reflect and shape how we see ourselves as a nation. Arguing about monuments is not a pointless debate about the past. It's a crucial negotiation for our future. The human brain is wired to learn from images. That's why making art is so important to all human cultures. We learn how to love, live, and die from images. Monuments can inspire us to change—or strengthen our determination to uphold traditions of discrimination and white supremacy.

If you're reading this and thinking that monuments aren't important to you, you're wrong. Unless we are rich enough to pay for a monument and powerful enough to place it in a public space, American monuments were built to show us our place within national hierarchies of power. Regardless of our race, they tell us to sacrifice ourselves to the interests of those more powerful than us.

The first part of this book, "Rising," digs into the histories of American monuments to reveal what is hidden beneath their placid sur-

faces, like the slave labor that made *Freedom* possible. I explain some of the ideologies, hatreds, and ambitions that gave us the monuments we have today. Some of these motivations are surprising. Mount Rushmore, for example, America's largest public monument, was compared by its sculptor to the Great Pyramids but was more of a pyramid scheme for defrauding his creditors. Other motivations are all too familiar. The country's largest Confederate monument, Stone Mountain, began as a pet project of the Ku Klux Klan and ended as a way for Georgia's governor to signal his resistance to school integration. But even the monuments whose histories might seem obvious were also the product of unexpected, more subtle motivations. I argue that many Confederate monuments were designed to keep white Southerners in poverty by discouraging them from joining labor unions—and also that even the bluest states are home to Civil War monuments that insist that Black people are not fully American.

America holds thousands of public monuments. This book is not a comprehensive survey. But the types of monuments that went up before Maya Lin's 1981 Vietnam Veterans Memorial fundamentally changed the nature of public art have enough in common with one another that I was able to use a few of them to demonstrate how we ended up with the monuments that fill our public landscapes.

Once I lay out how America got its monuments, the book's second part, "Falling," asks what we can and should do with them now. I talked to some of the most important participants in current controversies over monuments, including an activist who toppled a statue of Columbus, the Birmingham mayor who broke the law to dismantle a Confederate obelisk, and the head of an African American museum that offered a racist monument a new home. I wanted to understand their often complex and counterintuitive motivations—and see how these motivations interacted with legal regimes and political pressures whose importance often goes unacknowledged. A group of protesters hitching a monument to the back of a pickup truck under the cover of darkness might seem violent, irrational, and undemocratic . . .

unless you understand the absence of any peaceful, legal route to remove a monument that an entire community despises.

In 2020, for the first time ever, the majority of Americans said "yes" when asked if controversial monuments should be removed.[22] But deciding which monuments are harmful enough to warrant removal is tough. Should we honor only perfect people? If not, how much imperfection should we tolerate? Who should make these decisions, and how? This book covers recent developments in these debates, revealing some crucial yet little-known truths, like the fact that many monuments are being removed from public view only to be expensively stored for later re-erection, and that no amount of contextualizing signage will change most people's minds about statues.

This book doesn't give answers to questions about which monuments should stay and which should go. These decisions need to be made by communities, not by individuals. The histories of American public monuments too often demonstrate how a small group of powerful people imposed monuments on communities to send messages that would benefit only them. In recent years, communities have at last been coming together to discuss what they really want from their public monuments. These conversations are more difficult, and take longer, than the behind-the-scenes deals that created monuments. But this is how democracy works. And sometimes, a community decides to tear a statue down.

Part I
Rising

Melted Majesty

The king's head lay on a table near the sofa. "Would you like to see an instance of American loyalty?" Lady Townshend sardonically asked a visitor to her elegant home in Mayfair in late November 1777. When she whisked off the cloth covering the head, the visitor who recorded this scene in his diary wrote that he had instantly recognized the features of George III.[1] The pudgy upper eyelids, bulging lips, and supercilious squint belonged not to the king himself, who was alive and well, but to a larger-than-life-size golden portrait statue.

Lady Townshend explained that rebelling New Yorkers had beheaded the statue. A British officer stationed in America rescued the head and sent it to her husband, Lord Townshend, "to convince them at home of the Infamous Disposition of the Ungrateful people in this distressed country."[2] The head had arrived only the night before.

The 4th Viscount Townshend was a good choice for raising alarm bells about what British troops could expect from the Americans. His plump face and the bags under his eyes made him look a bit like George III, but he was far fiercer. He had served in the British Army in Canada under Gen. James Wolfe, assuming command of the troops laying siege to Quebec City after Wolfe was killed. Next, he was viceroy of Ireland, working hard to solidify the king's control over the Irish. Townshend's tightening of the screws was so resented that he fought

a duel with an Irish peer, the Earl of Bellomont, which ended with the earl shot in the groin.[3]

Lord Townshend's letters show that he had been keeping careful track of events in America during the increasing tensions that eventually led to the outbreak of revolution.[4] But it was Anne, Townshend's second wife, who took every opportunity to display the head. In 1777, she was just twenty-five years old. A portrait by Joshua Reynolds shows her as a slim beauty with clear eyes, an oval face, and powdered-gray hair piled up into a lofty beehive.[5]

Reynolds painted her cheeks with a slight blush, but they must have flamed when she talked about American disloyalty. Her younger brother, William Montgomery, a captain in the Royal Norfolk Regiment, had been wounded in the leg during the Battle of Fort Anne in upper New York in July 1777. American soldiers had surprised a small group of British troops in a steep, rocky, heavily wooded area. The British could hardly see their attackers, but the Americans had no trouble picking them off.[6]

Montgomery died of his wounds two days after the battle and was buried in America. Lady Townshend must have only recently learned of his death. She did not have her brother or her brother's body. All she had was the king's head. The story of how it got to her reception room is the story of how the history of American public monuments begins: not in creation, but in destruction. Long before American artists ever created a monument, American protesters tore one down.

The statue of George III was America's very first equestrian monument. When it arrived in New York in 1770, it was one of only a handful of full-length portrait statues in America. All of these had been made in Europe. An American-born artist would not make a similar monument for another seventy years.

Although the New York General Assembly had commissioned the

golden George III, not all New Yorkers were happy to see it arrive. The monument was a compromise. In a 1765 speech before the House of Commons, the statesman William Pitt had argued forcefully that Britain should not lay onerous taxes on the colonies because "they are the subjects of this kingdom, equally entitled with yourselves to all the natural rights of mankind." Although he would come to regret stirring up the "demon of discord" in America, many colonists praised him for the resulting repeal of the hated Stamp Tax.[7] A group of legislators, led by members of the prominent Delancey family, proposed that the New York Assembly commission a statue of Pitt to signal the colony's gratitude.

The more conservative faction of the assembly thought this gesture was too radical, and counter-proposed a monument to George III. The assembly debated for two years before simply deciding to order both.[8] As would be true for many subsequent American monuments, the George III monument proclaimed a loyalty to a certain version of reality not shared by everyone in the community. But as long as there were people with enough power to insist that this monument went up and stayed up, it adorned New York as though no one had ever even entertained a disrespectful thought about the king and his rule.

The assembly sent £1,000 to the London sculptor Joseph Wilton for a portrait statue of the king. While working on this commission, Wilton also made a near-identical statue of George III for London's Berkeley Square. Both of Wilton's Georges rode horses and wore ancient Roman armor and wreaths of laurel leaves, symbolizing victory, around their brows. He modeled their posture after Rome's famous ancient statue of a mounted Marcus Aurelius, who extends an arm over a defeated foe to show strong yet merciful leadership.

Underneath their gilt coverings, both kings were made of lead. Many sculptors at the time were experimenting with this metal, which melted easily and took details well from the mold. Better still, it was cheap. Records from the period indicate that a lead equestrian statue cost only about £150 to produce. Even considering the added cost of gilding and

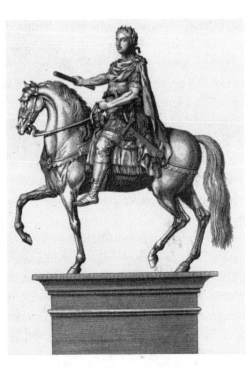

No images of Joseph Wilton's statue of George III for New York survive, but it probably looked very similar to the portrait of the king he made at the same time for London, shown here in a 1773 illustration for *Town & Country Magazine*.

shipping the statue to America, New Yorkers paid dearly for their mistake of not specifying which metal they wanted for their monument.[9]

When the statue reached New York, it was set up in the center of Bowling Green, a small park at the southern tip of Manhattan. King George faced the gates of Fort George, which housed his representatives, the British governor and garrison. The statue was raised on a fifteen-foot stone pedestal and surrounded by an iron railing, which most New Yorkers were forbidden to cross. Art historian Wendy Bellion, who has written a book about the statue and its fate, thinks the gilded statue was probably the brightest thing in the whole of New York City when the sun shone.

The statue was a constant reminder of the authority of the king over his colony. It sparkled with the golden wealth of Britain and demonstrated the skills of its craftsman—skills that no American could yet hope to match. By connecting George III with a revered ancient emperor, the statue also claimed that the king was the colonists' proper ruler not just because of who he was in himself but because the whole history of the world had led up to his birth.

The statue, which signified the king's strength, was not so strong itself. Wilton had made his kings larger than any previous lead sculptures. Within a few decades, the legs of the London horse began to buckle under the weight of its rider. In 1812, the statue was removed before it fell over entirely.[10] The New York statute would likely have suffered the same fate, but New Yorkers pulled it down before it could fall.

The Second Continental Congress ratified the Declaration of Independence on July 4, 1776. New York's Provincial Congress endorsed the declaration a few days later, on July 9, and Gen. George Washington ordered it read aloud to the troops quartered in Manhattan. The soldiers heard about their "unalienable Rights" to "Life, Liberty and the pursuit of Happiness." They learned that "whenever any Form of Government becomes destructive of these ends, it is the Right of the People to alter or to abolish it." When night fell, they began to exercise their right to abolish British rule by destroying its most prominent symbol on the island: the king's statue.

As the crowd of New Yorkers and new Continental Army volunteers moved south from the area where the declaration had been read toward the doomed statue, they would have been greeted by the horse's ass. Facing the British fort, the statue turned its back to the rest of Manhattan. Its gilding would have shone spectacularly in the light of the torches held up by the marchers, but not for much longer.

The crowd tied ropes around the statue and pulled it off its base. Once it was on the ground, some scratched at its surface to remove the gold leaf. Others swung axes to chop it apart. They cut the king's nose off, fired a bullet through his head, ripped away his victory wreath,

and then dragged parts of his body through the streets.[11] They sent the head uptown, intending to put it on a spike at Fort Washington to be displayed like the head of a decapitated traitor.

Washington's orderly book, the daily record of all orders he issued, noted that although he was sure that the "persons who pulled down and mutilated the statue . . . were actuated by a zeal in the public cause," he disapproved of the toppling because it seemed too much like a disorderly riot.[12] Washington might have officially disapproved, but he did nothing to stop the toppling or punish the perpetrators, even though he must have been well aware of their actions. At the time, his headquarters were just across a tiny street from Bowling Green, with a clear view of the monument.

A British captain, John Montresor, sent a spy into rebel territory to steal back the king's head. The spy buried it in a secret place, and when British troops reoccupied Manhattan, Montresor retrieved the head and shipped it off to Lord Townshend.[13]

If you ask most Americans today about pulling down statues, their first thought will be of Iraqis swarming over a bronze Saddam or Russians using marble Hitlers for target practice.[14] Toppling monuments seems like something that happens only in faraway places. In reality, monuments go up whenever a society changes and they fall whenever a society changes again, in America and everywhere else. Anyone who has ever taken a snapshot of an ex off their refrigerator after a breakup can understand the urge to remove a monument that celebrates a vision of power or society that no longer holds true.

In July 1776, after New Yorkers toppled the statue of the king, they tried to rid the city of all other signs of British authority. They broke off the tips of the iron railings surrounding Bowling Green because they bore crowns. They ripped royal insignia from churches and even tore down tavern signs with crowns or other images relating to the monarchy. They tore a painted portrait of George III hanging in the courthouse to pieces and then burnt it.[15]

When there weren't enough existing images to satisfy the rebels'

urge to destroy, they made effigies of the king so they could have the joy of destroying his image all over again. In a particularly elaborate ceremony in Huntington, Long Island, an effigy of George III draped in a British flag was hung from a gallows and then blown apart.[16]

In 1776, the lead that made the New York statue so easy to pull down was precious. Anticipating rebellion, the British had been refusing to allow colonists to import the metal necessary to make bullets. The rebels were so desperate to make ammunition that they pried apart the windows of city hall to get at the lead strips holding them together. The four thousand pounds of lead in the statue were much easier, and much more satisfying, to get. Ebenezer Hazard, the New York postmaster, wrote to the adjutant general of the Continental Army, explaining that the statue was "pulled down to make musket ball of, so that his troops will probably have melted Majesty fired at them."[17]

To make the king into bullets, militiamen took the pieces of the statue up the East River to the port of Norwalk, Connecticut, and then hired oxcarts to haul the pieces north to a military depot in Litchfield. There, the statue was melted down into 42,088 musket balls.[18]

Not all the pieces of the statue made it into the melting pot. One of the carters stopped for the night in his hometown of Wilton, Connecticut. There, several pieces went missing. Some of these pieces, including a swath of hair from the horse's tail, were discovered by accident in the nineteenth century by men plowing fields and draining a local swamp. The tail was purchased by the New-York Historical Society. In the mid-nineteenth century, another fragment of the statue was on display in a small museum in downtown Manhattan, alongside a two-headed calf, a pipe belonging to Andrew Jackson, and the taxidermized remains of a pig famous for butting people off a bridge.[19]

In 1991, a metal detectorist went looking for more pieces in Wilton and found the king's left hand. Pockmarked and sickly green-gray, stripped of its gilding and battered by its rough journey and two-hundred-year-long burial, the hand looks ready to burst from a grave in a zombie movie. When it was sold at auction in 2019, its high esti-

mate of $25,000 seemed optimistic. But once again, an American paid far more for lead than the worth of the metal. The winning bid was for $207,000.[20]

Wilton was home to many British loyalists. If they were trying to honor the king by saving the remnants of his statue from being melted down, they went about it in a strange way, grabbing a hunk of horse tail and other random pieces and pitching them into a swamp. A better explanation is that they were trying to sabotage the rebels' ammunition supply by reducing the amount of lead that would make it to the foundry. Several historians have noted that the statue produced only about half as many bullets as would be expected from two tons of lead, so the loyalists did a good job.

Still, the king's body did indeed help the rebels' cause. Nine musket balls found at the site of New Jersey's Battle of Monmouth, fought in June 1778, show exactly the same mixture of lead, tin, copper, and antimony as samples from the statue fragments.[21]

New Yorkers tore down the king's statue for the same reasons they put it up six years before: public monuments are about power. When the New York General Assembly resolved to commission the statue, it declared it did so to show "their Gratitude, and the Reverence due to his Sacred person and Character."[22] As long as the statue stood in Bowling Green, it reminded everyone who walked by that the king was the type of man Americans claimed they wanted to honor.

Then, as today, fights about monuments were really fights about power. When the Declaration of Independence labeled the king a "Tyrant . . . unfit to be the ruler of a free people," Americans celebrated their new agreement about power by pulling down the smug-faced embodiment of Britain's rule.

New Yorkers were not the only rebellious colonists to deface a statue of George III. During a short-lived period of Canadian opposition to British rule, a bust of the king in Montreal was splashed with

black paint, given a necklace of rotten potatoes, and eventually torn from its pedestal and thrown into a well.[23]

In fact, as soon as humans started making monuments to glorify rulers, others began tearing them down to show they didn't want to be governed by them. The ancient world is full of examples of the destruction of monuments. For example, in 24 BCE, when an army led by Queen Amanirenas of Kush invaded Roman territory in Egypt, soldiers hacked off the head of a monumental statue of the reigning Roman emperor, Augustus. The soldiers brought the head back home to what is now Sudan and buried it beneath the staircase leading to their temple of victory. For the next two thousand years, until archaeologists dug up the head, everyone entering the temple symbolically humiliated Augustus by treading on his face.

Those who come into power erase the art of those who have fallen from power. Hence the destruction of Catholic art by newly legitimized Protestants during the Reformation, the smashing of aristocratic art during the French Revolution, and the toppling of Communist-era monuments after 1989.[24] The newly powerful often replace destroyed monuments with new symbols of power. Historian Martin Warnke called these campaigns of destruction by new authorities iconoclasm "from above."[25]

By contrast, iconoclasm "from below" happens when people who lack the power to change a political regime instead attack its symbols. Those in power often disparage these attacks as mere vandalism, because they don't want to admit that anyone is questioning their right to rule. Iconoclasm "from below" tends to attack a monument and only partially destroy it, leaving the assault visible to symbolize ongoing protest against the existing political system.[26]

Not every moment of social change or political revolution leads to an attack on monuments. One scholar, Dario Gamboni, argues that monuments are targeted mainly during the fall of regimes that relied on monuments to "express, impose and legitimize" their power.[27] Thus, French revolutionaries not only guillotined aristocrats but also

destroyed art they had commissioned, because they had used this art
to display their power. Similarly, Soviet satellite states enthusiastically
toppled Communist monuments erected as a part of an imposition
of ideology.

To listen to many people today, you would think that Americans
had never harmed a single bronze hair on the head of a monument,
much less decapitated one. But as the story of George III shows, Amer-
icans have been rebelling against tyrannical art as long as they've been
rebelling against tyrants. And while the Kushites stored their smashed
statue underneath a temple, Americans proudly put the fragments of
George III on display in museums.[28]

In 1932, the cream of New York society even reenacted the destruc-
tion of the statue in an elaborate pageant during a ball at the Waldorf
Astoria Hotel.[29] The production included some five hundred actors,
with two hundred troops from New York's National Guard regiment
playing the role of Continental soldiers. The spectacle was produced
by a member of the *Ziegfeld Follies'* design team. Against a background
of bells and booming cannons, with lighting effects to resemble flick-
ering torches, the actors listened to a reading of the Declaration of
Independence and then formed, according to the program, "a frenzied
mob" that brought the statue "crashing to the ground among the huz-
zas of a throng drunken with their new patriotism."[30]

When power changes hands, new leaders often destroy whatever
supported the leaders they overthrew. Americans should remember
this, considering that the settlement of the country required both
expelling Indigenous people from their land and destroying the sacred
sites they left behind.[31]

Deciding to remove the statue of a hated ruler you've rebelled
against is easy. The decisions Americans have to make about mon-
uments today are much more difficult, because we do not yet agree
about who should hold power. Should wealth and power continue to
be concentrated in the hands of a small group of people, mostly of
a certain race and class? This question is necessarily also a question

about our public monuments, since they almost all honor a very nar-
row set of historically powerful people. Like the statue of George III,
these monuments are visual arguments that only people like the ones
on the pedestals are qualified to rule. The first American sculptor of
public monuments made sure of it.

Chain of Being

On a January night in 1843, the sculptor Horatio Greenough started a bonfire in the Capitol Building and nearly killed the transcendentalist philosopher Ralph Waldo Emerson. Greenough had carved a statue of George Washington for the Rotunda of the Capitol, but he hated the way it looked under its skylight. Washington's high forehead glared in the sunlight, but the details Greenough had sculpted on the sides of his chair were practically invisible. The artist wanted to show his work to his friend Emerson in a more flattering light.

Greenough arranged a nighttime visit. He placed oil lamps in a wooden case and had them hoisted them up high enough to illuminate the statue from what he thought was the proper angle. But, as Emerson reported in a letter to Margaret Fuller, the case caught on fire and crashed down, with "lamps melting & exploding & brilliant balls of light falling on the floor."[1] They dragged the flaming wreckage of the wooden case outdoors, "where it drew together a rabble from all parts."[2]

Emerson, who had first met Greenough in Florence in 1833, called him "a superior man, ardent and eloquent."[3] Emerson thought Greenough's face was so handsome and his body so well formed that he must have modeled his classical statues, including an Achilles, after himself.

Despite the chaos, and perhaps due to the presence of so handsome

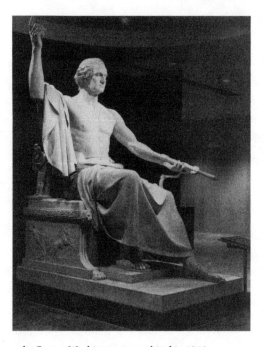

Horatio Greenough, *George Washington*, completed in 1840. *Courtesy Smithsonian Institution Archives, SIA RU000095.*

a guide, Emerson spent several hours sitting on the floor entranced by the statue after the smoke cleared, "with half a dozen persons whose shadows were colossal on the wall," while Greenough's shouts of "Higher, higher!" to the men holding the lamps reverberated up to the dome.[4] Emerson thought the *Washington* was "simple & grand, nobly draped below and nobler nude above."[5]

During the viewing session, Greenough told Emerson he was "not confident" that he had "translated the public sentiment of this country for Washington into marble."[6] The sculptor's worries were justified. His *Washington*, derided by congressmen and mocked by journalists, was expelled from the Capitol just a few months after Emerson saw it there.

Greenough was the first American sculptor to show what power

and subjugation looked like in the young nation. To do so, he had to strike America's strange balance between meritocracy and hierarchy. Greenough needed to portray the subjects of his monuments as if they had succeeded on their own merits while still communicating the widely shared conviction that certain categories of people were considered inherently inferior, never good enough to rise to the level of their betters.

Greenough's first attempt, his portrait of Washington, failed. His second monument for the Capitol, a violent fantasia of an invincible settler triumphing over an Indigenous warrior, won acclaim. Greenough's two monuments made him the model for generations of American sculptors. Washington might have been the father of our country, but Greenough is the father of our monuments. If we want to understand our visual landscape, we need to understand the example he set.

The road to Greenough's monument to Washington was a long one. It began with a fight over the president's body. The Continental Congress voted to erect a statue of Washington in 1783, just after America's victory in the Revolutionary War.[7] The original plan was for a statue that would have looked very much like the one of George III torn down at the war's beginning. Washington would have been riding a horse, wearing a laurel wreath, and holding a ceremonial baton that referred to imperial Roman symbols of command. The figure was to be placed between the planned presidential residency and Congress, to encourage future presidents and legislatures to follow Washington's heroic example.

This monument was never built, first because of shortness of funds and then, after Washington's death in December 1799, because the discussion turned to whether it should also include his tomb. The problem was that Washington had made two different plans for his own body. In 1793, he had approved a plan for the Capitol Building that included a crypt. The plan was to bury Washington in the center

of this building at the center of the capital city, with a portrait statue installed in the Rotunda above his tomb.[8] Instead of just seeing the heroic Washington in the distance, legislators would have both Washington's image and his actual body at the center of their business. But in the will revealed after his death, Washington had asked to be buried at Mount Vernon, his family home.

Fierce debates erupted in 1800, a year in which American politicians seemed to spend even more time debating monuments than they did in 2020. "Monuments are good for nothing," the North Carolina congressman Nathaniel Macon claimed, arguing that American citizens should learn about their heroes from reading, not from "pernicious acts of ostentation."[9] Macon proposed that the money for the monument should be spent instead on teaching the poor to read, so they could more thoroughly understand Washington's legacy.[10]

As historian Kurt Savage has shown, many Americans agreed with Macon's distrust of public monuments. Some thought it smacked of European aristocracy to honor only a few men with expensive artworks. Shouldn't a democracy honor the people instead? Others objected on religious grounds, reflecting Protestant suspicion of the Catholic Church's use of images to shape public behavior.

Meanwhile, an opposing faction thought the planned crypt wasn't grand enough. They proposed a freestanding mausoleum taller than the Capitol Building, a vision that eventually resulted in the Washington Monument, which was completed only in 1885.[11]

The controversy over the proper form for a monument to Washington created political deadlock that lasted so long that the very terms of the debate began to change. As Southern slave owners and politicians became more defensive about the growing abolitionist movement, arguments about a monument to Washington became arguments about whether American power should be concentrated in Washington or divided among sovereign states. The Northern congressmen who argued for the primacy of federal power wanted a glorious celebration of the first president in the federal capital. Southern congress-

men routinely opposed a national monument that would support the idea that the federal government was superior to that of the states.

Although Southerners were suspicious of Washington the city, they were eager to claim Washington the man as one of their own—a Southerner who believed that owning people could be morally justified. Even Macon, himself a slaveholder, decided that monuments were good for something after all when he helped arrange for a monument to Washington to be placed in the North Carolina State House in 1821.[12]

In 1832, the hundredth anniversary of Washington's birth, Northern congressmen finally had enough votes to overcome Southern opposition to a Capitol tomb. But it was too late. Washington's heirs refused to allow his body to be moved from Mount Vernon.

Congress could not have a body, but it still wanted a statue. On the very day legislators learned of the definitive refusal to move Washington's remains, the House approved commissioning a portrait statue for the Capitol Rotunda. To make it, they chose Horatio Greenough, who was only in his late twenties.[13] He had never carved anything as large as the planned statue. Then again, no other American had either.

Greenough was ten years old when the North Carolina legislature began planning their statue of Washington. Thomas Jefferson, asked for advice, replied that no American "would offer himself as qualified to undertake" such a statue.[14] Jefferson recommended a European sculptor instead, continuing what had so far been a consistent American tradition of importing either statues or sculptors from Europe.

Greenough seemed like the perfect candidate to break this reliance on European talent. Born into a wealthy, well-connected family in Boston, he had been obsessed with sculpting from an early age. He studied it wherever he could, including during his time at Harvard. Greenough skipped his graduation ceremony to sail for Italy in 1825 to be near the marble quarries he would need to realize his dream of becoming the first American to make his living from sculpture.

His first years abroad were hard. When his father's business dealings faltered, Greenough had to scrape by on loans from patrons like

James Fenimore Cooper. Made famous and wealthy by romantic tales like *The Last of the Mohicans* about the supposedly vanishing Indigenous peoples of America, Cooper had befriended Greenough during a trip to Florence.

Greenough had long hoped to make his mark on the world, and pay off his debts, by carving a national monument.[15] In preparation, he repeatedly sculpted portraits of Washington, the national hero he guessed people could agree on enough to pay to monumentalize.[16] The only thing standing in his way, as he saw it, was the government's tendency to hire Italian artists.

In 1830, he wrote to Cooper, describing his plan to propose a monument topped with Washington to commemorate the Revolutionary War for the Capitol. He asked the novelist to write an article: "thirty lines from your pen to point out to them the bad taste and the bad policy of giving the children's bread to dogs."[17] Greenough wanted Cooper to argue that the government should not give taxpayer money to foreign artists. Greenough was especially disdainful of the Italian artists who had worked at the Capitol, describing Italy as "a land so fraught with genius that even her starved out mediocrity commands a respect which I cannot earn."[18]

If Greenough did indeed send off this proposal to the capital, there was no response. By 1832, his financial situation was grim. He wrote to his good friend Samuel Morse (who would soon help to invent the telegraph, but was a struggling painter at the time), describing how "the spectre Debt has leaned over my pillow of late, and, smiling ghastily, has asked if she and I were not intended as companions through life."[19]

But Greenough had heard that Congress might commission him to carve a monument to Washington. He concluded his letter to Morse with the claim that he was talking back to Debt, telling her, "Don't grind your long teeth at me, or I'll read the Declaration of Independence to ye!"[20]

One of Greenough's art teachers at Harvard had recommended him to an old friend, the chairman of the committee in charge of commis-

sioning artworks for the Capitol Building.[21] Soon, Greenough wrote
Morse again to celebrate the definitive news that he had received the
commission: "Here's work and care and all the materials of life for
several years with the hope of being enrolled among the American *Old
Masters* if I do not sink under the burthen."[22]

Greenough's first act was to pay back the money he had borrowed
from Cooper.[23] Although the commission was for $20,000, Greenough
had to pay for all the expenses. This included quarrying an enormous
block of marble, outfitting a workshop large enough to hold it, and
paying the salaries of the workmen who would spend years chipping
away the excess stone.

Greenough would eventually make a profit, but not a large one. The
real benefit was in the renown the commission brought him. Before,
he had complained in his letters that the American consul in Florence
was reluctant even to tell visitors where his studio was. After news of
the commission broke, Greenough had orders for as many portraits
and other sculptures as he could handle from Americans eager to sup-
port their nation's artistic talent.[24]

Greenough wrote a letter to another friend mocking his own ner-
vousness about starting the statue, comparing himself to "a spoilt boy,
who, after insisting upon riding on horseback, bawls aloud with fright
at finding himself in the saddle, so far from the ground!"[25] His task
was indeed a hard one. Congress had specified that the portrait was
to be full length and should have a head copied after the portrait the
French artist Jean-Antoine Houdon had carved during the president's
lifetime, leaving the rest "to the judgment of the artist."[26] Greenough
was in charge of deciding the pose, clothing, and, in essence, the
meaning of his Washington.

Inspired by ancient Greek statues of an enthroned Zeus, the king
of the gods, Greenough decided to carve Washington draped in the
toga of a Roman senator and seated on a Roman throne. The sculp-
ture's head is recognizably Washington's: a dignified elder statesman,
with a stern mouth, wrinkles radiating from squinting eyes, and jowls

sagging below his jawline. A few inches farther down, the statesman transforms. His skin tightens and his muscles flare. Bare toes peek out from strappy sandals. Biceps bulging, Washington holds a sheathed sword out toward the viewer, signifying his voluntary surrender of power after the end of his presidential term.

Greenough was influenced both by ancient Greek and Roman art, where human rulers were often compared to deities through the use of heroic nudity, and the then-popular style of neoclassicism. European audiences were used to portraits of leaders rendered in a classical style in partial or even total nudity, like Antonio Canova's 1802 portrait of Napoleon, where the Frenchman is posed like the Roman god Mars and wears only a precariously clinging fig leaf.

But when *Washington* finally arrived in the United States in 1841, American audiences paid less attention to deciphering the meaning of Washington's symbolic sword and more to his nipples. The sculpture was widely mocked in newspapers and even on the floor of Congress.[27]

Representative Henry A. Wise of Virginia, offended by the statue's "plagiarism from the heathen mythology," thundered that "speaking as an American citizen, he must say that that was not the conception of George Washington which had any place in his mind." Wise said the monument looked too much like Washington was sitting on a throne, something not to be tolerated in a republican country. He proposed that Congress keep the statue's dignified head, but "throw the body into the Potomac, to hide it from the eyes of all the world, lest the world should think that that was this people's conception of their nation's father."[28]

Other critics agreed, calling the sculpture "unnational" and faulting it for "not being characteristic of our republican country."[29] The architect of the Capitol Building joked that the monument showed Washington in a towel, getting ready to take a bath, while a New York politician opined that "Washington was too prudent and careful of his health to expose himself thus in a climate so uncertain as ours."[30] One critic thought Washington looked "stripped to the buff like a stage boxer,"

while another wrote in the *New York Herald* that his toga looked like a "winding sheet," as though Washington had just risen from his coffin.[31]

Besides the $20,000 paid to Greenough, the government had spent tens of thousands more shipping the statue, constructing its pedestal, and strengthening the Rotunda's floor to support it. But in 1843, after just two years, they spent even more to kick it out of the Capitol Building, re-erecting it outside on its grounds. Even there it did not escape mockery. One popular prank, recorded by the *Washington Post* in the late nineteenth century, was to insert a firecracker between Washington's fingers to make it look as though he had just taken a puff from a fittingly massive cigar.[32]

Finally, the statue was transferred to the Smithsonian. It is now on display in the National Museum of American History, awkwardly wedged next to an escalator. Today, the sculpture's upraised hand looks as though it points the way up to the next floor.

What did Greenough intend that hand to mean? Describing the sculpture in a letter written as he prepared to ship it to America, he claimed it contained two of the most sublime ideas he knew: "the duty of all men toward God" and "the duty of great men toward the human race."[33] Greenough explained that Washington's right hand, which points "heavenward," showed him as "a conductor standing between God and man, the channel of blessings from heaven."[34]

Public monuments always pose the question of what type of people are worthy of honor. For Greenough, Washington was the greatest of great men because of his direct connection to God. That connection made Washington greater than all the viewers who might look up to him.

That's why he looks so silly. Greenough attributed not just moral and intellectual perfection to his hero but physical perfection as well. The classical statues of deities and emperors that inspired the European tradition of portraits of leaders, including New York's statue of

George III, present them as all-powerful and above question. But neither Zeus nor George III were democrats. Americans didn't like being told that they could never be as good as their first president.

In the end, Greenough's *Washington* failed because he looked too much like someone who attained power through divine favor rather than anything he himself did. There's no American dream in Greenough's *Washington*, no hint that anyone else deserved to follow him as president. Though Greenough's Washington holds out his sword toward the viewer, trying to pass on his power, the sculptor made clear he didn't think viewers were likely to deserve it.

No wonder that Representative Wise fulminated against the monument's "conception of George Washington," since he himself held presidential ambitions, eventually becoming a candidate for the 1860 election. Neither Wise nor the other congressmen who led America wanted to walk past a statue every day that reminded them of their shortcomings. The rejection of Greenough's *Washington* proved that, in America, statues must show power as aspirational. If too few viewers think that they, too, could one day be honored with a similar statue, the monument will fail.

In recent years, protests against monuments have usually come from members of minority groups. But, as the fate of Greenough's *Washington* shows, even the most powerful of Americans will also act to get rid of statues that they find oppressive. The officials who removed *Washington* did not need to throw him into the Potomac, as Wise had facetiously suggested. Instead, they had enough power to remove him peacefully.

This is the main difference between the way that monuments are protested by those who hold power and those who lack it. They will both find ways to achieve their goals, but it is more likely that powerful protesters will be able to take advantage of the legal means offered by a system that they also control, while groups without political dominance struggle, often in vain, to get new monuments approved or old monuments removed.

Of course, the powerful do not often need to protest monuments, since they also control their creation. In most cases, they keep as careful an eye on their progress as Jefferson Davis kept on *Freedom*. Greenough's *Washington* solidified this impulse toward control. Never again would an artist be given so much freedom in designing a national monument with so little inspection of preliminary sketches and models.

The critics of Greenough's *Washington* generally ignored the two small figures who lean against the sides of the backrest of Washington's chair.[35] They are shown as subordinate, but critics would not have found this controversial. Although Greenough erred in showing Washington as an unreachable exemplar of power, these subsidiary figures communicated beliefs about racial and ethnic hierarchies that were common at the time. These beliefs would shape American public sculpture long after Greenough's *Washington* left the Capitol.

At Washington's right, balanced on the edge of the chair where a shove of the president's hips would send him tumbling him to the ground, a man dejectedly looks downward. He wears a heavy necklace and sports a tuft of hair gathered at the top of his otherwise shaved head. Greenough explained that this was an "Indian chief," included to show "what state our country was in when civilization first raised her standard there."[36]

Greenough also explained that the vines and garlands of flowers ornamenting Washington's chair symbolized that men would flower "when well planted" and cultivated by sound government.[37] By contrast, the chief leans against a dead tree stump, showing that his civilization was at an end.[38] Greenough's sculpture expresses a belief, part wistful and part hopeful, then current among white Americans—the belief that the country's Indigenous population was vanishing. His friend Cooper had helped popularize this idea in his *Leatherstocking* novels.

At Washington's left, a man wearing a toga leans against the chair,

crossing his legs and twirling one finger in a long beard while he contemplates a globe. Although he looks like a biblical prophet or an ancient philosopher, Greenough meant this to be Columbus.[39] Greenough explained that he added him "to connect our history with that of Europe."[40] But he showed an indolent Columbus, satisfied with his discovery but not taking any further action. Greenough thus implied that it required Washington, a greater man, to forge the new land into a nation.

Columbus was not Greenough's first choice. He had first intended to pair the Indigenous man with a figure of a "negro," making clear that America depended on the firm control of both Indigenous and enslaved inhabitants.[41] But in 1839, Greenough wrote to Charles Sumner (who would become a famed abolitionist senator but was then a young Boston lawyer), saying he had decided to take Sumner's advice to include Columbus instead of an enslaved man, "because as you convincingly observed—I ought in a *first great* work, appealing to great national sympathies, to keep clear, quite clear of debatable ground."[42] The sculptor had decided that if he wanted to create a monument that would unite Americans with its vision of a glorious past, he had better leave out reminders of issues they were currently arguing about, like slavery.

Greenough himself relished debating the topic. He laid out his views in an essay that he was preparing for publication shortly before his unexpected death in 1852. He wrote that the mere presence of Black people disgusted him, and claimed to avoid employing their services when he was traveling in America, preferring to do "very disagreeable things for myself rather than being very near a black man."[43]

Greenough believed that his place in what he called "the chain of being" was very far above the place of Black people.[44] He also considered himself better than many white people, seeing great differences between what he described as a "dirty, low, white man" and his betters: "It is only our race that can show a nincompoop and a Napoleon."[45] Greenough believed (most probably mistakenly) that he was

descended from English nobility and described his ancestors as "those who used the sword and not . . . those who felt it."[46] He accepted the existence of "low" white men because he understood them as a product of lesser ancestry than his. But he was firmly convinced that there could never be a great man who was not white.

At the time, some white abolitionists argued that the cruel conditions of slavery prevented enslaved people from attaining their full potential. Greenough found this argument specious. He believed a "low" white man could better himself, but was convinced that the Black man "perishes in the process of civilization."[47] He thought that the free Black people he met in the North "do not prosper, develop or do good."[48] Instead, he thought the waiters and "steamboat lackeys" he encountered were marked by "impudence and laziness."[49]

For Greenough, people of African descent would develop as far as they were able to go under the civilizing effects of slavery. He thought slavery was "morally justified" because "we leave them better than we found them," and claimed that "the dullest negro in Tennessee would shame all the woolly heads in Africa."[50] Greenough insisted emancipation would lead to the "annihilation" of Black Americans (although he did not specify the mechanism).[51] Greenough ended his essay with what he thought was the ultimate argument to convince his audience: that when there were no more Black slaves, white men would be forced into slavery instead.[52]

Greenough's *Washington* shows a great white man as stronger, closer to God, and more active than the sculpture's tiny, languid, lower Columbus and Indigenous man.[53] It is no wonder that Greenough, with his beliefs about the inferiority of Black people, changed his mind about including one on his statue.[54] Black Americans were impudent enough for Greenough's taste. If he was disgusted by their presence, why subject the president to an eternal proximity? Instead of letting them think they deserved to be this close to greatness, it was better to render them invisible.

Greenough's racist "chain of being" was even more clearly on view

in the second monument he carved for the Capitol. The federal government commissioned it from him in 1837, before his *Washington* arrived in America.[55] Greenough was allowed to choose whatever subject he wanted. He proposed a monument showing a settler family threatened by an Indigenous warrior. He called it *Rescue* and explained that it would "convey the idea of the triumph of the whites over the savage tribes."[56]

Greenough decided to take a new approach to *Rescue*. Instead of showing a timeless allegorical moment, as he did for *Washington*, he would tell a story. He arranged his characters into different levels within the space of the monument. At its bottom sits a woman soothing an infant. Above her looms a white man holding the arms of an Indigenous man.

At first glance, this strongly muscled warrior seems on the verge

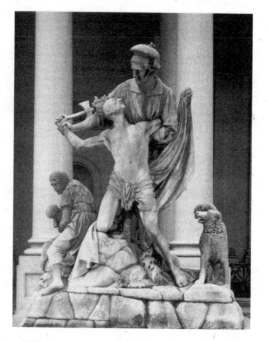

Horatio Greenough, *Rescue*, completed in 1850.

of freeing himself and killing the settlers with his tomahawk. Closer examination shows that what we are seeing is not the moment of crisis but its aftermath. The settler's gun lies on the ground by his feet. He has already used it. The warrior is not attacking—he is dying.[57] Even the settler's dog knows the danger has passed. He stands still, alert but not attacking. Rather than cowering in fear, the settler's wife is shielding her eyes from the unpleasant aftermath of a failed attempt to stop her family from making their claim on new land.

Greenough equipped the sculpture's warrior with a mishmash of generic "Indian" accessories. He was not concerned about understanding the details of Indigenous culture. But to his incredulous dismay, congressional officials had ignored his repeated demands to ship him "Indian skulls."[58] Greenough did not want to use an Italian or himself as a model for the warrior's head, because he believed the skulls of different races were shaped differently.[59] He fumed in a letter to his brother that he would be "obliged to make my savage by guess-work."[60]

Like many in the nineteenth century, Greenough believed the supposed different physical characteristics of the races showed the biological basis for white men's superiority. He thought he could see in the bodies of Black people "a certain backward thrust in the pelvis, making a curve in the lumbar region very different from the noble and vertical station of the Caucasian spine." He argued this curve meant that Black people had walked on all fours more recently than white people.[61]

Greenough also scrutinized the bodies of Indigenous people. When visiting Washington as a young man, he wrote to his brother to describe a group of Native Americans he had met, whose "slit ears hung in rags on their velvet collars." He said they were "strong men of beautiful skeletons, [with] legs like arrows."[62] Greenough, disgusted by Black people, admired Indigenous bodies. But he thought white bodies were even better.

If Greenough wanted to show why a powerful warrior would crumple to the ground when faced with a superior white man, he would

have to get these biological differences right. Washington's refusal to send him any skulls would have been all the more frustrating, because several American scholars were collecting Indigenous skulls as Greenough was planning his monument.[63] When no one was willing to share, he eventually had to content himself with plaster casts of Indigenous skulls sent to him by a fellow artist.[64]

The differences in the bone structure of the sculpture's figures might have been visible only to a few viewers, but Greenough's composition made the lesson clear. He arranged the figures into a pyramid to show their positions in the "chain of being," with the white man at the top, the dog at the bottom, and Native Americans and women hovering between.

As he was putting the final touches on this sculpture, Greenough proudly wrote to his brother that he had succeeded in conveying the "gentle firmness" of the settler's "superior nature, which, while conquering, feels compassion."[65] When *Rescue* was installed in front of the Capitol in 1851, American critics agreed. One journalist wrote that *Rescue* "will not be, like his *Washington*, open to criticism" because it was an "appropriate and *national*" composition that illustrated "an important point in the history of our country, and in the progress of humanity from barbarism to civilization."[66] Another described the newly installed monument as "typify[ing] the settlement of the American continent" by showing "the ferocious and destructive instinct of the savage, and his easy subjugation under the superior manhood of the new colonist."[67] A third commented on the way the settler's "rebuking force is a shade saddened and softened by the melancholy thought of the necessary extinction of the poor savage, whose nature is irreconcilable with society."[68] These critics saw that Greenough's monument represented not just the defeat of one man but the impending disappearance of all Indigenous people under the onslaught of "society."

American politicians had long debated how to handle the problem presented by the country's Indigenous inhabitants. The policy in effect when Greenough was sculpting *Rescue* began in 1830, when Andrew Jackson signed the Indian Removal Act, authorizing the expulsion of Native Americans from their lands east of the Mississippi River. Jackson had decided they could never be trusted to live in U.S. territory after the War of 1812, during which some tribes aligned with the British.

The expansion of American territory far beyond the Mississippi quickly rekindled conflicts. In 1851, the year Greenough's *Rescue* was installed, Congress created the reservation system, once again forcibly removing Indigenous people from areas targeted by white settlement. Still, battles between tribes, settlers, and the troops sent to protect them would sometimes simmer and sometimes rage for the rest of the nineteenth century.

Rescue told its story about American destiny and white superiority to American lawmakers through decades of these "Indian Wars." The monument decorated the eastern front of the Capitol Building, and several presidents, including Abraham Lincoln, took their oath of office and gave their inaugural addresses in its shadow. Its picture of the irredeemably violent and inferior status of Indigenous Americans helped shape these presidents' decisions, as when Lincoln authorized the hanging of thirty-eight Dakota men after hasty, flawed trials, without defense counsel or interpreters, in Mankato, Minnesota, in December 1862.[69]

By 1890, virtually all Indigenous Americans were confined to reservations or otherwise controlled. Federal policy changed back toward assimilation. Instead of attacking Indigenous Americans' bodies, federal authorities attacked their languages, religions, and family structures. In white America's popular imagination, Indigenous Americans transformed from enemies to be feared to a conquered, disappearing people to be celebrated, pitied, and mourned. *Rescue*, once perfectly attuned to how federal authorities and most white Americans wanted

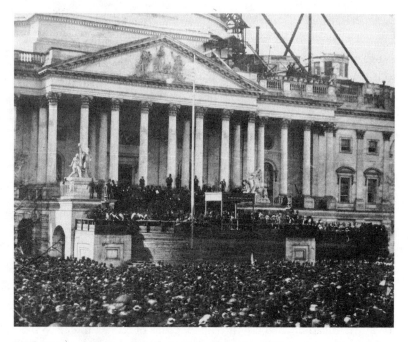

Inauguration of Abraham Lincoln in 1861 with *Rescue* visible to the president's left.
Library of Congress, Prints & Photographs Division, LC-USZ62-22734.

to think about Indigenous people, became less and less acceptable as opinions changed.

In 1939, a joint resolution of Congress called for *Rescue* to be "ground into dust" and "scattered to the four winds" so that it would not be a "constant reminder to our American Indian citizens" about "our barbaric past."[70] This time, the barbarism was not that of supposedly savage Indigenous people, but of the supposedly civilized settlers. In 1941, a similar joint resolution called *Rescue* "an atrocious distortion of the facts of American history and a gratuitous insult" to Native Americans.[71]

Neither these resolutions nor protest by Indigenous groups had any official result. But in 1958, all sculpture was removed from the Capitol Building's eastern front in preparation for repair work. After this work was completed, nearly all the sculpture was returned or replaced with

identical replicas. *Rescue* remained in storage. In 1976, a crane dropped the sculpture as it was moving it to a new storage area. Its fragments linger in a government warehouse.

The removal of *Rescue* is another example of what happens when enough people decide that the messages encoded in a monument are unacceptable to them. It was probably not the objections of Indigenous activists that had the decisive effect. Many of the nineteenth-century paintings and carvings that still decorate the Capitol Building also portray Native Americans as insultingly inferior to white settlers. But *Rescue* showed the settlers themselves in ways increasingly unpalatable to their descendants, who no longer wanted to think of themselves as cold-bloodedly exterminating their inferiors.

Scholars, activists, artists, and ordinary citizens have continually criticized American monuments for showing non-white Americans as inferior.[72] Many of these monuments have been protested ever since they went up. Yet, they remain in place. It often seems that the heavier the criticism, the higher the protection. The fate of *Rescue* set a pattern still followed in current debates about monuments: they come down only when those who hold political power find them personally insulting.

Greenough died thinking *Rescue* a success. He had moved back to Boston in 1851, renewing his friendship with Emerson and beginning to move in literary circles with new acquaintances like Bronson Alcott and Henry Wadsworth Longfellow, who called him "a tall handsome fellow . . . full of fire and vigor and excitement."[73] This excitement sometimes grew too great. In late 1852, after giving a series of increasingly incomprehensible lectures on "Art as Related to Life" in Boston, Greenough was strapped in a straightjacket and taken in a closed carriage to McLean Hospital. He died two weeks later, raving in Italian in what was described as a state of "violent mania." The types of public monuments he invented for America lived on.

Few would now defend Greenough's beliefs that some humans are inherently superior to others. Many would argue that this doesn't matter, thinking that we should judge art on its own terms without condemning it merely because of the beliefs or actions of its maker. Yet, even if we want to separate the artwork and the artist, we should not ignore the artist's biography. Investigating an artist's beliefs pushes us to consider whether those beliefs are reflected in the art itself.

Greenough's sculptures, the first thoroughly American national monuments, were also the first in a long line of public artworks to address questions of how much Black and Indigenous lives matter in America. He and his monuments claimed these lives didn't matter at all. Greenough's monuments assert that only people of a certain gender, class, and race deserve honor.

Greenough's beliefs informed not only his own sculpture but all the subsequent American public monuments based on his influential examples. The sculptors who followed him might not have believed that northern Europeans were the highest members of an imaginary "chain of being," but they continued to sculpt monuments that personified virtues in northern European bodies. The sculptures of Freedom and Justice that adorn American legislatures and courthouses, with their tall bodies, ancient Greek faces, and gently waving hair, suggest that freedom and justice are not available to people who do not look like them.

While *Rescue* quietly disappeared, the conflict brewing when Greenough died would soon culminate in the Civil War—whose aftermath saw monuments making claims about America's racial order springing up across the nation.

Shafts

n June 1865, as the last Southern troops surrendered, the Virginia
planter Edmund Ruffin wrapped himself in a Confederate flag and
shot himself through the head.[1]

Hundreds of enslaved people worked Ruffin's plantations. Eager to
protect his right to own these workers, Ruffin had started agitating for
the South to secede nearly a decade before the Civil War began. He set
out his views in a pamphlet explaining why the South's economy could
not survive without slavery. He also pointed out that slavery permitted
the "master class" to have the leisure necessary to support the "con-
stant tendency to improvement of that class in mind, manners, and in
social advantages and virtues."[2]

Pamphlets were not enough. Ruffin also sent pikes carried by John
Brown's men during their failed attempt to instigate a slave rebellion
to the governors of several Southern states. He hoped to convince
them other abolitionists were planning similar violent attacks. Ruffin
bought the pikes after disguising himself as a military cadet to sneak
into Brown's execution at Harpers Ferry in 1859.

Only a few Southerners killed themselves rather than accept defeat.
Many more, perhaps as many as ten thousand, fled America rather
than submit to federal rule.[3] Many headed to Brazil, where slavery was
still legal, hoping to reconstruct elite Southern society. Matthew Fon-
taine Maury, an oceanographer and officer in the Confederate Navy

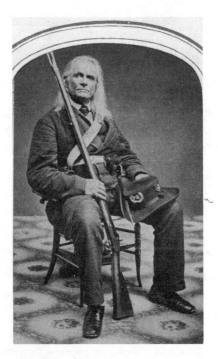

Photograph of Edmund Ruffin, ca. 1861. *Courtesy National Archives, photo no. 111-BA-1226.*

who would later be honored with a statue on Richmond's Monument Avenue, chose Mexico.[4] He convinced its ruler, Emperor Maximilian, to appoint him a commissioner of immigration and tried to recruit elite families to emigrate to his "New Virginia."[5] He asked them to bring along "negro skilled laborers in agriculture."[6] Slavery was technically illegal in Mexico, but Maury planned to hold these laborers in peonage. After farm owners advanced them food, clothing, and shelter on credit, they would work for the rest of their lives to pay an ever-increasing debt.

Few Black Americans jumped at the chance to reinvent Southern slavery. Nor did the established elite of Latin America show themselves willing to allow newcomers to take over their privileges. The Confederate emigration movement was short-lived. Maury left Mexico

in 1866, and most of his fellow self-exiles also returned home by the end of the decade.

But what was home? Elite white Southerners had grown up thinking that bravery and skill in arms defined what it meant to be a man. The wives and sisters of Confederate soldiers wrote in their diaries and letters about how "utterly hopeless," "exceedingly quiet," and "crushed and disconsolate" the veterans appeared.[7] The veterans themselves recorded feeling as though they were "walking in a dream" or not yet "recovered from the stunning effect of mingled surprise and grief caused by the sudden prostration of our cause."[8]

Some veterans described the South as "emasculated," as if they had literally lost their manhood along with their fight.[9] Stonewall Jackson's former chief of staff told an audience that veterans like himself were "subjugated to every influence from without, which can be malignantly devised to sap the foundation of their manhood, and degrade them into fit material for slaves."[10] He was not alone—many other Confederate veterans also unironically compared themselves to slaves.

Faced with defeat, white Southern society had to come up with a new conception of manliness. Monuments soon became one of the most important means of reshaping white Southerners' collective memories of the war. Instead of dwelling on a foolishly hopeless fight for the right to own their fellow humans, they would soon warm themselves with memories of their tragically hopeless defense of freedom.

Southerners were not the only ones who had to reconsider their role in society. The postwar period was a time of much upheaval in America. Settlers continued to press west, continually raising questions of who should control American land and culture. The increased immigration into the United States after the Civil War troubled conceptions of American identity even more. Monuments took up these questions, too, by demonstrating the hierarchies of race, ethnicity, and class that showed people their place in America.

But the largest dilemma facing white Americans after the end of the war was to decide how—or whether—to keep emancipation's promise

of equality for newly free Black citizens. How should these new citizens be educated? Should they be able to vote and hold political office? What role should the government play in regulating social relationships, including marriage, between Black and white citizens? Debates raged between those convinced that Black Americans should be truly equal and those who insisted they should remain a permanent class of uneducated laborers. Civil War monuments came to play a large role in these debates. Monuments in former Confederate and former Union communities alike visually defined the rules for interactions between white and Black Americans.

At first, though, monument-building went slowly. A combination of private grief for immediate losses and a hesitation to defy the federal troops who occupied portions of the South during Reconstruction meant that Southerners generally mourned or celebrated the Confederacy in the relative obscurity of homes and cemeteries during the first postwar years.[11] Of the ninety Confederate monuments erected during the two decades after the war, sixty-four were placed in cemeteries. Only twenty-six were built in the center of a town, and the majority of these had funereal, mourning imagery.[12]

In the mid-1880s, with Reconstruction over and federal troops withdrawn, white Southerners turned their energies to erecting Confederate monuments in prominent places, facing courthouses, post offices, city halls, and other legislative buildings.[13] Eighty-five percent of the more than four hundred Confederate monuments erected from 1886 to 1912 were in public spaces other than cemeteries.[14] The Southerners who banded together to organize these monuments wanted them to be placed "where all will see [them]: in daily view, familiar to the eyes of our people and commanding the attention of every stranger within our gates."[15]

New organizations formed to put up these monuments. The most prominent of these was the United Daughters of the Confederacy,

founded in 1894. The Daughters were responsible for nearly all of the South's Confederate monuments.[16] "Every man in the South knows that the monuments erected everywhere to the Confederate soldier have been planned and the money raised for them by women," was how one official summarized their role.[17] These monuments went up as marker stones on racial boundaries. The story of the creation of North Carolina's State Confederate Monument is just one of many possible examples.

In 1892, a group of Raleigh's socially prominent white women formed the North Carolina Monumental Association. To raise money, they orchestrated a number of events, including a reenactment of a wartime camp scene complete with the "best known citizens of the city" dressed in their old Confederate uniforms. Whether or not they still fit into these uniforms, the event was so popular that it ran several days longer than scheduled.[18]

While the sight of the aging veterans was popular, it was soon apparent that private donations would not go far enough. In early 1893, when the state legislature debated a bill appropriating $10,000 for the planned monument, the ladies filled not only the visitors' gallery but also the lobbies and aisles of the legislative chamber. They even perched on the steps of the speaker's stand. "In the presence of so many fair patriots," a local newspaper approvingly noted, "there was no disposition manifested to antagonize the Monument bill."[19] The legislature approved the funds and mandated that the monument be installed on Raleigh's Capitol Square.

The women laid the monument's cornerstone in 1894. They filled it with relics of the Confederacy, including a strand of hair from the tail of Lee's horse. Even with its foundation in place, the monument's future was uncertain. The association needed to make a $10,000 final payment for the monument. But it was out of money.

The association again turned to the legislature. This time they asked not for an appropriation but just for a loan to cover their temporary shortfall. After several legislators indicated they did not plan to

approve the loan, the association ran notices in Raleigh newspapers, pleading for "every lady who is interested in the Confederate monument" to join them at the legislature for the vote.[20] Although they again filled the visiting galleries, this time the ladies did not get their way. A new legislature had taken office just a few weeks before. For the first time, the members of an interracial coalition party, the Fusionists, were in the majority. They voted down the association's bill.[21]

Black men had gained the right to vote with the passage of the Fifteenth Amendment in 1870. White Southerners immediately went to work, devising a combination of laws and intimidation that would eventually shut Black citizens out of the vote. But for a brief period, Black men voted and held political office—including the five Black candidates who won seats in the North Carolina legislature in 1895. They were part of a wave of Fusionist candidates who convinced many of the state's white voters, including farmers and others who had suffered in the postwar economic depression, to align with the state's Black voters to fight for economic policies that would benefit all citizens, not just the state's white elite.[22]

The Fusionists, who had promised to crack down on governmental spending, rejected the loan to the Monumental Association as an unnecessary expenditure. They suspected the "loan" would never be repaid.[23] They also thought the proposed monument would "[stir] up sectional bitterness that would better be left to quietly perish."[24] One senator decried the arguments for the monument as "pure sentimentality and gush."[25]

The monument was to prove a major test for the Fusionist alliance. Several days after the legislature denied the loan, a Raleigh newspaper ran an editorial cartoon on its front page.[26] On one side of the image, white women cluster around the city's unfinished monument, begging for funds "to commemorate the virtues of our fallen dead." One woman has even fallen on her knees, reaching out her arms in desperation. Her pleas are in vain. On the other half of the cartoon, the artist drew legislators burying their faces in handkerchiefs, standing around

LADIES MONUMENTAL ASSOCIATION TO THE LEGIS-
TURE NOW IN SESSION:

Let us teach posterity that patriots die not in
vain. A land without monuments is a land with-
out memories. Lend us of your means to com-
memorate the virtues of our fallen dead.

THE NORTH CAROLINA GENERAL ASSEMBLY TO
THE LADIES:

It is not your dead, but our Fred over whom
we weep. "Bear with us; our hearts are in the
coffin there with Caesar, and we must pause
till they come back to us"

Editorial cartoon satirizing the Fusionist refusal to fund the state Confederate
monument, *Raleigh News and Observer*, February 24, 1895.

a coffin labeled "Fred Douglas." They deny the ladies' request, saying,
"It is not your dead, but our Fred over whom we weep."

This anti-Fusionist cartoon linked the legislature's refusal of a loan
for the monument to another vote that had happened two days prior,
when the North Carolina House passed a resolution to honor the
death of Frederick Douglass. The newspaper reacted by calling on its
readers to "stand together to preserve the Anglo Saxon civilization."[27]
The mere recognition of the existence of a Black intellectual threat-
ened to upset the belief in white superiority to which many white
Americans clung.

As historian Catherine Bishir has explained, the cartoon appealed
to fears of Black dominance over white Southerners by accusing the
white legislators of caring more about a Black man than white women.
The criticism worked. White legislators who had crossed racial lines
to make political alliances scrambled to defend themselves. Just five
days after they had denied the association's request for a loan, the leg-

islature voted on a new association bill.[28] This time, they awarded the Association $10,000—as an appropriation, not a loan. White legislators were trying to buy their way out of a scandal by demonstrating that they were more loyal to the Confederate dead than to their living Black political allies.

Just a few months later, the Fusionist candidates lost in Raleigh's local election. Raleigh's anti-Fusionist newspaper announced the triumph of "pure white Democracy" in the city with the headline "The City Still Ours . . . No Negro Rule in Raleigh."[29] The North Carolina Fusionists had fallen, just as similar interracial coalitions were crushed in other former Confederate states in the late nineteenth century.[30]

The unveiling of the completed North Carolina State Confederate Monument in Raleigh, days after the election results were in, was another chance to celebrate the victory of "pure white" politics. Thirty thousand people came, thanks to special discounted train fares. Raleigh's inhabitants decorated their homes along the parade route and then cheered the mile-long procession of speakers in carriages and marching veterans waving battle-torn Confederate flags. Stonewall Jackson's widow sat on the speaker's platform and his granddaughter pulled the cord that unveiled the monument. A visiting Northern observer remarked on "the absence of negroes" during these ceremonies.[31]

Confederate monuments helped intimidate Black citizens by insisting that a state's political spheres and public spaces belonged to and were rightly controlled by white people.[32] But intimidating Black voters was not these monuments' main purpose. White Southerners had much more effective techniques for keeping Black citizens from voting, ranging from voter suppression laws to lynchings.[33]

Besides, the timing was wrong. Former Confederate states erected most of their monuments beginning in the late 1880s, only after they had suppressed their Black citizens' right to vote. North Carolina is the exception that proves the rule. The Fusionist experiment with interracial coalitions took place in North Carolina well after hopes of

North Carolina State Confederate Monument on the state capitol grounds in Raleigh, North Carolina, dedicated 1895. *Library of Congress, Prints & Photographs Division, photograph by Carol M. Highsmith, LC-DIG-highsm-43739.*

Black political participation had died in other Southern states. While the state put up only five Confederate monuments outside cemeteries before the Fusionists lost power, more than fifty went up in the two decades after the Fusionists were defeated.[34] In other words, Confederate monuments went up, state by state, only after it was already assured that few, if any, Black voters could exercise their rights in that state.

Of course, politicians could, and frequently did, gain votes by mak-

ing white citizens worry about the mere possibility of Black citizens resuming the exercise of their rights. For instance, Julian Shakespeare Carr, one of North Carolina's wealthiest men, campaigned for a Senate seat in 1900 with the slogan "The White Man Shall Rule the Land or Die."[35] Carr's campaign was so dependent on white supremacy as its central issue that he had to publish an open letter defending himself against allegations that his charitable donations to Black vocational schools proved he was betraying his race. Carr reassured voters that he was "a friend of the Negro in his place, but mind you, HE MUST BE IN HIS PLACE."[36]

Carr routinely claimed all of North Carolina's problems were caused by "the great crime" committed by the federal government when it gave "millions of ignorant vicious colored people" the right to vote. Fortunately, "it was never too late to correct a mistake."[37] Carr, like many other white Southern politicians in the early twentieth century, explicitly promised to keep Black citizens from voting.[38] He explained this was for the best, since "it is an admitted fact, that the negro is not capable or competent for self-government."[39]

Certainly, Black citizens would not have admitted this "fact." And many of the white working-class men Carr was addressing had voted for the Fusionists not long before. Carr and the other Southern elites could not maintain their hold on political power if these voters once again began to think it was in their best interests to make alliances across race lines.[40]

White voters were hard to control. Their right to vote was not in question. They could not be kept in line by whippings or lynchings carried out without fear of prosecution.[41] They had to be carefully persuaded if they were to vote against their own interest. And it was Confederate monuments that did much of the work of this persuasion.

When we see that a monument shows some people as inferior, we assume it acts as a cheery pat on the back to the people it claims are superior. But sometimes a pat on the back can push you into danger. When we think a monument flatters us or our ancestors, we need to

look very carefully to see just what part of our history it praises and just what it wants our future to be.

Stand up. Feet together, face front. Move your right foot three inches straight back and bend your left knee slightly. Imagine you're holding a rifle instead of this book, with its butt resting on the ground. Grasp its muzzle at the center of your chest.

You are now standing in same pose as the ten-foot bronze infantry-man on the North Carolina State Confederate Monument. Hundreds of other Civil War monuments—the vast majority of them—feature a similar unnamed, low-ranking soldier on a high stone pedestal.[42]

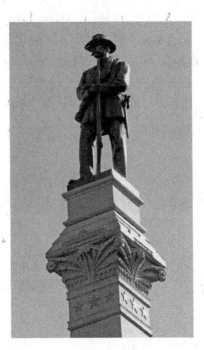

Soldier at parade rest topping the North Carolina State Confederate Monument. *AP Photo/Gerry Broome.*

These monuments were so common that the United Daughters of the Confederacy referred to them as "shafts."[43] Their soldiers take nearly identical poses.

What exactly is this pose? Civil War–era soldiers would not have stood like this when fighting, unless they wanted to make themselves an easy target. The pose is not one of a soldier marching to a battle, lying wounded or exhausted after one, or coming home. Instead, the pose, known as parade rest, is for demonstrating obedience. As recorded in an 1867 manual on infantry commands, new recruits stood in parade rest to listen to instructions about the next piece of

Parade Rest.

Illustration of parade rest from Emory Upton's *New System of Infantry Tactics, Double and Single Rank, Adapted to American Topography and Improved Fire-Arms* (1867).

drill they would have to master.[44] The manual explains it is a command "imposing both steadiness of position and silence."[45] A soldier in parade rest was forbidden to speak or even move while his drill instructor spoke.

The hundreds of Confederate monuments topped with soldiers in parade rest are not praising these soldiers for their skill or honoring them for their courage. Instead, they laud them for their obedience. In the late nineteenth century, when most of these monuments rose, the Southern elite who paid for them very much wanted to be obeyed.

Life in the South changed dramatically after the war. Before it, most Southerners lived in rural areas and worked in agriculture. By the late nineteenth century, many Southerners had left the countryside to live in towns, where they competed for jobs in manufacturing plants or other new industrial occupations with the millions of immigrants who came to America in the last decades of the century.[46]

Social changes accompanied these economic shifts. Women were agitating for the right to vote as well as other equalities that brought into question the ability of fathers and husbands to control their families. To be a white, working-class, Southern man at the dawn of the twentieth century, your traditional hold on power slipping, was to feel as upended and confused as many of their descendants would feel during the digital and social revolutions of the beginning of the twenty-first century.

As Southerners' accustomed way of life dissolved, a group of writers and orators began to reinvent the memory of the Civil War. They made the low-ranked soldier into the central figure of their account of Confederate history. "The purest spirit, the deepest love, the greatest hero, the noblest manhood" of the Confederacy, one of these writers declared, resided in infantry privates, not Confederate officers.[47]

The leaders of the United Confederate Veterans were especially eager to spread this message. A new national organization founded in 1889, as the South began to fall into a major recession, its largest gains in membership came during the depths of the depression of 1893.[48] At

its height, as many as one in three living veterans was a member of the United Confederate Veterans. These members, facing unemployment and foreclosure, were comforted by its answers about what had gone wrong.

Above all, the United Confederate Veterans tried to convince its members that Confederates had never been rebels. Countless publications and speeches stressed that the South had legally seceded, not rebelled. "If we cannot justify the South in the act of Secession," one United Confederate Veterans leader wrote, "we will go down to History solely as a brave, impulsive but rash people, who attempted in an illegal manner to overthrow the Union of our Country."[49] The United Confederate Veterans refused to use the terms "rebel," "rebellion," or "revolution," even chastising school boards who dared to buy textbooks describing the war as a rebellion.[50] One recruiting leaflet for the United Sons of Confederate Veterans asked, rhetorically, "Was your father a Rebel and a Traitor? . . . Or was he a patriot, fighting for the liberties granted him under the Constitution, in defense of his native land, and for a cause he knew to be right?"[51]

In place of rebellion, the United Confederate Veterans praised Confederate soldiers for their obedience. As Carr, one of the leaders of the United Confederate Veterans, claimed in a speech in 1904, "the glory of the private soldier of the South was that, an intelligent unit, he permitted himself, for duty and for love, to be made into the cog of a wheel."[52]

Carr and the other leaders of the United Confederate Veterans were eager to transform the memory of Confederate soldiers from individualistic, daring rebels into obedient cogs because they needed cogs for their own machines. Carr owed his wealth to investments in a number of the South's new manufacturing processes and industries, from tobacco and textile production to newspaper printing and railroads. Many other United Confederate Veterans leaders were also white-collar entrepreneurs.[53] And their wealth was threatened in the 1880s, when tens of thousands of Southerners joined workers-rights organi-

zations like the Knights of Labor, which organized strikes for shorter hours and higher wages.[54] Membership in the Knights of Labor was open to both white and Black workers, and quite a few of its Southern chapters had interracial memberships.

The Southerners who owned the factories where Black and white workers were demanding new rights were furious. They blamed their troubles on "Northern pencil-pushers" who, "like the meddling abolitionists of a quarter century ago . . . are very sure that we are not capable of regulating our own affairs."[55] Factory owners fired strikers and called in police or private detectives to break strikes using violence.

The industrial elite also used what would prove to be a far more effective technique. While fulminating against Northern agitators, they tried to convince their white workers that they should take pride in their Confederate heritage—but told them that this heritage was one of deference to their social superiors.[56] Factory owners could not afford for their workers to think of themselves as rebels who would take matters into their own hands when they saw the authorities, whether in Washington or in the factory office, treating them unfairly.

The United Confederate Veterans organized many events to spread their message. The most popular were the annual reunions they held during the first decades of the twentieth century. Every summer, tens of thousands of Southerners would convene on whatever city was hosting the reunion—a lucrative honor for which cities competed fiercely. The 1903 reunion in New Orleans drew more people than that year's Mardi Gras. The celebrants could impress even a resident of that jaded city: "Just fancy 1,500 Texans, well primed with corn whiskey, turned loose on the bully—and behind a half-dozen brass bands playing the Bonnie Blue Flag!"[57]

Every reunion ended with a parade of marching veterans, greeted by spectators with "yells (not cheers) of triumph and enthusiasm that knew no bounds."[58] Young women sometimes ran into the lines of marching veterans to hand them flowers, "to clasp them around the neck [and] to kiss the wrinkled faces."[59] Historian Gaines M. Foster

argues these parades provided "a model of social order that met the needs of a society experiencing rapid change and disorder."[60] During the parades, only United Confederate Veterans leaders rode on horseback. The other veterans, even the former cavalrymen, walked humbly below them.

As the years went on, veterans themselves made up a smaller and smaller percentage of these crowds. The 1902 reunion in Dallas drew 140,000 attendees, but only 12,000 were veterans. The rest were their sons, daughters, or anyone else who wanted to see the spectacle. In this way, messages about what it meant to be an obedient Confederate soldier were broadened into messages about what it meant to be a Southerner.

The appearance of Black people as voluntary spectators at a reunion was so rare that newspapers remarked on it when it happened.[61] Like monument dedications, reunions served to unify the white Southern population. Their atmosphere of festive celebration and near-exclusive whiteness drove home their organizers' message.

When the brass bands packed up their instruments, Confederate monuments remained standing to remind viewers of the lessons of the reunions. According to the Southern Poverty Law Center, more than eight hundred of these monuments were put up in public spaces; more than half of them went up before World War I. These shafts would have been seen every day by elite white Southerners. But these men, or their fathers, had been Confederate officers. The audience who would have identified more closely with the privates on the shafts they saw every time they approached their towns' commercial or political centers were the South's working-class white farmers, laborers, and tradesmen.

Carr and other mythmakers of the Confederacy used these shafts as props in their creation of a picture of the antebellum past as a time of prosperity and the type of racial harmony that supposedly results from everyone knowing their rightful places.[62] If you were a white man working in one of Carr's factories in North Carolina in the early twentieth century, you could comfort yourself by believing

these good days would come again—even as you were struggling to make a living.

Of course, not everyone listened. Some white Southerners joined labor movements, voted for populist candidates, or otherwise tried to change themselves to meet the ways the world had changed. But many others pinned their hopes on the world swinging backward, to a time when people like them had supposedly been happy and powerful.

The South's factory owners and political leaders encouraged this impossible dream, warping the memory of the Civil War into the perfect consolation prize for white Southerners' suffering. The Confederate shafts let viewers interpret their suffering as noble. The more they suffered, the more pride they could take in their heritage. But trying to escape their suffering by adopting a new approach to life, like one where white and Black workers fought for fair wages together? That would be as cowardly as deserting from the Confederate Army, doomed as it was.

In the North as in the South, an anonymous, low-ranking solider in parade rest was by far the most common choice for Civil War monuments.[63] Northern and Southern shafts were often even produced by the same manufacturers. The same bronze foundry that cast the North Carolina State Confederate Monument also made the earliest Union soldier monument, erected in Cleveland, Ohio, in 1864.[64]

Very few Union monuments include Black figures. One of the exceptions, the 1887 Soldiers' Monument placed in a park in the center of Brattleboro, Vermont, makes it clear that Union monuments did not just look the same as Confederate ones—they also similarly functioned as guideposts for race relations.

The monument's bronze soldier stands in parade rest atop a granite shaft decorated with bronze plaques. One of these shows Union and Confederate officers shaking hands. An allegorical figure representing the United States stands above them, and a barefoot Black man in

ragged pants kneels below them.[65] The Confederate officer holds one hand to his chest, as if overtaken by a swell of brotherly emotion at his kind welcome back into the Union. The stolid Union officer shoves a scroll marked "Emancipation" into the Black figure's outstretched hands without meeting his eyes.

By showing white men elevated above a Black man who receives freedom as a gift, the image implies that white people will rule America together, leaving Black citizens forever crouched in a dependent place. Historian Kirk Savage has shown that other Union Civil War monuments that feature Black figures give similar messages.[66] But the image isn't the most discriminatory part of the Brattleboro monument. That comes in its inscription, which explains that the monument "commemorates the loyalty of the men of Brattleboro who fought for Liberty and the Union in the Great Rebellion of 1861–1865. Enlisted 381. Died in service 31."

In 2015, a group of local middle schoolers dug into Civil War records and found that the inscription's totals omit Brattleboro's Black

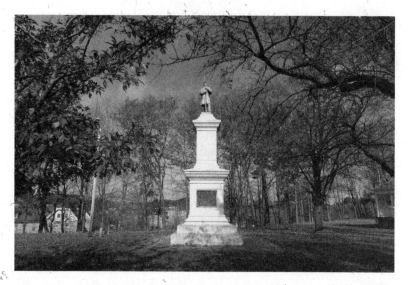

Soldiers' Monument, Brattleboro, Vermont, dedicated 1887.

Detail of Brattleboro Soldiers' Monument, showing Emancipation and the reunion of Northern and Southern soldiers.

veterans.[67] One of these, Charles P. Smith, was born in Brattleboro and died while serving in Port Hudson, Louisiana, in 1863. Two others, Isaac Sawyer and Benjamin Loney, were living in Brattleboro after escaping from slavery in Virginia. Loney died at the age of twenty in 1865, while stationed in Brownsville, Texas. Sawyer survived the war and settled in Charleston, South Carolina. Sawyer, Loney, and Smith volunteered for the army just days after the creation of the Bureau of Colored Troops allowed them to serve. Another seventeen Black men traveled to Brattleboro to enlist as paid substitutes for drafted Vermonters who wanted to avoid serving.

Brattleboro's Black soldiers were placed in Massachusetts Colored Troops regiments, but both Vermont and federal records credited Brattleboro with the Black men who mustered there. And yet, the town's

monument erased them from its memory. In the place of actual Black citizens like Sawyer and Loney, who seized their own freedom and then fought for that of others, the monument substituted the image of a kneeling Black man begging for liberty.

By the end of the war, 186,017 men had served in the Union "Colored Troops" regiments.[68] Seventy-eight percent of Black men in the North between the ages of fifteen and fifty had donned a uniform—along with a relatively astonishing 14 percent of Black men from the South. Sawyer and Loney were far from exceptional in taking the fight back home.[69]

When going into battle, Black Union soldiers would often shout "Remember Fort Pillow!" to remind themselves that, unlike white soldiers, they did not have the option to surrender. When the Confederate cavalryman Nathan Bedford Forrest attacked Tennessee's Fort Pillow in April 1864, it was being used as a Union supply depot.[70] The outnumbered defenders quickly surrendered. Among the men who threw down their arms were hundreds of Black troops. "Forrest ordered them shot down like dogs," one Confederate soldier wrote in a letter home a few days after what he called "the most terrible ordeal of my whole life." He explained that the slaughter of the surrendered Black soldiers stopped only when "our men became sick of blood."[71] A Union soldier reported that after he surrendered, a Confederate told him "we do not shoot white men," and then "ordered me away; [and] kept shooting the negroes."[72]

The massacre was so shocking, even in the context of the Civil War, that a congressional inquiry condemned Forrest's behavior. Forrest seems to have believed that to accept Black men's surrender and treat them as prisoners of war would have been to admit that they could be soldiers at all. If they were man enough to be soldiers, their enslavement would have been unjust.

Forrest denied that Black men could be soldiers and ordered them shot down like dogs. When they pretend that Black men never served, Union monuments quietly agree. Southern monuments denied that

slavery was the war's cause. Northern monuments joined them in denying that equality should be the war's outcome.

Even Fort Pillow itself tried to silence Black soldiers' plea to remember their fallen comrades. Members of the Association for the Study of African American Life and History were outraged when they visited the Fort Pillow State Historic Park and saw that the only mention of the massacre was a sign euphemistically describing the death of "some Negroes."[73] Their efforts sparked a campaign to acknowledge the loss. A historical marker about Fort Pillow's Black troops finally went up in 2018—but it was more than fifty miles away, in the Memphis cemetery where some of them were buried.[74] It was not until 2020 that signage at the fort was expanded to describe the massacre more accurately and list the names of the dead.[75]

In June 2020, Congresswoman Eleanor Holmes Norton, who represents the District of Columbia, announced she would seek the removal of the Freedmen's Memorial, an 1876 monument in a park about a mile from the Capitol Building.[76] Norton said the monument failed "to note in any way how enslaved African Americans pushed for their own emancipation."[77]

As art historian Renée Ater has described, the monument shows Lincoln bestowing freedom on a weak, subordinate, and passive Black man.[78] Lincoln holds the Emancipation Proclamation with one hand while stretching the other protectively over this man who, clad only in a loincloth, crouches at his feet. He clutches at the links of a broken chain attached to the manacle still bound around his wrist while gazing off into space, as if dazed by his new freedom.

Shortly after Norton's announcement, a ten-foot chain-link fence went up around the monument, supposedly to protect it from vandalism, but really to protect it from change.[79] The Freedmen's Memorial became a talking point for many who thought that protests against monuments were going too far. "They're looking at Abraham Lincoln,"

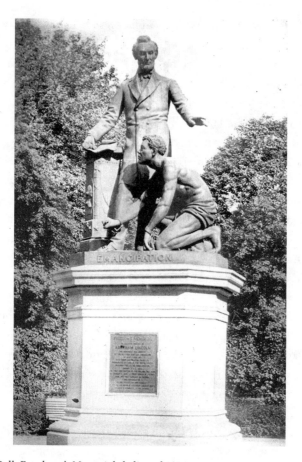

Thomas Ball, *Freedmen's Memorial*, dedicated 1876. *Library of Congress, Prints & Photographs Division, LC-DIG-npcc-00104.*

President Trump said about protesters shortly before he issued an executive order instructing authorities to prosecute those who vandalized monuments to the fullest extent of the law. "Not going to happen, not going to happen. Not as long as I'm here."[80]

The executive order claimed it was directed against "extremists" whose "selection of targets reveals a deep ignorance of our history." The story of the Freedmen's Memorial shows that today's protesters,

far from being ignorant of history, are continuing a history of pointing out the discriminatory intent of American monuments—a history that began as soon as the monuments went up.

Soon after Lincoln's assassination, a newly free woman named Charlotte Scott gave $5, her first earnings, to the man who had owned her. She said she wanted the money to be a contribution to a monument celebrating Lincoln, her emancipator. (At least, this is the way an Ohio newspaper reported the story.) Soon, an organization called the Western Sanitary Commission of St. Louis took control of the memorial project. The commission raised all the funds for the monument from Black Americans, many of them Union veterans. The white commissioners retained total control of the monument's design.

One of these commissioners was William Greenleaf Eliot, a Unitarian minister, abolitionist, and grandfather of the poet T. S. Eliot. He visited the studio of an American sculptor named Thomas Ball and admired a half-scale sculpture, *Lincoln and the Kneeling Slave*, Ball had created after hearing of Lincoln's death. In 1871, the commissioners accepted Eliot's recommendation that Ball should make a life-size version of this work for their monument.

Ball followed long-standing abolitionist imagery in showing the enslaved man nude, kneeling, and chained.[81] But he modeled the man's body on his own. Ball sculpted *Lincoln and the Kneeling Slave* in a spare room of his apartment. In his autobiography, Ball wrote that he hired a Black model to pose for the work, but fired him after two or three sessions, since "he was not good enough to compensate for the unpleasantness of being obliged to conduct him through our apartment."[82] To avoid the "unpleasantness" of letting his family get too close to a Black man, Ball "decided to constitute myself both model and modeler." He worked while kneeling in front of mirrors and boasted that he "succeeded in making one of the best of my nude figures."[83]

For the new monument, the commission asked Ball to change the face of the kneeling man to make him resemble a Black man named

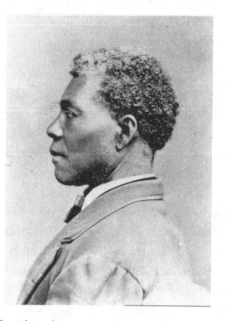

Photograph of Archer Alexander, c. 1870, taken in the studio of J. A. Scholten (St. Louis, Missouri). *Courtesy of the Missouri Historical Society, St. Louis.*

Archer Alexander.[84] Ball was spared any unpleasant contact, though—he worked from a photograph.

Alexander had escaped from slavery in early 1863, when he was in his mid-forties. The Emancipation Proclamation had just come into effect—but only in Confederate states. Alexander was in Missouri. There, and in the other Union border states, slavery was still legal. But when the Union officer who oversaw Missouri issued an order freeing anyone who escaped from a Confederate loyalist, Alexander ran.

He ended up in St. Louis, where Eliot hired him as a gardener. A few months later, Alexander "was suddenly & violently assailed by three men, who threatened his life with pistols & daggers, cruelly beat him with clubs, knocked him down, stamped upon & handcuffed him, dragged him to a wagon & carried him to jail," according to the letter Eliot wrote to complain to the military authorities.[85]

This was the second time Alexander had been kidnapped. The unclear legal status of slavery in Missouri meant that some who escaped from slavery had gained legal freedom, while others had not. Slave catchers took advantage of the confusion to seize both runaways and freedmen and sell them back into slavery before statewide emancipation finally went into effect in January 1865. Alexander had managed to escape the slave catchers the first time on his own. This time, Alexander was released thanks to Eliot's intervention, while the men who had falsely imprisoned him were jailed.

When Eliot took Alexander to a St. Louis photography studio in 1871 so he could send Ball his portrait, the irony of his choice seems to have escaped him. Alexander was no crouching supplicant, receiving freedom as an unearned gift. He had freed himself—twice. Like the Black Civil War veterans who paid for the monument with their donations, he had risked his life to obtain freedom.[86]

The Freedmen's Memorial was dedicated in 1876, on the eleventh anniversary of Lincoln's death. Congress, the Supreme Court, and President Ulysses S. Grant all turned out to listen to Frederick Douglass deliver an oration. The published version of his speech does not mention the monument's Black figure. But in an impromptu aside, Douglass criticized the way the sculpture showed the Black man kneeling.[87] A few days later, Douglass sent a letter to the editor of the *National Republican*, making his objections even clearer:

> The negro [on the monument], though rising, is still on his knees and nude. What I want to see before I die is a monument representing the negro, not couchant on his knees like a four-footed animal, but erect on his feet like a man.[88]

Douglass might have been thinking of the work of Edmonia Lewis, a sculptor born in New York to an Ojibwe mother and a Haitian father. In 1867, she carved a statue of a just-freed man and woman.[89] The man raises a fist wrapped in the manacle he has just broken. The woman

kneels, but she does so to offer thanks to heaven, not to a white savior. Lewis made *Forever Free* in Italy, where she spent most of her adult life. It was then publicly displayed in Boston for a short time before entering a private collection. Thus, Douglass, a longtime friend and supporter of Lewis, had indeed seen a sculpture of a free Black man "erect on his feet." What he meant in his letter was that he wanted to see a man like this on a public monument, rather than a sculpture tucked away in a collector's home. Douglass would not get that wish before he died.

In 1916, Freeman H. M. Murray, a Black intellectual, journalist, and activist, tracked down all the representations he could find of Black Americans on public monuments. There were not many. He collected them in a book, asking of each one "What does it mean? What does

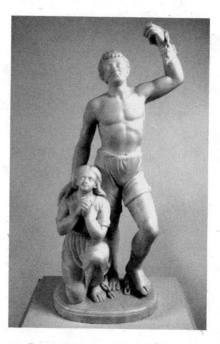

Edmonia Lewis, *Forever Free*, 1867. *Courtesy of the Howard University Gallery of Art, Washington, DC/Licensed by Art Resource, NY.*

it suggest? What impression is it likely to make on those who view it? What will be the effect on present-day problems, of its obvious and also of its insidious teachings?"[90]

Like Douglass, Murray criticized the Freedmen's Memorial's crouching man. He thought the man showed "little if any conception of the dignity and power of his own personality and manhood."[91] If he were to speak, Murray imagined, he would doubtfully murmur, "Oh Lincoln, am I free?" instead of declaring "Well, sir—you see I am free." Murray argued that American monuments depicted Black people not as they really were, but as white Americans wished they would behave. They were shown as subordinate, obedient, second-class citizens, grateful for their freedom and accepting, as Carr claimed, that they were unfit for real political or social equality.

Murray proposed removing the Black figure from the Freedmen's Memorial, thereby rendering it "much less open to objections" as a memorial to Lincoln alone.[92] If not, he thought the monument should be renamed back to Ball's original title, *Lincoln and the Kneeling Slave*, since it did not show two free men.[93]

The Freedmen's Memorial was installed just months before the federal government withdrew the last remaining troops from the South. With the end of Reconstruction, any remaining hopes that the federal government would help Black Southerners maintain political representation died. Just as the Black man on the Freedmen's Memorial hovers between kneeling and standing, between slavery and equality, the government left Black Americans crouched in a painful position—no longer enslaved but still subordinate.[94]

The only nineteenth-century public monument to show Black soldiers in full uniform was Boston's Robert Gould Shaw Memorial, unveiled in 1897. Shaw died while commanding the 54th Regiment Massachusetts Volunteer Infantry, the regiment in which Brattleboro's Isaac Sawyer served. Shaw rides at the monument's center, his Black troops marching below and behind him like a decorative backdrop. As the twentieth century went on, only a handful of new monu-

ments acknowledged the existence of Black soldiers, and a national monument to the Union's Black soldiers went up in Washington only in 1998.[95]

The absence of Black soldiers on war monuments is all the more apparent because of just how many of these monuments there are. Hundreds of Civil War monuments were created in the twentieth century—many of them put up by men who had discovered how very profitable they could be.

A Shrine for the South

The ax drove into the middle of Robert E. Lee's face.[1] The attacker swung his weapon again and again into the plaster and wire that formed the portrait of the Confederate general until his bearded chin lay in fragments on the ground and his nose dangled by a single strand of wire. Only Lee's hat remained intact. The attacker could not reach that high; Lee's face and shoulders were as tall as his entire body.

It was midafternoon on a Wednesday in late February 1925. The morning had been cool, but as the sun warmed the workshop where Lee's head stood, the attacker shrugged off his overcoat. He walked a few steps to another artwork. This one showed Lee riding alongside Gen. Thomas "Stonewall" Jackson and Confederate president Jefferson Davis. The men and their horses were life-size. The sculpture was large—but it was just a model for the colossal work slowly progressing outside the workshop. The entire cliff face of Stone Mountain, a few miles from Atlanta, Georgia, was being carved into a Confederate monument. It would be the world's largest relief sculpture. For now, only the head of Lee had emerged from the mountain.

Soon, the horses' legs were all that remained of the model. The heads and limbs of the Confederate leaders mixed with bits of their uniformed bodies on the ground. Satisfied, the attacker dropped his ax, its head now coated in plaster dust, among the debris. He and an

Gutzon Borglum and his model of Lee's head for Stone Mountain.

accomplice carried some smaller models from the workshop to a wait-
ing truck and then fled so quickly that he left behind his overcoat.

Police in four states began searching for the attacker, whose iden-
tity was not a mystery for long. The mountain was a popular stop for
tourists who wanted to see the monument's carvers suspended hun-
dreds of feet above the ground as they worked, and the man who ran a
stand to sell soft drinks to these visitors had recognized the person he
saw going into the workshop.[2]

The ax-wielder was named Gutzon Borglum. His photograph had
been appearing for years in newspapers across the nation. Borglum
was not tall, and his head rose to a dome of polished baldness. That
afternoon, he was a few days shy of his fifty-eighth birthday. But he
was so charismatic that women adored him and men gave him incred-
ible sums of money in exchange for the slimmest of promises.

Borglum lived in Connecticut and was so obsessed with the Union's

The model of Lee's head after the 1925 attack, with an investigator holding the ax used by Borglum.

martyred president that he named his son Lincoln. When he picked up the ax, he believed that the monument had become a Ku Klux Klan plot to defraud donors.

Borglum was right. The Klan was deeply involved in Stone Mountain. But he wasn't angry that the Klan was siphoning off donations. He was a Klansman himself. He was angry he wasn't getting a cut.

Borglum was a sculptor. Ten years before, he had been hired to create Stone Mountain's Confederate monument. It was he who had created the plaster models he smashed. The committee that controlled the project had just fired him.

To understand why they ever hired Borglum in the first place, and to understand how Stone Mountain, which is still Georgia's most visited tourist site, came to be carved, we have to go a long way back. To

Gutzon Borglum in his studio, c. 1915. *Genthe Photograph Collection, Library of Congress, Prints & Photographs Division, LC-DIG-agc-7a00238.*

do so is crucial for our broader conversation about American monuments. Stone Mountain shows us the importance of looking deeper than just the people portrayed on a monument. We also need to know what the people who carved them there wanted—and what sort of behavior the monument has encouraged.

Borglum was born in 1867. He spent his first year in a two-room cabin in Bear Lake Stake, a Mormon frontier settlement in Idaho, along with two half-siblings, his father, and his father's two wives. They were Danish converts who had been ordered by the Church to emigrate to America. Borglum's father married his first wife in a mass wedding ceremony. There had been too few bunks for the hundreds

of Mormons waiting to board the ship to America, and so the leaders of the expedition paired up the single men and women to save space.

Once in America, Borglum's father and his new wife traveled west by riverboat and train. When they reached the end of the line, they walked the remaining thousand miles to Salt Lake City. Seventeen days after the wife's younger sister arrived to join them, the three were united in a polygamous marriage. But they grew disenchanted with the Mormon Church. Since polygamists outside Mormon territory were routinely ostracized, prosecuted, and even jailed, the family decided that Borglum's mother, the younger sister, would stay behind when Borglum's father was admitted to medical school in St. Louis. Borglum never saw her again.

Borglum, five years old, became an angry child. For the rest of his life he would stay angry, always ready to turn any encounter into a fight. Supreme Court Justice Felix Frankfurter, who was later friendly with Borglum, recalled his "uncompromising" nature: "Gutzon was for war, for all sorts of war, six wars at a time. People weren't wrong; they were crooked. People didn't disagree with him; they cheated him."[3]

Borglum taught himself to draw. When he was a teenager he apprenticed with a lithographer in Los Angeles and then carried drop cloths and buckets for a crew of fresco painters. Soon, he convinced an older artist to share her studio and her money with him while he studied painting. They married in 1889, when she was forty and Borglum was twenty-two.

Over the next decade, living mostly in London, Borglum painted portraits of the members of high society. His elegant lodgings and extravagant hospitality meant that no matter how much he earned, his expenses were always greater. After he exhausted both his own earnings and his wife's savings, she borrowed money from her relatives.

She wrote them placating letters, apologizing for delays in repaying their loans. Borglum himself was seldom bothered by his debts. He spent his life owing friends and colleagues astounding amounts of money. The more he owed, the more he spent and the more he

borrowed. Borglum seemed to think that the world, having taken his mother, could never give enough to repay him.[4]

While his wife dealt with their precarious finances, Borglum stewed over his failure to make great artworks: "my poor brain is a killing pen where the tenderest emotions . . . are dissected and torn to bits," he wrote in his diary.[5] In 1901, Borglum impulsively separated from his wife and moved to New York City. There, in love with the young woman who would eventually become his second wife, Borglum found a new artistic pursuit he thought was sure to bring him fortune and fame: monumental public sculpture.

Sculptors like Augustus Saint-Gaudens, Daniel Chester French, and John Quincy Adams Ward were living well on monument commissions—far better than painters stringing together enough portrait commissions to survive. But these established sculptors took most of the jobs.

Borglum first tried to break into their lucrative world by entering a 1902 competition for a memorial to honor Ulysses S. Grant. The contract would pay $250,000. Borglum's entry was a scale model of a 190-foot frieze of Civil War scenes with Grant and Lee reconciling at its center. After his model was thrown out of the competition without explanation, Borglum claimed the jury believed that he, an untried sculptor, must have secretly hired European artists to produce work of such quality. Borglum indignantly declared he would never enter a monument competition again.

Instead of wasting time preparing a model for a competition with no certainty of a victory, Borglum decided to use his political connections. Upon returning to America, he had quickly become involved in conservative politics on both the local and national levels. He was valued for campaigning as creatively and fiercely for political candidates as he did for his own artistic reputation.[6]

His most important connection was Theodore Roosevelt, whom Borglum had met when Roosevelt was a New York City police commissioner. Borglum had failed to sell Roosevelt any art, but the two

became friends, both seeing themselves as giants in a world of weaklings. When Roosevelt became president, Borglum frequently visited him, becoming a familiar sight in the drawing rooms of Washington's high society. His party-going was strategic. The guests at these social events controlled public monument commissions.

In 1907, Borglum persuaded a hostess to seat him for dinner next to the widow of Gen. Philip Sheridan, a Union Civil War hero. Congress had authorized $50,000 for his monument, hiring John Quincy Adams Ward to sculpt it. When Ward had finally unveiled his plaster model in 1906, seventeen years after he began the project, rumors spread that Sheridan's widow and son hated its depiction of an aging officer with his uniform stretched across his paunch.[7]

Borglum knew about these rumors. Over dinner, he described the monument he would have made instead. He told Mrs. Sheridan he would have used her son as the model for a young Sheridan, mounted on his famous horse, Rienzi, charging toward the Battle of Cedar Creek in October 1864.[8] The Confederates had launched a surprise attack while Sheridan was miles away from his troops. Sheridan heard the distant artillery and sped toward the battle. He rallied his retreating troops, shouting, "You'll sleep in your tents tonight, or you'll sleep in hell!" Sheridan turned a rout into a victory that effectively expelled Confederate forces from the Shenandoah valley.

Charmed, Mrs. Sheridan canceled Ward's contract and awarded the commission to Borglum. His sculpture, unveiled in Washington's Sheridan Circle in 1908, was a success. Viewers swore they could almost hear General Sheridan's famous rallying cry.

Borglum had proved he could make a monument. Now he wanted to show he could carve Lincoln. With the hundredth anniversary of Lincoln's birth approaching, several major projects were in the works, including what would become the National Mall's Lincoln Memorial. Borglum wanted those commissions.

As a first step, Borglum persuaded the financier Eugene Meyer to pay him to carve a large marble bust of Lincoln. When an art dealer

Gutzon Borglum, Sheridan monument, dedicated 1908. *Library of Congress, Prints &*
Photographs Division, photograph by Carol M. Highsmith, LC-DIG-highsm-10131.

had introduced the two, Meyer was already a wealthy man, but he
did not have the Washington connections he wanted. Borglum's bust
would solve both of their problems. Roosevelt let Borglum display his
work in the White House for Lincoln's ninety-ninth birthday in 1908,
giving Borglum an excuse for introducing Meyer to the president and
launching Meyer's Washington career. (He would eventually serve as
chairman of the Federal Reserve, first president of the World Bank
Group, and publisher of *The Washington Post,* where his daughter Kath-
arine Graham would succeed him.) After Meyer offered to donate the
bust, Roosevelt asked Congress to accept the gift for display in the
Capitol Rotunda.[9] Todd Lincoln called it the most remarkable likeness
of his father he had ever seen. Borglum's reputation as a sculptor of
Lincoln was secure—and just in time.

Shortly after Borglum's Lincoln bust took its place in the Capitol, a

wealthy Union veteran died, leaving $75,000 for the creation of a Lincoln memorial in Newark, New Jersey. The commission in charge of the memorial began planning a competition to pick a sculptor. Before this competition could begin, Borglum presented them with a model of a monument with Lincoln seated on a bench, glumly contemplating the progress of the war. The well-connected Borglum had been tipped off by a friend, who was in charge of executing the will. The commission found the model so impressive that they canceled the competition and gave Borglum the job.

Roosevelt dedicated the monument on Memorial Day in 1911. It remains in place outside the Newark county courthouse, the president's knees shiny from generations of children clambering into his bronze lap. The pleased committee awarded Borglum the additional $100,000 the donor's will had set aside for a war memorial.[10]

Borglum received $175,000 for the Newark commissions, but out of this, he had to pay all the expenses of producing the monuments. Not much remained after Borglum paid for the bronze, the foundry's fee, and his workmen's salaries. But he did have a grateful patron.

In 1910, Meyer lent Borglum $40,000, the equivalent of well over a million dollars today, to purchase several parcels of land in Connecticut. The sculptor dubbed his new estate "Borgland" and threw himself into making a home as marvelous and astonishing as the monuments he wanted to create.

A crew of Italian stonecutters dug up granite boulders from the estate's fields, cut them into blocks, and began building Borglum a massive studio. He dammed a river to create a pond and stocked it with trout. He even bankrolled a bus company to make it more convenient to get from the train station to his estate. But his hatchling trout died. Then someone blew up his dam. Work on the new studio progressed so slowly that Borglum had to keep renting his old New York City studio. And his bus company folded, leaving him deeper in debt.

Congress finally launched its Lincoln Memorial project in 1910. In 1912, as the committee slowly pondered designs, Borglum named his

newborn son Lincoln.[11] But all his maneuvering came to nothing. In 1914, the commission for the memorial's central statue went to the sculptor Daniel Chester French. And the outbreak of World War I the same year meant that most other plans for monumental sculptures were put on hold, even before the United States entered the fight.

By the end of 1914, Borglum's creditors were dunning him and he had few prospects of new commissions. He was reduced to mortgaging and even selling off pieces of Borgland, keeping the money for himself instead of repaying Meyer. But as the sculptor brooded in his unfinished studio in Connecticut, his salvation was brewing in the dreams of an elderly Confederate widow in Georgia.

Caroline Helen Jemison Plane was born on one of her father's Alabama plantations. Her brother served as a senator in Alabama's Confederate Congress.[12] The grand house he began to build in Tuscaloosa in 1859 featured the city's very first flush toilets. They were powered by an enslaved person in the basement, pumping up water from a cistern.[13]

Plane's husband, a lawyer turned captain in the Confederate Army, died at Antietam in 1862.[14] Honoring his memory, Plane founded the Atlanta chapter of the United Daughters of the Confederacy. She was also the first president of the Daughters' Georgia State Division.[15] By 1914, Plane and the Daughters had erected more than twenty Confederate monuments in Georgia. Plane, then eighty-five years old, should have been well satisfied with her work. Instead, she launched her largest project yet.

Plane had read an editorial in the *Atlanta Constitution* written by the son of a Confederate veteran. He described his dream of carving giant statues of Confederate heroes on the face of Stone Mountain, which he could see from his office in downtown Atlanta. Plane was inspired. She began arguing that the Daughters should stop putting up "small and

perishable local monuments." Instead, they should create "a shrine for the South . . . of which all Americans may be justly proud."[16]

Stone Mountain is not much of a mountain. It rises only around eight hundred feet above the surrounding treetops. But this is higher than anything else for thirty miles. And although you can stroll up one side of the mountain, the other side has a dramatic perpendicular cliff face, fifty stories high.

Plane's first letter was to the man who owned the mountain, Samuel Hoyt Venable. He had been born in 1865 to once-wealthy parents who lost nearly everything in the Civil War. As a young man, Venable's grain operator business failed, his savings evaporated when he speculated in cotton futures, and the grocery store he borrowed money to open burned down a day after his insurance policy lapsed. But then, in 1879, he and his brother began to quarry Stone Mountain. Its hard, durable stone absorbed little water and was uniformly gray with few discoloring iron deposits. It was perfect for building.

By 1893, the Venable brothers owned the whole mountain. Their company could produce two thousand feet of curbstones and two hundred thousand paving blocks per day.[17] Stone Mountain granite paved the streets of downtown Atlanta and was used in hundreds of courthouses and post offices across America. As you go up the steps of the east wing of the U.S. Capitol Building, you are walking on parts of Stone Mountain. Its granite guards your money in the vaults of the Treasury Building, Fort Knox, and four Federal Reserve banks. Your online orders and even the food you eat might come to you through the locks of the Panama Canal or the tunnel from Canada to Detroit— both built from Stone Mountain granite. Surely to Borglum's dismay, its stone also forms the foundation of the Lincoln Memorial.

Stone Mountain helped build America. Venable enthusiastically agreed with Plane that it was now time for it to honor the Confederacy.

With Venable's cooperation assured, Plane formed a special committee, the Stone Mountain Memorial Association, within the Daugh-

ters' Georgia Division. In June 1915, she sent an invitation to her sculptor of choice: Borglum.[18]

Borglum spent three days exploring Stone Mountain, taking measurements and sitting with Venable on the porch of his summer home at the foot of the mountain to watch its changing appearance as the sun set. Borglum soon reported back to Plane and the Daughters that Stone Mountain was not only "suitable for colossal monumental work," but that if "Egypt or Greece possessed a mountain of such sound building materials they would have shaped the entire mountain into a temple to their deity."[19] Borglum promised that, with his help, Georgia could outstrip the ancients. Stone Mountain could become "not the eighth but the first wonder of the world."[20]

The only problem Borglum saw was Plane's limited imagination. She had explained that she wanted him to carve a massive bust of Lee, but Borglum insisted it would appear as insignificant on the vast cliff face as a dime fallen on a rug. Borglum presented his own vision. He wanted to send more than seven hundred figures sweeping across the mountain, circling a central group of Lee, Stonewall Jackson, and Jefferson Davis. Nathan Bedford Forrest would be riding in from the side with his calvary, with the Confederate infantry and artillery descending from above to join them. Mounted officers would represent Confederate heroes from each state. Each of these hundreds of figures would be at least thirty-five feet tall.

Nor did the gentlemanly Borglum neglect the women of the Confederacy. He wanted to shelter them inside the mountain by hollowing out a huge Memorial Hall. At its center would sit a statue honoring Southern women as the carriers of the memory of the Confederacy. Borglum promised this sculpture would be as big as the one French was carving for the Lincoln Memorial.

Borglum, who began his career by designing a monument to the glory of Grant, who won fame with his portraits of Sheridan and Lincoln, and who had never carved a mountainside, seemed an unlikely choice to glorify the Confederacy on Stone Mountain. But as the

Sheridan monument had shown, he specialized in carving horses and charming society ladies. He soon won over the women of the Memorial Association.

Next, Borglum presented his plan at the Daughters' annual national convention. He described the pyramids, the Athenian Acropolis, and the Colossus of Rhodes—and promised that Stone Mountain would be greater than all of them. "The Confederacy furnished the story, God furnished the mountain," he told them. "If I can furnish the craftsmanship and if you will furnish the financial support, then we will put there something before which the world will stand amazed. The whole world is waiting for us to begin."[21] He asked for $2 million.

The whole world may or may not have been waiting, but Borglum's creditors certainly were. His proposal was as vast as his debts were deep. He was in enough financial trouble that the payment for a single sculpture, even as large as the bust of Lee envisioned by Plane, would not save him. Borglum negotiated to be paid a percentage of the monument's total cost. The more elaborate Stone Mountain became, the more money he would make.

A few days after Borglum sold the Daughters on his vision of a gigantic monument, Stone Mountain witnessed the awakening of the Klan from its fifty-year slumber. On Thanksgiving night of 1915, Venable arrived at the luxurious Piedmont Hotel in Atlanta. He had received an invitation to be one of the founding members of a new fraternal society. But the hotel was just the gathering point. A bus was waiting to take Venable, along with fifteen others, back to his own property. They climbed Stone Mountain's gently sloping back by flashlight, led by their host, William Joseph "Doc" Simmons, a failed Methodist minister.

On the mountain's granite top, Doc Simmons pointed them toward a kerosene-soaked cross made of pine boards. The men donned bedsheet robes and pointed hoods, set the sixteen-foot cross alight,

Postcard celebrating the 1915 revival of the Klan at Stone Mountain. *Courtesy Virginia Commonwealth University Libraries.*

and took their initiation oaths to join the reborn Knights of the Ku Klux Klan.

The Klan had first been formed in 1866 by a group of six Confederate veterans in Pulaski, Tennessee. They were of Scotch-Irish descent (hence the "Klan") and wanted to form a circle of friends ("Ku Klux" was modeled after the ancient Greek word for circle, *kuklos*). The Klansmen soon began to direct their energies to harassing newly emancipated Black Southerners. They stole their weapons, destroyed their property, and tried to intimidate them by dressing up as the ghosts of Confederate soldiers.

The Klan soon expanded far beyond Pulaski. Its members invited Nathan Bedford Forrest to lead them. Forrest, who had commanded the massacre of surrendering Black troops at Fort Pillow, became the Klan's Grand Wizard in 1867. His fame led to even more growth. Just before the 1868 election, Forrest told a reporter that he presided over more than half a million members.[22] The Fourteenth Amendment had

been ratified earlier in the year, but Forrest commanded his Klans-men to stop Black citizens from making it to the polls. When they succeeded at their campaign of intimidation and secured office for the candidates they backed, the Klan's activities became even more brazen and violent.

Finally, in 1871, Congress began to investigate the murder of the South Carolina politician Benjamin F. Randolph. Shortly after he was elected to the South Carolina state legislature in 1867, three men shot him on a train station platform in broad daylight and then rode off unpursued.[23] Convinced that local authorities were unable or unwill-ing to stop the Klan, Congress passed legislation allowing victims to sue the Klan in federal court. President Grant also deployed troops in South Carolina to curb Klan violence. Faced with prosecution and punitive damages, the Klan faded away. But Southerners never quite forgot the image of the Klansman.

Doc Simmons had been inspired to revive the Klan by D. W. Griffith's *Birth of a Nation*, which premiered in January 1915. Originally titled *The Clansmen*, the movie included scenes of Klansmen defending white Southerners during Reconstruction. Plane was one of many who were stirred by the movie's heroization of the Klan. "I feel that it is due to the Ku Klux Klan which saved us from Negro domination and carpet-bag rule," she wrote to Borglum, "that it be immortalized on Stone Mountain. Why not represent a small group of them in their nightly uniform approaching in the distance?"[24]

Borglum responded that it would be anachronistic to include Klans-men in the memorial, since the organization did not yet exist during the war. But he agreed to include a Klan altar in his plan, and Plane persuaded the studio to donate a portion of *Birth of a Nation*'s Atlanta proceeds to the Stone Mountain project.[25]

The massive publicity campaign for *Birth of a Nation* and its roman-tic vision of the Klan went on for months as the movie and its dedi-cated orchestral accompaniment toured America. Doc Simmons ran announcements seeking members for his newly formed Klan, described

as "the World's Greatest Secret, Social, Patriotic, Fraternal, Beneficiary Order," alongside advertisements for *Birth of a Nation*, which premiered in Atlanta a week after the Klan's Thanksgiving rebirth.[26] Within days, Simmons's Klan boasted ninety-one members.[27]

Venable was appointed to its ruling council.[28] He seems to have wasted little time in recruiting his new friend Borglum. Borglum, of course, had very good reason to make sure that Venable liked him: the Klansman still owned Stone Mountain. Venable had granted the Monumental Association a deed to the cliff face, but it would revert to him if the monument was not completed by 1928. If the association wanted to renew the deed after this fast-approaching deadline, it would have to pay attention to Venable's demands. Borglum tried to make sure that one of these demands would be his own retention as the project's sculptor. And so, Borglum joined the Klan.[29]

Even if Borglum hadn't wanted to keep close to Venable, he would have found the Klan congenial. Anti-Semitism was a key part of Simmons's revival of the Klan, several of whose founding members had abducted a Jewish man wrongly convicted of the rape and murder of a white woman from prison and lynched him just a few months before they followed Simmons up Stone Mountain.[30] Borglum was an active anti-Semite. He was willing to borrow money from Jewish patrons like Meyer, but he wrote several long papers on "the Jewish question," claiming that Jewish people "do not share or create" but instead made their money by exploiting the labor of others.[31] The Klan's insistence on the superiority of the "Anglo Saxon race" also fit right in with Borglum's way of seeing the world, or at least himself. He described himself as a "Viking and Crusader" whose creed was "physical efficiency and perfection."[32]

The Klan also offered Borglum a new way to engage in his beloved political maneuvering. Borglum saw the Klan as a chance for farmers and other white, working-class people to win power, extricating themselves from exploitation by the Jewish bankers he believed controlled the world's finances. Borglum used his connections to try to bring the Klan into national politics. In 1922, he arranged for the Klan's

new Imperial Wizard to meet President Harding.[33] And in the lead-up to the 1926 elections, Borglum acted as a political adviser for a Klan leader campaigning for an Indiana Senate seat, hosting him at Borgland and exchanging letters about their plan "to organize the power within the Klan into an effective body of voters."[34]

Borglum finally got to work on Stone Mountain in 1916, when Plane and the Daughters turned control of the project over to a new organization, the Stone Mountain Confederate Monumental Association. Borglum's first act was to destroy the prehistoric enclosure built on the mountaintop by Indigenous inhabitants long before the arrival of settlers.[35] The enclosure was probably a ceremonial space, but we cannot be sure, because Borglum ordered all the remaining stones thrown down the mountain. He didn't want them lying there as potential ammunition for someone to damage his carving.

Borglum decided he would begin by carving the central group of Lee, Jackson, and Davis. He sculpted the group in clay and then cast these sculptures in plaster (which would not shrink or crack, as clay would, over the years it would take to carve the stone). He also hired a force of mainly Black Stone Mountain quarry workers. These men hung from leather harnesses to drill holes in the mountainside to anchor a staircase and work platform. They carried iron rods and lumber to build these structures up the last stretch of the slope, which was too steep for trucks. One of the workers, a man named Homer, "could take a piece of timber four by eight inches and eighteen feet long, put it on his shoulders, carry it to the top of the cliff and down the stairs without dropping it or pausing for breath."[36] The air compressor to power the carvers' drills was so heavy that it took two days to pull it up the slope. Two workers crawled beside it on hands and knees the entire way to keep the rollers underneath it in line.

Black men would never be permitted to do artistic work at Stone Mountain. But their labor made the whole project possible.

While his workmen crawled, Borglum placated his creditors. He could now tell them that the whole South would fund the monument, which could well employ him for the rest of his life. There was just one thing standing in the way of Borglum's rosy future: he had no idea how to carve Stone Mountain. Sculpture this large had never before been carved from a mountainside, especially not on a site five hundred feet above the ground.

Borglum's first major challenge was simply to get his design onto the cliff face, so the carvers would know where to cut. He announced he would use a projector to shine his drawing on the mountainside. Then, he would pour down chemicals to fix the image, treating Stone Mountain like the world's largest photographic negative. Newspapers around the world raved about this plan before professional photographers convinced him it would never work.

Borglum's next plan was to have painters copy the lines of his design as it was projected on the stone. But the largest available projectors had a range of only a few hundred feet, far short of the distance from the ground to the carving site. Borglum hired a photographic engineer to design the special, one-ton projector he needed. When it was finally ready, Borglum switched on the lamp and immediately saw another problem. When the mounted Confederate leaders of the central group were projected at the planned height of fifty feet, they looked puny. Borglum fiddled with the lens, enlarging the image until the horsemen seemed properly impressive. His workmen, dangling from harnesses, measured the enlarged figures. The Confederates now stood 168 feet tall from heads to hooves, tripling Borglum's planned project in an instant. Of course, the bigger the project, the more Borglum stood to make.

Doc Simmons possessed a flair for the dramatic, but in his Klan's first years, he managed to recruit only a few thousand members.[37] During the same period, work on Stone Mountain was also proceeding slowly. Even after Borglum figured out the technical difficulties, not enough

donations came in to pay for the work. In 1920, both Stone Mountain and the Klan were saved by the same man: Edward Young Clarke.

Clarke was a public-relations expert. When he learned of the Klan's trouble recruiting members, he saw great possibilities for himself. Each new Klansman paid Simmons $10 in initiation fees (grandly referred to as "klectokens") as well as $6.50 for his white robe and hood.[38] Clarke negotiated a contract with Simmons. He would take over all the costs and work of recruiting new members. In return, he would keep $8 from each klectoken.

Clarke soon deployed more than one thousand paid recruiters, dubbed "Kleagles," to seek out new members across America. Clarke's major innovation was to expand the Klan's range beyond its anti-Black and anti-Semitic foundations. He told the Kleagles to claim that the Klan would also target whomever it was that potential members hated. Soon, the Klan was against Catholics, immigrants, political radicals, bootleggers, corrupt politicians, and anyone who violated conventional social and sexual mores.

Clarke's campaign was incredibly successful. Within a year, the Klan was back at its Reconstruction-era size of five hundred thousand members.[39] By 1924, the Klan was gaining an estimated half a million new members a year.[40] To increase their profits, they even bought a garment factory in Atlanta to manufacture their own robes and hoods.

Clarke and Simmons collected millions in klectokens. They and other Klan leaders grew rich by selling Americans the fears and hatreds they already possessed, in a gigantic multilevel marketing scheme whose products were white robes, burning crosses, and lynchings.

Borglum also proposed that Clarke be put in charge of the donation campaign for Stone Mountain. As with the Klan, Clarke negotiated a steep fee, keeping 25 percent of the donations he solicited. And in June 1923, after nearly eight years of preparatory work and wartime delays, Borglum finally began carving the mountain. He strapped himself into a harness and drilled the first symbolic holes of the sculpture during an elaborate ceremony. The governor of Virginia delivered a speech

claiming the monument would "outlive the centuries" and "carry the history of our Southern War to a future so distant that the mind of man is not gifted to grasp it."[41]

As workmen began to rough out the head of Lee, it soon became apparent that the monument, whether or not it would outlive the centuries, would definitely take centuries to complete at the pace they were going. The granite was so hard that a near-continuous row of holes had to be drilled around the edges of any piece they wanted to remove. An engineer from Belgium's hard stone quarries who happened to be vacationing in Georgia stopped by the site and rescued the project by showing Borglum how to use small amounts of explosives for precision blasting.

To reassure donors, still skeptical that the monument was possible, Borglum planned a spectacular unveiling for Lee's 117th birthday, January 19, 1924.[42] He drove his workers hard to give him something to unveil. In the final stretch, the men worked in shifts twenty-four hours a day. Pots of coals hung beside them to keep their hands warm enough to drill. They managed to complete only Lee's head and part of his torso, but it was enough of a milestone to celebrate.

Borglum kicked off the ceremonies by inviting a group of dignitaries to a meal of fried chicken and biscuits served on the scaffolding. One end of the makeshift table rested on Lee's shoulder. The following day, Borglum carried Helen Plane, now ninety-four years old, to her seat on the speaker's platform. When she held up a small Confederate flag as a signal, a giant American flag dropped from the carving site. "It's General Lee!" an elderly man wearing a Confederate uniform shouted, and the thousands of spectators cheered.[43]

No matter how many figures he carved on Stone Mountain, the payments Borglum earned from his work would never be enough. Borglum had borrowed more and more money to live the life he thought matched his genius.[44] It seems he promised each new creditor he would pay them back when donations to Stone Mountain began to flow.

At first, these new creditors did not know about one another or

Postcard commemorating a lunch on the scaffolding at Stone Mountain in 1924 to mark the completion of the head of Lee.

realize how impossible it would be for Borglum to pay them all. But shortly after the unveiling, Meyer finally lost patience and sued Borglum for nearly $80,000.[45] Borglum had never repaid any of Meyer's 1910 loan, and the accumulated interest had doubled the original debt. Soon, others caught on that Borglum had no intention of repaying them; his attorney dealt with nearly fifty lawsuits from impatient creditors in this period.[46]

Meyer would eventually settle his suit, receiving new, and undoubtedly equally worthless, promissory notes from Borglum.[47] Most of the sculptor's other creditors were also relatively easily dissuaded. His attorney replied to their complaints by pointing out that there was no point in suing, since there were so many others already in line to claim Borglum's few assets. But in late 1923, Borglum had borrowed $30,000 from a man he knew would not resign himself to a loss so easily.[48]

This lender was named David Curtis Stephenson. When the Klan had named him Grand Dragon of the Northern Realm in 1923, two

hundred thousand robed and hooded Klansmen attended his inaugu-
ration.[49] Stephenson promised them that "the fiery cross is going to
burn at every crossroads in Indiana" and, with him in charge, "we are
going to Klux Indiana as she has never been Kluxed before."[50] Nearly
a third of Indiana's white men belonged to the Klan, and Stephenson
had profited richly from his share of their initiation fees and dues.
A combination of bribes and Klan-orchestrated voting blocs kept the
state's highest elected officials in his pocket.[51] Stephenson was also a
violent and vindictive alcoholic—not someone even Borglum would
want to default on.

Fortunately for him, Borglum had come up with a new scheme—
one that would scam the entire nation for funds he could use to pay
back Stephenson.

In late 1923, President Coolidge met with Borglum and Hollins N. Ran-
dolph, an Atlanta lawyer and Klansman who was the president of the
Stone Mountain Confederate Monumental Association. They pitched
the president on Borglum's newest fundraising idea. He asked permis-
sion to design a half-dollar coin commemorating the monument. The
Mint would produce the coins and sell them to the association at their
face value, fifty cents. Then, the association would sell the coins for at
least a dollar, keeping the difference to fund the monument.

Ignoring the logical problems of commemorating an incom-
plete monument—at this point, not even the head of Lee had been
finished—Coolidge persuaded Congress to pass a bill authorizing the
minting of 5 million coins. In a less-than-convincing bid to lessen
the coins' celebration of the Confederacy, the text of the legislation
claimed to honor Southern soldiers for the way their valor inspired
"their sons and daughters and grandsons and granddaughters in the
Spanish-American and World Wars."[52]

Borglum helped make the coins more nationally palatable by leav-
ing Confederate president Davis off the coin. Only Lee and Jackson

remain, riding horses whose legs are awkwardly squeezed between the coin's side and the words "Stone Mountain." Thirteen stars dot the background. Borglum claimed Northerners would interpret them as representing America's original colonies, while Southerners would see them as the Confederate states. On the coin's reverse, the motto "E Pluribus Unum" is uneasily juxtaposed with an inscription explaining that Stone Mountain is a "Memorial to the Valor of the Soldier of the South."

After delays due to federal authorities demanding several rounds of revisions to Borglum's designs, the Philadelphia Mint began to strike the commemorative half-dollars in early 1925.[53] Selling the full authorized minting of 5 million coins would have meant at least $2.5 million in profit. This was a fortune—a fortune Borglum was eager to claim.

As the coins went into production, Borglum demanded the association pay him $40,000, even though no payment was due under his contract.[54] According to Randolph, Borglum also demanded that the association turn over control of the coinage sales to him and a group of friends "whose names he refused to divulge."[55] In reaction, the association held an emergency meeting on February 25, 1925. They calculated that Borglum had finished less than 5 percent of the monument's central group of Lee, Jackson, and Davis, but had already drawn nearly 75 percent of the $250,000 the contract allocated for it.[56] There

Stone Mountain commemorative half-dollar, minted 1925.

seemed little prospect of Borglum completing this group, much less the monument's hundreds of other planned figures. Citing the sculptor's "offensive egotism" and "delusions of grandeur," the association canceled his contract.[57]

When the news reached Borglum, he picked up an ax and laid waste to his workshop. A famously irascible man who yelled at his carvers over the slightest mistake, he was likely extremely angry about being fired. But smashing his plaster models was also a strategic, if desperate, move. Borglum's quick work with the ax meant it would not be easy to continue the project without him, meaning he was in a better position to negotiate reinstatement. He told journalists that his move was altruistic, claiming he was afraid the association would order the workmen to carve the mountain in his absence.[58] Borglum said that the models were not detailed enough to allow the workmen to determine his intent, and thus that he had to destroy his models to protect Stone Mountain from a misshapen fate. Borglum also insisted that the models belonged to him and that it was no one's business what he did with his own property.

The association disagreed. They claimed Borglum's contract had transferred the ownership of the models to them, and accordingly lodged a criminal complaint for their destruction and theft.[59] But Borglum had disappeared. Even his wife professed ignorance as to his whereabouts, telling reporters he would "undoubtedly return at the proper time."[60] Meanwhile, armed guards patrolled Stone Mountain day and night to prevent any further damage.[61]

After three days on the lam, Borglum was arrested in North Carolina.[62] He was detained for only a few hours, having borrowed $5,000 for bail from Bennehan Cameron, a wealthy planter.[63] In the few days that he had been in North Carolina, Borglum had convinced Cameron that he would carve a new Confederate monument on the side of a North Carolina granite mountain—conveniently located on Cameron's land.[64]

The impecunious but persuasive Borglum also convinced three attorneys to volunteer to represent him in the upcoming hearing to

determine whether he would be extradited back to Georgia.[65] The hearing was canceled when the association announced it would drop its extradition request. They sniffed that Borglum was just using the fight to "pose as a martyr" in the press.[66]

The "deposed sculptor," as the *Atlanta Constitution* dubbed him, was front-page news in the paper for nearly a month after he smashed the models—and no wonder, because Borglum was desperately trying to use the publicity to convince his creditors that they shouldn't worry about his solvency. To journalists, he fervently argued that the association had no choice but to rehire him, since no honorable sculptor would take on the task of completing another man's work.[67] Borglum also claimed the association owed him $200,000 and that Randolph planned to embezzle the proceeds from the sales of the coins.[68]

Not everyone believed Borglum. Stephenson, the Indiana Klan leader, sued to recover his $30,000 loan while the sculptor was still on the run.[69] And the association denied Borglum's claims, described his "lust for money [as] inordinate and insatiable," and made it very clear, and very public, that it would never rehire him.[70]

The association knew no one would want to buy the millions of half-dollars for which it owed the Mint if the monument they commemorated was stalled. They quickly hired another sculptor, Henry Augustus Lukeman, to take over the project. They also quietly yet dramatically reduced the scope of their plan. Lukeman was ordered to carve only Lee, Jackson, and Davis. The hundreds of figures Borglum had dreamt of slunk off the mountain face.

Venable resigned from the association, agreeing with Borglum that Randolph was using his position as president to embezzle the proceeds of coin sales.[71] In 1928, Venable finally obtained a copy of an audit of three years' worth of the association's records. It showed that the association had spent less than 20 percent of the $1.4 million it had received on carving the monument. The remaining money had gone to overhead, including salaries. An outraged Venable denounced this

as "a wild orgy of extravagance unparalleled in the history of patriotic enterprise."[72]

The details may be lost to history, but the overall picture is clear. When the association unveiled Lukeman's head of Lee in 1928, three years and the equivalent of $20 million in today's money had been spent to bring the mountainside right back to where it was when Borglum was fired. And his head of Lee was gone too. Lukeman's figures were sized a third smaller than Borglum's, which meant that Lukeman had to carve another Lee from scratch. Before the Association unveiled Lukeman's Lee, they blasted Borglum's off the mountain.

The Georgia Senate voted to accuse the association of gross mismanagement of funds. Randolph resigned and Venable resumed control of the association. Borglum, hopeful that he might be rehired, came to Atlanta in 1931 and told a rally that he was eager to do the job, with just one change: he now thought the figures should be twice as high as he had originally planned. A panicked Lukeman wrote letters to local newspapers accusing Borglum of plotting to add a portrait of Union general Ulysses S. Grant to the mountainside.

Borglum's hopes and Lukeman's fears were in vain. Venable was negotiating with the City of Atlanta to take control of the project. Although the city was willing, disputes about land ownership and who should be responsible for the association's debts dragged on for years, during which work on the mountain ceased.

It is often argued that monuments should be left up no matter how controversial, because we should respect what a community once honored instead of sitting in anachronistic judgment, imposing modern value systems on the past.[73] Stone Mountain, paid for in part by a national fundraising drive, might seem like the perfect example of this argument.

But it is important to note that the association brought in far less than it had hoped from the coins. The Philadelphia Mint had struck

2,310,000 half-dollars, but within a few years, nearly a million were returned, unsold, to be melted back down.[74] The association deployed paid salesmen, held competitions, and tried to strongarm politicians into endorsing the coins, but in the end, public interest was low. Relatively few Americans were willing to donate even fifty cents to see Stone Mountain go up.

Stone Mountain is what it is not because any great number of Americans wanted it to be that way, but because a small number of people realized they could benefit from making a monument. Keeping Stone Mountain up has little to do with honoring anyone from the nineteenth century, and much to do with keeping a twentieth-century scam going. And Stone Mountain wasn't just used by those who wanted to fool people out of their money. It was also a valuable tool for convincing them to take action against their neighbors, whether by casting their vote or putting on a white hood.

In the decades before the state of Georgia finally acquired the monument in 1958, Atlanta Klansmen continued to burn crosses on the mountaintop during annual rallies. Venable had granted the Klan an easement, legally protecting their right to enter the property even after he no longer owned Stone Mountain. When deciding whether the Confederate monument should stay on the mountainside, we must consider this pattern of use—especially because Stone Mountain has played host to the revival of the Klan multiple times.

Membership in the Klan fell precipitously in 1925, when Borglum's friend and creditor Stephenson was convicted of raping and murdering a young woman named Madge Oberholtzer.[75] The trial made front-page news across America. Many Klansmen had been attracted by Stephenson's emphasis on Christian values. Stephenson even waived membership fees for ministers. After his arrest, he was reviled as a hypocrite. The Klansmen who had celebrated the deaths of so many other Americans could not stand to be associated with an attack on just one white woman.

In the fall of 1963, James Venable held a gathering on his land at

Stone Mountain to revive the Klan. Two months earlier, during the March on Washington, Martin Luther King Jr. had spoken of his dream of Black Americans finding freedom from the "manacles of segregation and the chains of discrimination." King envisioned a freedom so true and so universal that it would ring even from a place where it had never been heard before: "Stone Mountain of Georgia."

James Venable had climbed Stone Mountain with his uncle, Sam Venable, on that Thanksgiving night in 1915 when Doc Simmons conjured up the new Klan. Little Jimmy, just fourteen years old, was the Klan's youngest member. When Venable saw thousands of Black Georgians lined up to vote in the 1960 presidential election, he feared America would soon "be dominated by the inferior race of black people."[76] And so, he became the Imperial Wizard of a new faction, the National Knights of the Klan, which he ran until 1987.

Like Klan leaders in the 1920s, Venable profited from his position. In an oral-history interview in 1982, he claimed that members did not become "a Klanslady or a Klansman" until they underwent the ceremony of "the third degree," which required ten and a half hours of their time "and about $40,000 worth of paraphernalia."[77] But Venable made a comfortable living as a lawyer.[78] He did not want his members' money as much as he wanted their votes.

When Georgia eventually condemned Sam Venable's easement, the Klansmen simply moved to the base of the mountain. They burned their crosses during annual rallies on land owned by the Venable family until the early 1990s.[79] Even now, the Klan keeps hoping to climb Stone Mountain; they applied for a permit as late as 2017. "We will light our cross and 20 minutes later we will be gone," the permit request promised, but authorities denied the application.[80] Other groups that hold similar opinions, just less openly, continue to use Stone Mountain. It played host to a large Confederate rally in November 2015, just two months after a white supremacist named Dylann Roof, hoping to start a race war, murdered nine Black worshippers at Charleston's Mother Emanuel African Methodist Episcopal Church.

It is no wonder that these groups feel at home on Stone Mountain, since the state of Georgia took over the monument in 1958 to spread exactly the same racist ideologies. In 1955, Marvin Griffin was elected governor of Georgia after running an anti-integration campaign. The 1954 Supreme Court case *Brown v. Board of Education* had signaled that federal authorities would not tolerate the use of blatant segregation to keep education as well as political power out of the reach of Black citizens. Just as in the 1890s, many politicians realized they would not remain in office for long if Southerners voted for candidates who supported this change. Just as in the 1890s, politicians used Confederate monuments to convince white voters to toe the line.

In his inaugural address, Griffin pledged that as long as he was governor "there will be no mixing of the races in the classrooms of our schools and colleges."[81] To signal the state's rebellion against federal demands for Black civil rights, he changed Georgia's state flag to include the image of the Confederate Army's battle flag. Then, Griffin orchestrated the $1.1 million purchase of Stone Mountain.[82] He explained the monument would be "a rallying point for all of us who believe in preserving the ideals for which our forefathers fought."[83] Stone Mountain would stand, as so many shaft monuments already did, for the idea that white and Black Southerners belonged in separate, very different spheres.

How many more times must the Klan be reborn on Stone Mountain before we admit that something about it nourishes these growths? Of course, a historical pattern does not necessarily dictate the future. We can change how we encounter and use a monument. But a pattern, especially one as deeply embedded as at Stone Mountain, will not change by itself. We need to recognize the pattern, talk about it, and take steps to make sure it does not repeat. Pretending that Stone Mountain is mainly the product of the romantic dreams of a mourning widow does nothing but provide cover for those who want to continue to use it as what it was designed, built, and maintained to be: a source of strength and encouragement for white supremacists. If we change

nothing, we will forever be waiting to achieve the equality that would at last let freedom ring from Stone Mountain.

Unlike Helen Plane and the Daughters, state authorities did not think a monument alone would be enough to attract sufficient visitors. Accordingly, they developed the site as a recreational park, adding amusements including a replica plantation that opened in 1963. Butterfly McQueen, who had played Prissy in Gone with the Wind, was a tour guide there on weekends until mid-1965.

The plantation's promotional materials called enslaved people "hands" or "workers," pointed out how neat and well-furnished their quarters were, and insisted that many white Georgians had voluntarily freed their slaves before the "War Between the States."[84] By the late 1960s, millions of visitors a year were coming to see the monument, imbibe dubious historical claims, and enjoy the park's many other features, including a golf course and a beach area with a (now demolished) Polynesian-style marina.

Both Borglum and Lukeman were long dead, but alternate proposals for completing the monument poured in. Borglum's son, Lincoln, wanted to cover Lukeman's carvings with concrete and start again higher up the mountain. Ultimately, an advisory board asked a sculptor named Walker Hancock to finish Lukeman's carving of Lee, Jackson, and Davis. Hancock agreed, although he modified Lukeman's design so that the horses' lower bodies fade into the mountain, as if the Confederates were riding through fog.

When carving resumed in 1964, workers used thermo-jet torches. These burned so hot that moisture within the granite turned to steam, causing flakes to burst off the cliff face. One man with a torch could remove as much stone in a day as twenty men had been able to do with drills in a week when Borglum began carving. Proposals to modify or remove the memorial are often met with claimed horror at the thought of destroying a priceless historical artwork. But the monument was not

dedicated until 1970, and carvers were working on finishing touches until 1972.

Today, Stone Mountain draws over 4 million visitors a year. But some Georgians have long protested the park's Confederate monument. The president of the Atlanta chapter of the NAACP, Richard Rose, described it as "the largest shrine to white supremacy in the history of the world" and called on the governor to remove it and all other "symbols of hate" from state property.[85] Stacey Abrams, while running for the governorship of Georgia, declared the carving "a blight on our state," and said it should be removed.[86] Even Grand Wizard James Venable considered the completed monument "a disgrace to our society."[87] (His objection was to the horse, which he didn't think looked at all like Lee's famed mount, Traveller.)

Debates about monuments often turn into arguments about the character of the people they honor. But we could learn everything there is to know about the lives of Lee, Davis, and Jackson without understanding anything at all about Stone Mountain. We need to talk about our monuments as monuments. For what purpose were they made, and how do they continue to shape the lives of viewers today? If we ask these questions, we can see what history Stone Mountain truly represents. It's not a shrine to the South—it's a shrine to a scam. Stone Mountain was created by people more interested in lining their own pockets than in honoring Southern history. Why should we keep celebrating the work of con artists?

Monuments like Stone Mountain are often defended as sources of historical truth. We think monuments manifest the highest ideals of a community. Borglum shows that their creators were often willing to celebrate the deathless virtue of whomever paid them best.

Fortunately for Borglum, he was fired from the world's largest Confederate monument only to find a new, and even more powerful, set of marks. In early March 1925, less than two weeks after he smashed his models of Lee, Davis, and Jackson, Borglum told the Associated Press he had just signed a contract to carve portraits of Washington and Lin-

coln in the Black Hills of South Dakota.[88] Borglum had defected back to the Union.

The state historian of South Dakota had written to Borglum in early 1924, asking if it "would be possible for you to design and supervise a massive sculpture." The writer admitted that "the proposal has not passed beyond the mere suggestion," but Borglum replied that he would come to South Dakota as soon as possible.[89] The proposal, no matter how nebulous, must have seemed like a lifeline to Borglum.

Borglum made his first trip west in September 1924. He was greeted by members of South Dakota's Rapid City Commercial Club, who told him about their idea of a few "Wild West" figures, like Custer or Lewis and Clark, carved on the rocks alongside a local scenic highway. But Borglum, just as he had expanded his patrons' idea of what Stone Mountain should be, had no intention of letting the project remain in such modest form. He wrote to a friend about "my own big plan" for a "great Northern Memorial in the center of the nation." Borglum wanted to carve something equal to Stone Mountain, which he described as "the Southern Memorial," insisting that a twin monument was necessary for "the principle of the Union."[90]

At least this time, Borglum was more realistic about the time needed to complete such a project. His spokesman told the press that it would take fifty years to complete the planned "National Memorial." If Borglum could help South Dakota raise the necessary funds, he would be financially secure for life.

Borglum negotiated with South Dakota businessmen and politicians for months until, just in time, he finally persuaded them to turn their initial idea into a "great Northern Memorial": Mount Rushmore.[91]

As was true at Stone Mountain, the figures Borglum actually carved were a small part of an ever-expanding master plan.[92] Mount Rushmore, he said, would one day feature a history of America carved into the mountainside in a panel in the shape of the Louisiana Purchase. He even got Calvin Coolidge to agree to write the text for it.[93] A colossal staircase would lead visitors to a Hall of Records hollowed out of

the mountain's interior. This time, it would shelter not a statue honoring Confederate women but the original Declaration of Independence along with other precious American documents. Borglum planned to decorate this repository by carving portraits of notable Americans who didn't make the cut for the mountainside.

Once again, Borglum could point his creditors to the sight of workmen swarming over the face of a mountain, telling them to be patient until the massive rewards for this massive project would be given to them. Only another mountain would allow Borglum to overcome his mountain of debt. And he did not seem to care who suffered while he carved these mountains, be they victims of the Klan or the Lakota whose sacred land he was invading.

Borglum lived well off Mount Rushmore until he died of a heart attack in 1941. The monument was tidied up and declared finished. Borglum's memory lived on, not as a scandal-ridden scam artist but as the great sculptor of American pride. His involvement in Stone Mountain has mostly been forgotten.

Part II

Falling

Bring Your Drums

Columbus's deportation would be loud with the sound of drums. Mike Forcia had it all planned out. His Bad River Anishinaabe relatives, along with representatives from all the other Indigenous people living in Minnesota, would fill the state capitol lawn with drummers and dancers, sending song and the ringing of jingle dresses into the air around the ten-foot bronze statue of Columbus that had stood there since 1931. He would invite the Somalis and the Hmong too—everyone living in the Twin Cities of Minneapolis and St. Paul as refugees or immigrants. "I wanted them to bring their drums and their outfits," he told me when describing his vision, "their dance, their food, their art and their history."[1]

But then, on the night of June 9, 2020, protesters tore down a statue of Columbus in Richmond, Virginia, set it on fire, and then rolled it into a lake.[2] A few hours later, police discovered that someone had decapitated a Columbus in a park in Boston.[3] Forcia heard through the grapevine that someone was also planning to take down Minnesota's Columbus under the cover of darkness.

"I just panicked," Forcia said. "I panicked because I had plans for that statue." The Columbus statue had been unveiled in front of a crowd of thousands, and he had promised himself that a monument "put up in broad daylight . . . should come down in broad daylight."[4] So, on the morning of June 10, Forcia took to Facebook to issue an

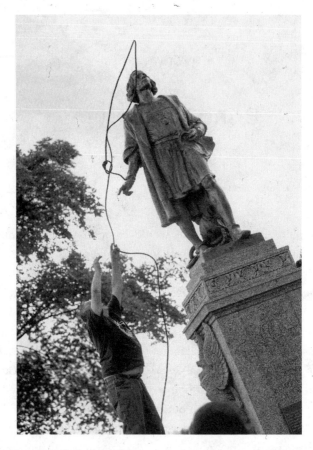

Mike Forcia and the St. Paul Columbus monument. *Courtesy Nedahness Rose Greene.*

invitation for people to meet him at the statue at five p.m.—still full light in the long Midwestern summer. "Today's the day we remove this POS from the State Capitol!" the post read. "Bring your drums!"[5] Columbus's deportation would not be as grand as Forcia had imagined, but he would do his best.

Videos of the crowd tugging Columbus off his base that day provided some of the defining visuals of the summer of 2020. The scene played on the news so often that you would be forgiven for assuming

that more monuments shared Columbus's fate. In reality, of the nearly 170 monuments that came down after the death of George Floyd, around 80 percent were removed officially, following decisions by local authorities. Protesters pulled down only around a dozen Confederate monuments and twenty monuments to other controversial historical figures like Columbus.

Most of these protesters hid their faces or struck at night. They likely wanted to avoid the potentially heavy criminal and financial penalties for such acts. Forcia is one of the very few people who have taken full, public responsibility for toppling a monument. This means he can explain what he hoped to achieve by doing so—and why it was worth the risk.

Forcia, who has a scar across his nose and wears his gray hair scraped back into a ponytail, is in his fifties. He's been an activist for Indigenous issues for thirty years. The Twin Cities have been a center of Indigenous activism since the 1952 federal Urban Relocation Program, which promised housing assistance and jobs for Native Americans willing to move to cities. "The idea was to assimilate us. Get us off the reservation," the Indigenous attorney and Twin Cities resident Terri Yellowhammer explains.[6]

The East Phillips neighborhood of Minneapolis became one of the largest concentrations of urban Indigenous people in America. Many never got the job placements they were promised, and the neighborhood remains plagued by poverty and substance abuse. In reaction, the American Indian Movement (AIM) formed in Minneapolis in the late 1960s.[7] AIM volunteers began patrolling East Phillips, hoping to provide an alternative to traditional policing.

Forcia, a member of AIM since the 1970s, is the chairman of the Twin Cities chapter.[8] Speaking to me while waiting for the verdict in the trial of Derek Chauvin, the Minneapolis police officer charged with killing Floyd by kneeling on his neck, Forcia told me that "I have experienced the knee of a Minneapolis cop on my neck as well." In 1999, he was beaten by officers; Forcia thinks he angered them by trying to

intervene when he saw one holding a gun to an Indigenous woman's head.[9]

He revived the AIM Patrol in 2010 after he found an Ojibwe elder, Old George, struggling on the ground outside the East Phillips American Indian Center. Old George had boot marks on his ribs, left by someone who wanted to steal his pain medication. Forcia was horrified both by the crime and its aftermath: "When the EMTs came, they had this look of disgust on their faces. Rather than place him on a gurney, they grabbed him by his feet and around his ribs. . . . He died shortly thereafter. No one was ever charged for killing Old George."[10]

AIM volunteers walked the streets of East Phillips, offering to escort women and elders who didn't feel safe alone. They watched over encounters between Indigenous residents and police so they could serve as witnesses if necessary. They also cooked hot breakfasts for the unhoused, using the café at the American Indian Center. And Forcia kept participating in activism for other issues he cared deeply about, like opposing the construction of a new oil pipeline in Minnesota's Iron Range, through territory where the Ojibwe possess treaty rights to hunt, fish, and harvest wild rice.

After Floyd's death, when the Twin Cities erupted in protest, Forcia began patrolling again. In June 2020, as he was deciding what to do about Columbus, his bedroom "smelled like burnt city" from the smoke that clung to his clothes.

"We have to be careful as a people of color to not get distracted," said the niece of one of the models who once portrayed the caricatured "mammy" figure of Aunt Jemima in advertisements in an interview in the summer of 2020, worried that people who paid too much attention to "the statues and the images in all the news" would forget to focus on campaigning for the upcoming fall election.[11] Many have similarly argued that protesting against monuments is a distraction from more important issues. Why complain about a statue, they ask, when you could be doing something that would actually help people? Forcia is someone who works hard to help his fellow Minnesotans. So

why, between protecting the unhoused, feeding the hungry, and helping community members get home safely, did Forcia also want to take down a monument?

When Forcia drove to a Home Depot that morning to purchase two insubstantial-seeming nylon ropes—one black and one yellow—he knew there would be consequences. Perhaps jail time. Perhaps a huge financial liability for the damage to the statue. He would have, for the first time, a criminal record. When he toppled Columbus, Forcia risked his ability to carry out all his other forms of activism.

But for him, it was well worth it.

On October 12, 1931, a crowd of twenty-four thousand, mostly Italian Americans, gathered for the unveiling of the Columbus monument.[12] They had converged from all over the region for three days of dedication ceremonies, including a High Mass at the cathedral.[13]

On the day of the unveiling, school was canceled. Thousands of children, accompanied by ten marching bands, paraded to celebrate the statue.[14] Some of the drummers from these bands gathered around the monument's base as the governor praised Columbus.[15]

The celebrations culminated in a dinner in a hotel ballroom for 1,500 guests.[16] Many of them had contributed to the $50,000 cost of the monument. Italian Americans had been raising money for it since the idea was first proposed in 1927.[17] By 1929, a dedicated organization was formed: the Columbus Memorial Association of St. Paul, whose mission was "to maintain, perpetuate, and, if necessary, defend the historical accomplishments of Christopher Columbus, Discoverer of America."[18]

Columbus wasn't always celebrated as a hero in the United States. He never even set foot in North America. His voyages reached only the Caribbean and the northern coast of South America.[19] It was only after the Revolutionary War, when the newly independent country no longer wanted to give credit for colonizing America to the British, that

Columbus became a standard part of the nation's origin story.[20] Monuments to him began to multiply only in the early twentieth century, when Columbus became a tool for Italian immigrants to argue their claim to American citizenship—and to whiteness.

The St. Paul Columbus is a perfect example. The Columbus Memorial Association ran a competition to choose a sculptor, who was required to be a Minnesotan "of Italian blood."[21] The winner, Carlo Brioschi, had trained in the fine arts in Milan and emigrated to New York in 1899. He and Gutzon Borglum lived there at the same time, both aspiring to be professional artists. While Borglum kept himself afloat by borrowing money he had no intention of paying back, Brioschi made an honest living as an ornamental plasterer.

In 1909, Brioschi came to St. Paul to decorate a luxury hotel and stayed to establish his own business. He had made only a few freestanding sculptures before he won the competition, but his resulting regional renown meant that he went on to create a number of other public monuments, including another Columbus for Chicago's Grant Park, paid for by another Italian American fundraising campaign.[22]

The *Minneapolis Star* praised the choice of Brioschi, noting that the sculptor had "recently returned from a trip to Italy, where he studied numerous Columbus memorials."[23] Either the reporter or the sculptor was exaggerating with that "numerous," since there were only a few monuments to Columbus in Italy at the time.[24] Brioschi likely was inspired by Milan's nineteenth-century statue of the explorer.[25] Like it, his Columbus stands amidst a jumble of nautical paraphernalia with one foot advancing over the edge of his base and his right hand pointing outwards to signal his discovery.

Brioschi would have had to use models like the Milan statue, because there are no surviving contemporary portraits of Columbus. We simply don't know what he looked like. Thus, Columbus monuments always reveal more about their creators' intentions than the man being memorialized. And it is no accident that both of Brioschi's Columbuses look as though they had just stepped out of a Northern

Renaissance painting. When Italian immigrants began to arrive in the United States (more than 4 million of them between 1880 and 1920), whiteness was still defined as Greenough had seen it: people of "Anglo Saxon," Germanic, or Nordic descent.[26] Italians were relegated to an uneasy position, above other non-white people but not fully white.[27]

Many of the Italians who settled in Minnesota were laborers from Southern Italy. They found work in the mines of the state's Iron Range.[28] Historians Mattie Harper and Peter DeCarlo have described how Iron Range officials and employers referred to Italians and other Southern Europeans as "black" and called them "inefficient and worthless . . . fit for but the lowest grades of work in the open-pit mines."[29]

Italian Americans organized to push back against these stereotypes, which were used to restrict them to low-paying work and exclude them from political participation.[30] Instead of challenging America's prioritization of whiteness, Italian American leaders tried to take advantage of it by insisting that Italians were fully white.[31] Brioschi's Columbus, with his straight nose and strong jaw, was a visual argument for the whiteness—and therefore, the Americanness—of the artist's fellow Italian Americans.[32]

In 1924, the Johnson–Reed Act imposed immigration quotas that severely restricted new arrivals from Italy. These restrictions quieted worries that American-born citizens would be displaced by new arrivals. Public attention turned to assimilating those immigrants who were already in the country. Minnesota's Columbus was one of many similar memorials that went up across America in these years, when the state officials who governed the placement of memorials were at last as eager to accept them as Italian American communities were to give them. The statues symbolized an exchange of promises: like Columbus, Italian Americans would serve America—and Americans would adopt them as their own, as they had integrated Columbus into American history.

At the dedication of the Minnesota Columbus, Guy Stanton Ford, the president of the state historical society, gave a speech claiming

Columbus "opened to our ancestors—yours and mine alike—a new land, a new home, and the possibility of a new social and political order."[33] Ford's ancestors had been in America for at least a century, and he himself "as a boy held a plow that broke the virgin soil of Iowa," but he was happy to celebrate his newly discovered kinship with Italian Americans in their shared "new land."[34]

Of course, the land was not new, and praising Columbus as its discoverer ignored the Indigenous people who already lived there. This uplifting of Columbus as an American hero also came at the expense of many Italian immigrants. As a tool for assimilation, Columbus was a knife. Celebrating him meant that immigrants had to cut off the parts of themselves that did not fit into their new country.

After Italian immigrants won access to the wealth and power held by white Americans by successfully arguing that they were white as well, Columbus remained an important part of their new identity. For decades, the Twin Cities' annual Columbus Day Parade ended at the statue. The Columbus Memorial Association, which continued to raise funds to maintain the monument, dissolved only in 2017.[35]

The Italian Americans who erected the monument acted as though their choices would never be questioned. They applied only a little cement to the bottom of the statue before they lowered it onto the blocks of granite stacked up into a pedestal. Nothing held those blocks together except their own weight. The celebrants could not imagine a time when people would no longer respect this precarious balance of stone and power.

After Forcia put out the word about his planned statue toppling, he issued some personal invitations. He called the offices of the governor and the mayor of St. Paul and left messages to say that he knew "that they were very busy with the riots," but if they had ten minutes to spare, he "could put them right on the front of the rope."

No officials took Forcia up on his invitations, but the governor and

his public safety commissioner did discuss the matter during a midaft-ernoon press conference. The commissioner responded to a journalist's question about Forcia's post by saying he had arranged for someone "to be out there to meet" the protesters to explain "the process that is already in existence" for removing a monument from the capitol.[36] Although it was not publicly announced, the Minnesota State Patrol also stationed thirty-five troopers at the capitol in case Forcia did not agree to follow what the commissioner several times referred to as the "lawful process."[37]

When Forcia and Sue GoodStar, a Dakota woman and AIM member, arrived at the monument an hour before the protest was scheduled to start, Capt. Eric Roeske of the Minnesota State Patrol was there to greet them.[38] Roeske offered Forcia a copy of Minnesota Statute 15B.08, explaining that it outlined how to request Columbus's removal.

"There's a process," Roeske began to explain, but Forcia interrupted him.

"Are you new to Minnesota?" he asked incredulously. "Don't you know how many times we protested this?"

Forcia turned to the people who had already begun to gather. "You've all grown up watching us protest this thing. How many times must we protest it? Let's take it down. Let's take it down!"

Roeske clutched the rejected printout in his hands, his forearm resting on the yellow grip of the Taser holstered in his belt. "Every time we come here, there's a 'process,'" Forcia continued, pointing at Columbus. "And the 'process' is to keep him up."

Indigenous Minnesotans had protested the Columbus monument at least since the 1970s.[39] Almost every year on Columbus Day, someone would toss a water balloon filled with red paint—or sometimes their own blood—at its face. At a more elaborate protest in October 2015, dancers and drummers surrounded the monument, while members of the Ogichidaakwe Council's elders group sang and protesters marched with signs, one reading STOP HONORING GENOCIDE.[40] A blue sticky note covered the part of the base's inscription that called Columbus

"the discover of America," naming him instead "the father of violence against Native people."

Over the decades, activists also circulated petitions and repeatedly asked the state to reconsider the statue. Peggy Flanagan, a member of the White Earth Band of Ojibwe, even coauthored a bill to remove it when she served in the Minnesota House of Representatives. The bill went nowhere.

In 2018, Flanagan was elected lieutenant governor of Minnesota. Forcia, who has known her for decades, congratulated her on Facebook and posted a photograph with his arm around Flanagan's shoulder. Beaming, she wears a T-shirt reading NATIVE AMERICANS DISCOVERED COLUMBUS.

As lieutenant governor, Flanagan became the chair of the Capitol Area Architectural and Planning Board, the body with the authority to make changes to the capitol's monuments. Minnesota Statute 15B.08, the one Captain Roeske was trying to give to Forcia, states that "no substantial change or improvement may be made to public lands or public buildings in the Capitol Area without the written approval of the board." Beyond that, there was nothing. "We don't have any process for how to handle removals," the board's executive secretary would admit shortly after the statue came down. "We've never done this before."[41]

Those years of petitions had not been rejected—they had simply gone unconsidered. Even Flanagan, chair of the board, was unable to persuade them to act.

The board certainly knew about the protests, because they oversaw the cleanup. When protestors splashed oil-based red paint on the statue in October 1992, the contractor hired for the emergency cleaning scrubbed too vigorously. The resulting damage to the statue's patina and protective wax coating required an expensive restoration.[42] A "disaster response policy" was developed to prevent similar ineptitude in the future. Nothing was done to respond to the protests themselves.

If you see news footage of protesters pulling down a monument,

you might condemn them for acting violently or impetuously. What you won't see in the footage are the preceding decades of trying to get a fair hearing. Forcia and many others who have protested monuments have again and again been told to follow a process that either simply didn't exist or was a rigged game, always deciding in favor of keeping a statue up. Before you fault someone for not following the process, you have to be sure there is one.

When there is no process, people lose hope that their voices will be heard. And then they take action, even if there's no legal route to do so. But this action might not be the one they really want to take. Perhaps they want to have a community-wide conversation about a monument or make some changes to it. Understanding and reconciliation can happen in many ways—but when authorities refuse to listen to calls for removal, some people will think they have no choice but to topple a monument.

"I'm not going to perform for folks," Flanagan said at a press conference after the Columbus monument fell. "I'm not going to feign sadness. I will not shed a tear over the loss of a statue that honored someone that by his own admission sold nine- and ten-year-old girls into sex slavery."[43] By contrast, President Trump issued a proclamation on Columbus Day 2020, fulminating against the "radical activists" who "seek to replace discussion of [Columbus's] vast contributions with talk of failings, his discoveries with atrocities, and his achievements with transgressions."

It's not just activists who are skeptical of Columbus's supposed achievements. For decades, scholars have been busily reconsidering the rosy portrait of Columbus taught in elementary school.[44] They have found that Columbus enslaved Indigenous people, shipping them back to Spain for sale. Bartolomé de las Casas, a priest who accompanied Columbus when he served as governor of the colony of Hispaniola (now the Dominican Republic and Haiti), wrote about acts of

sexual violence against Indigenous women and girls as well as torture of those who failed to bring back the gold Columbus ordered them to find. Columbus's reign was so cruel that he was arrested and brought back to Spain in chains.

Forcia traces the history of the taking of Indigenous land back to Columbus's claim of the "New World" for European colonization. In 1851, with settlers moving into America's new Minnesota Territory, the Dakota ceded most of their land there in return for promises of payment and supplies. Many Dakota resettled on the Lower Sioux Reservation in southwestern Minnesota. In an oral history, an elder living on the reservation explained how some Dakota there, including her father, came to have the last name "Columbus":

> They couldn't pronounce the Indian names, so when they built the church here, the people got baptized and they changed their names. . . . And because our family was one of the first families here . . . that's how we got the name, Columbus.[45]

For Forcia, toppling the Columbus statue wasn't about the distant past—it was about the way that those changes in Indigenous people's names and religion continue to reverberate today. "When Columbus came here, he brought with him Jesus, Satan, and alcohol," Forcia told me. "And that's what did our people in."

Land loss and religious change are deeply tied together in the history of Minnesota. Many settlers who had moved to the territory abandoned their claims after the Dakota killed farmers during the U.S.–Dakota War of 1862. The war ended in the largest mass execution in American history, when President Lincoln authorized the hanging of thirty-eight Dakota men after hasty, flawed trials.[46] The other Dakota were stripped of their treaty rights and expelled from Minnesota.

In 1874, Lt. Col. George Armstrong Custer led an expedition to the Black Hills, in what is now South Dakota, looking for gold. His discov-

eries set off a gold rush. Soon, railroad companies began building lines across the Great Plains toward the new boomtowns.

These lines had to pass through western Minnesota, which was still largely unpeopled after the U.S.–Dakota War. Railway companies, finding it too costly to run a rail line through a region without farmers who could pay to ship their crops to market, began to subsidize new settlements. Three railroads named the bishop of St. Paul their land agent.[47] Beginning in 1875, the bishop arranged for more than four thousand Catholic families to homestead across four hundred thousand acres of western Minnesota.

The Catholic Church was not only intimately involved in the resettlement of Minnesota; it also played a large role in the forced assimilation of the Indigenous people who lived in the state. These included the Dakota who began to return to the state in the 1880s and the Anishinaabe who settled in Minnesota after being pushed out of territory farther east.

In Minnesota, as elsewhere in the United States, Indigenous children were made to attend government-funded boarding schools.[48] The commissioner of Indian affairs could withhold annuities or rations from parents who failed to cooperate. At times, children were forcibly abducted. The goal was to "kill the Indian, save the man," as the head of one of the first boarding schools put it.[49] The schools stripped students of their cultural traditions. Their hair was cut, their traditional clothes were burned, and they were punished for speaking anything but English. Physical and sexual abuse was pervasive.

Minnesota had sixteen boarding schools, some of which did not close until the 1970s. To call them "schools," though, is an exaggeration.[50] Many pupils learned only basic reading and arithmetic, spending most of their time working on school farms. Their labor, which made the schools economically feasible, was intended to be the largest part of their education. The authorities hoped that students would use their agricultural training when they returned to their reservations—

even when these reservations, like the ones in Minnesota, were composed of land ill-suited to farming.

When the students finally went home, it had usually been years since they had seen their families. Many had forgotten, or had never had a chance to learn, key parts of their culture and religion. Forcia's mother was one of these students. She attended Saint Mary's Catholic Indian Boarding School on the Ojibwe reservation in Odanah, Wisconsin.

"She was infected with Christianity," Forcia recalls. "Before she died, she said, 'Mike, all I know is Jesus. I don't know the Big Lodge or the Big Drum. I don't know the stories.'" Forcia calls forced conversions like hers "America's greatest victory over Native Americans."

Mary Annette Pember is an Ojibwe journalist whose mother attended the Saint Mary's School around the same time as Forcia's mother. Pember remembers her mother describing the school's Mother Superior as "a monster" who beat and shamed her students "with a delusional zeal, as though she believed that she was the very right hand of God."[51] The nuns labeled the students "dirty Indians," inferior beings unfit for any future higher than being servants in white households.[52]

Pember describes the school as "the crucible that formed the little tightened fist that was my mother."[53] Generations of children who grew up in the institutional setting of the boarding schools brought their trauma home. Deprived of loving care, they often became distant, difficult parents who replicated in their own families the abuse they had experienced.[54] One advocate for Indigenous families in Minnesota described a case where a mother "was making kids kneel on broomsticks and would hit their arms and hands with another broomstick," because "that's how she was punished and her parents were punished in boarding schools."[55] Indigenous children are still disproportionately removed from their parents' custody by Minnesota's child welfare system.[56]

Forcia's family was no exception. He spent a decade of his early adulthood not speaking to his mother or anyone else in his family. When he decided to reconcile with them, he kept distant from their Christianity. At his uncle's funeral, "everybody went in [to the church] to do their thing," but Forcia waited outside, "because I can't be part of that anymore."

The Italian immigrants who put up the capitol's Columbus statue did so as part of a campaign to become white and American. Forcia is part of a long tradition of Indigenous resistance to the pressure to assimilate. He does not want to be either white or American. He does not want to benefit from the system; he wants to do away with it.

Forcia does not blame Italian Americans for Columbus or Christians for the boarding schools. In fact, he even admires the sculpture he toppled ("as far as the art goes, it's a beautiful piece of work"). If he's speaking to a group of non-Native people, he tells them:

> You weren't there. You didn't do it. And I wasn't there. It didn't happen to me. Your ancestors were there and they may have done some very awful things to my ancestors, but you didn't do it. Don't feel guilty. . . . But what you have to understand is that you all are still benefiting from those atrocities. And me and my family and my people are still suffering to this day from those atrocities. And that's what we have to come to terms with.

Guilt doesn't accomplish anything. Instead, Forcia wants everyone to learn about Indigenous history and then take action. He has often been disappointed. During a crisis of homelessness in the Twin Cities in 2018, he called the archdiocese to ask if people could sleep on the cathedral's pews or put tents in its gardens, but his requests were rejected. "All I was asking for was just a tiny fraction of the riches they

derived from the killing of our ancestors and the theft of our land and resources," Forcia wrote on his Facebook page.[57] The archdiocese had recently declared bankruptcy so it could pay settlements to the victims of molestation by church personnel. Forcia asked the priest he spoke to "about all the molestation and rape my ancestors had endured," he reported. "He said, 'You're too late, it's all gone.' "[58]

Forcia traces the Indigenous community's poverty, homelessness, substance abuse, and mental health issues to the loss of lands, taken for the sake of their natural resources by America's "corporate capitalist economy." Forcia believes assimilation robbed his people of the wealth of their ancestral tradition and "its wisdom and guidance for a living in a good way with all creation." Deprived of this guidance, humanity began to steer a course for both social and environmental collapse. In other words, he has much more important things to worry about than a hunk of bronze.

And yet, the Columbus monument, standing just outside the state legislature, was a highly visible symbol of the ways in which authorities were continuing to ignore the Indigenous past and present, as well as its warnings about the future. Forcia wanted to use this very visibility to bring light to hidden pain and make those warnings clear.

"We'll help you pick him up, we'll help you carry him into the capitol. We'll make sure we don't get hurt. We'll pay for any damage," Forcia told Captain Roeske, "But he has to go."

"Are you going to beat me for it?" he continued. "Are you going to tase me?" The crowd around the statue grew bigger. "Will you kneel on me?"

"I'm out here by myself," Roeske replied softly.

"We don't want anyone 'resisting arrest' and accidentally getting killed," Forcia said.

"Nobody wants that."

"No, nobody wants that, but look how many times that's happened," Forcia replied acerbically. "Let's be Minnesota nice."

Roeske walked a short distance away to contact his superiors. The

troopers already mobilized for the event began to move in, but without urgency. It was as if they were convinced that the thin ropes Forcia began to prepare wouldn't be enough to take down a figure supported by centuries of adulation.[59]

Forcia tied slipknots and tried to toss loops of rope over Columbus's head before another man scaled the statue's base to help him. Then Forcia put one of the most important parts of his plan to work. "We have so many missing and murdered Indian women," Forcia shouted to the crowd. "And he was the start of it all. I think our women should be in the front of that rope."

It was still a few minutes before the official start of the protest, but nearly 150 people had already gathered. Around twenty women, mostly Indigenous, grabbed each rope. Most were dressed for a summer afternoon in shorts and slip-on shoes. They did not come expecting to do the work of taking down Columbus. But after just a few heaves, the blocks of the pedestal slid apart and Columbus tilted downward.

The statue twisted as it fell. Columbus's right index finger pointed toward the spot where he would soon land, then bent inward when it hit the pavement. Columbus had finally discovered the ground.

"It's a beautiful thing because we have suffered from what he did to us," said Dorene Day, an Ojibwe woman who brought several of her children and her grandchildren to the protest.[60] She understood what Forcia had dramatized by asking women to take the ropes. Indigenous women, girls, and transgender and two-spirit people in Minnesota experience disproportionate violence.[61]

The economic exploitation of the natural resources that once sustained Indigenous people is carried out side by side with the sexual exploitation of Indigenous women. The largely non-Native men who work in extractive industries—like those constructing oil pipelines in Minnesota's Iron Range—increase the demand for commercial sex in surrounding Indigenous communities.[62] Often, they view Indigenous women both as highly sexual and worthless. Some activists describe the intertwining of resource extraction and violence against Indigenous

women as "the two rapes," since both regard land and women as "disposable resources" that can be exploited "for personal use and profit."[63]

Those who commit violence against Indigenous women can also count on authorities to pay little attention to their crimes. Indigenous women and girls, just 1 percent of Minnesota's population, account for 9 percent of all female murder victims in the state over the last decade.[64] In Minnesota, missing Indigenous women are less likely to be found, and murdered ones are less likely to have their cases prosecuted, than victims of other races.[65]

The same devaluing of Indigenous lives led authorities to ignore protests against the Columbus statue. So, Forcia used Columbus to draw attention to the missing and murdered women. "Traditionally, they are our leaders," he told me when I asked him why he invited women to take the ropes. "I want to make sure they retain and resume that role in our communities."

The women broke into joyful screams as Columbus fell. Off to the side, Forcia jumped up and down, his hands in the air. Then he walked up to the fallen statue, put his foot on its neck, and shouted, "I want everyone to come up and kick him in the face!"

The crowd happily complied. In a symbolic reversal of Floyd's death, Gabriel Black Elk, a Lakota activist, knelt on Columbus's neck. He held a flag whose stripes bore the names and last words of Indigenous people killed by police.

Several protesters unfurled a huge banner printed with END WHITE SUPREMACY behind the musicians who began to perform. Once again, as at the statue's dedication, drummers proclaimed their triumph. A round dance formed, with protesters moving in a ring around the statue. In the circle, a teenager in jean shorts held hands with her mother, who wore a tie-dyed windbreaker. Another woman danced while recording the scene on a pink cell phone, her fluffy white dog bouncing around the statue. Forcia used a pocketknife to cut the ropes into pieces, handing them out as souvenirs.

Captain Roeske returned to negotiate with Forcia, who agreed to

help disperse the crowd before the troopers felt obliged to arrest any-
one. "It's time," Forcia called to the celebrants. "They want to remove
the body."

The ring of dancers broke as the troopers encircled the statue. They
wore maroon pants and black leather gun belts with large gold buck-
les. Each had a fistful of plastic handcuffs hanging from their belts—
enough to arrest all the protesters ten times over—and gripped scarred
wooden batons in their black gloves.

"You don't have to use your sticks," Forcia chided them. "You just
have to ask." He told the protesters to keep backing up, "so they can
move the trash out of the sidewalk." While everyone waited for a truck
to come to cart away the statue, a woman performed a jingle dance
down the line of troopers, red ribbons floating behind her.

When the statue was gone, taken to an undisclosed storage loca-
tion, Forcia prepared to turn himself in. He had promised Roeske he
would do so. Before he left for the police station, he climbed up onto
the empty pedestal.

"Chris had a pretty good view up here," he told a few remaining
supporters. All the rest had dispersed calmly, with no arrests made.
"Tomorrow we can say, as Native people, we are still here. And
he is gone."[66]

Forcia was charged with a felony for criminal damage to property. Six
months after Columbus came down, Assistant County Attorney Sarah
Cory addressed the judge overseeing his case.[67] "The violence, exploi-
tation and forced assimilation that has been inflicted upon Native
people has been perpetuated from colonial times into modern times,"
Cory said. "The impact of those harms is largely unrecognized by or
unknown to the dominant culture." The prosecutor also acknowledged
"the failure of public systems" to provide a real process for seeking
removal of the monument, calling the toppling an "unlawful act that
was committed out of civil disobedience." She informed the judge that

the prosecutors had agreed to drop all charges once Forcia performed community service: one hundred hours spent educating people about the legacy of trauma that had led him to topple the statue.

This unexpected outcome, where a prosecutor read a statement that would not have been out of place at the rally itself, was due to the work of Jack Rice. An attorney and member of the Luiseño tribe, Rice volunteered his services to Forcia and then started negotiating with the County Attorney, John Choi. Rice and Choi eventually agreed to pursue a restorative-justice process instead of an adversarial trial, with the aim of uniting the community rather than further dividing it.[68]

The prosecutor's office arranged a series of meetings called "talking circles," with volunteer representatives from the community concerned with the monument and its toppling.[69] The circles included retired cops, former legislators, law professors, clergy, and community activists. There were Indigenous and non-Indigenous participants and both urban and rural dwellers. Some had grown up in Minnesota and others had moved there later in life.

In the first meeting, the participants discussed how toppling the statue harmed the community. In the second meeting, they talked about historical trauma and how the statue's presence had itself been harmful. The final session asked them to come up with ideas about how to repair both these harms. In a traditional trial, a judge would have decided how to punish Forcia for breaking a specific law. But the goal of the talking circles was to have the community itself make recommendations about how it wanted to repair the harms done both by the statue and its toppling. Shifting the focus from punishment to restoration meant that the process could take all sorts of considerations into account, and that the participants could both chide and praise Forcia instead of having to condemn or exonerate him completely. Talking circles, unlike monuments, allow for nuance.

In the end, the agreement was unanimous: Forcia should not be

convicted of a felony. In fact, many of the talking circles' participants volunteered to join him in his educational efforts.[70]

This alternate model of justice was crucial for Forcia, because applying the law as written would have led to only one result. There is no defense of necessity to the charge of harming a monument. The law simply does not recognize the pain they cause.

To get a fair result, the prosecutor had to abandon the American criminal justice system in favor of a restorative-justice process based on Indigenous models. Very few others charged with damaging monuments have been as lucky. Indeed, in the future, even Minnesotans cannot depend on access to restorative justice, given how outraged some of the state's conservative politicians were by the prosecutor's action. "Rioters do not dictate the policies of our state," state senator Bill Ingebrigtsen said, vowing to return Columbus to his pedestal.[71]

The toppling let Forcia spread his belief that America's "whole foundation is built on sin, greed, corruption, genocide, and slavery," as he told an interviewer the morning after Columbus came down. "When you have a foundation built like that, it's going to crumble. And we see it crumble before our eyes now."[72] Forcia thinks there are two roads open to America. "One road is green, where we see and respect all people as brothers and sisters and respect is given to all living beings and all creation." The other road, "black and charred," leads to destruction.[73] Forcia is influenced by an Abishanaabe tradition known as the Seven Fires Prophecy.[74] He gives America only a decade or so longer if we don't change our path. Forcia intended his act to startle people "infected by capitalism" out of thinking of everything in terms of the quarterly report. He urges people to think deeper into the past—and much farther into the future.

Taking Columbus down was well worth it for Forcia, because "once he hit the ground, those conversations started happening." "I've gotten death threats," Forcia told me. "I've gotten hate mail. But I've also

gotten eagle feathers in the mail, with sage and sweet grass." Since Forcia's action, numerous other monuments that honored Columbus or other violent colonizers or that denigrated Indigenous people have been removed from their pedestals in America. Many more are under scrutiny.

Hideous Spectre

On May 31, 2020, six days after the death of George Floyd, the mayor of Birmingham, Alabama, rotated slowly in the middle of a crowd of protesters clustered around the base of a Confederate monument so tall it faded up into the dark night sky.[1] As Randall Woodfin turned, he looked into the faces of the protesters surrounding him. When I interviewed him almost a year later, he could still picture their expressions. He saw anger and frustration, but also sadness and fear.

Woodfin, a Black thirty-nine-year-old lawyer turned politician, felt the same emotions. He still had on the blue blazer and maroon T-shirt with the city's slogan, PUTTING PEOPLE FIRST, he had worn to address a rally about Floyd's death earlier that day. Another speaker at that rally, Jermaine "FunnyMaine" Johnson, a stand-up comedian and activist, had called for the audience to follow him to Linn Park in downtown Birmingham.

"We need to tear down something tonight," Johnson told the crowd. "Birmingham, the home of the civil rights movement, [needs to] tear some shit down tonight."[2]

Johnson meant Birmingham's Confederate Soldiers and Sailors Monument. Its large base, installed in 1894, was inscribed with a quote from Jefferson Davis, praising those who died for the Confederacy: "The manner of their death was the crowning glory of their lives."[3] In

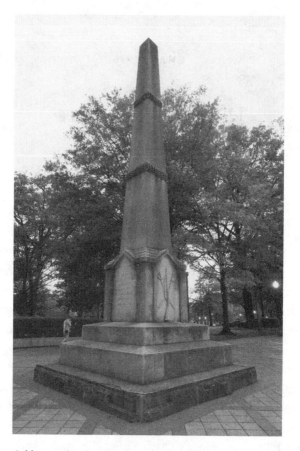

Confederate Soldiers and Sailors Monument in Birmingham, Alabama, dedicated
1894 (base) and 1905 (shaft). *Joe Songer/AL.com via Associated Press*

1905, the city topped the base with a fifty-two-foot stone obelisk deco-
rated with a few restrained carvings of anchors, sabers, and a musket
to represent the various branches of the Confederate forces.

The protesters, mourning the manner of Floyd's death, followed
Johnson to the park. First, they toppled one of its newer statues,
erected in 2013, of Charles Linn, a sea captain who smuggled cotton
through the Union blockade to help finance the Confederacy. Then,

chanting *"One more to go,"* the protesters moved toward the main monument. They tore away a plywood box covering its base and chiseled at its inscription. They prodded the shaft with boards and lassoed it with ropes. Dozens of people heaved, trying to bring it down.

Woodfin was in his office at city hall. One of his staffers, tracking the protest on social media, called him over. Woodfin saw a video of a red Ford F-150 backing up to the monument. Protesters attached a rope to its tow hitch and the driver hit the gas.

The rope broke. If it hadn't, Woodfin realized the monument would have crushed the truck as it fell. He decided he had to intervene before someone got hurt.[4]

In the preceding days, many other cities had tried to quash protests by sending in police. Woodfin believed this only escalated protesters' anger. He wanted the crowd in the park "to calm down and go home," but he thought the best way to convince them was to "put myself in the middle of it."

Woodfin hurriedly covered the few blocks from city hall to Linn Park and waded into the crowd. He borrowed Johnson's megaphone and raised a hand. The protesters quieted to listen, holding up camera phones whose flashes spot-lit the mayor as he spoke. "I understand the frustration and the anger you have," he said. But when he told the crowd, "I gotta ask you to stand down," they broke into boos and shouts of "No justice, no peace!"

It's not that Woodfin wanted the monument there. He thinks Confederate monuments celebrate the "suppression of an entire Black race." He grew up in Birmingham using textbooks that barely mentioned slavery, thanks to the efforts of the United Daughters of the Confederacy. Once he grew up, he realized how harmful their distorted picture of history was. "What the hell do we look like honoring behavior that says it's OK for Black people to be slaves and second-class citizens?" Woodfin asked me. "What the hell?"

The city's legal department had advised Woodfin against removing the monument. He feared he might even be criminally prosecuted

and expelled from office if he ordered it to come down. But, he said, "when I went into that crowd, all of that went away." He had never seen anything like this: people coming together to try to tear down a monument "with their hands." He decided to follow his moral compass. Woodfin held up his megaphone and said, "Allow me to finish the job for you."

Still, the protesters refused to leave the park. "Do it tonight!" someone screamed. "There's a sledgehammer up there," another voice cried out. "Take a swing and show us you mean it."

Woodfin lowered the megaphone and negotiated with Johnson. He promised the monument would be gone in twenty-four hours. Johnson urged the protesters to trust the mayor—and to return to the park if the monument was still there after the deadline. If they had to come back, "we're going to bring all the chains," Johnson promised. "We're going to have all the goddamned ladders!" In the meantime, he would give the mayor a chance—"but the clock is fucking ticking."

The clock had been ticking for quite some time. Birmingham had been a majority-Black city since the late 1970s, and city officials had been trying to remove the monument for years.[5] But they had failed, even though Birmingham was founded in 1871, well after the close of the Civil War. On that night in May 2020, Woodfin was negotiating with protesters about a monument that praised a Confederate past his city didn't even have. So how did it get there? And why had it proven so hard to get rid of?

In 1893, a national depression sent the price of coal falling precipitously. The crisis had an outsized impact on Birmingham. Built at the crossing of newly constructed railroad lines to exploit the area's coal and iron deposits, the city was then little more than twenty years old.[6] The promoters who founded the city named it after their industrial role model, the English factory city of Birmingham, and the city had quickly grown to more than one hundred thousand residents. Its

wealthiest citizens owned or managed the mines and factories that dotted the surrounding countryside.

As coal prices fell, these owners sought to decrease their labor costs. They cut wages, recruited recent immigrants willing to accept lower pay, and leased convict labor. In protest, workers staged sporadic strikes beginning in late 1893. A relatively small percentage of Southern miners had been advocating for fairer wages and better working conditions since just after the Civil War through organizations like the Knights of Labor. In early 1894, the United Mine Workers of America was the central organizing group for miners across the country. They began planning a national strike.

Birmingham's Black and white miners led segregated lives. They lived in different neighborhoods, rode different buses or train cars to work, worshipped in different churches, and even played for segregated baseball teams and brass bands. But the United Mine Workers, which had an interracial membership, convinced them to work together to protect their livelihoods. After all, as the union reminded its members, capitalism itself "knows neither color, race, nation, or creed"—except when doing so increased profits.[7] Both Black and white miners took leadership roles in the strike planning.[8] Their cooperation was essential, since Black workers made up a large percentage of Birmingham's industrial workforce.

Birmingham's industrialists and city officials scrambled to fend off the threatened strike by breaking this interracial alliance. They criticized the United Mine Workers for promoting racial equality, claiming this was the first step on the path to interracial sexual relationships. Birmingham-area mining towns passed ordinances outlawing racially mixed meetings, which made organizing more difficult.[9] And white citizens took violent action too. Alabama's Jefferson County, which includes Birmingham, claimed the most lynching victims in the state during this period.[10]

Birmingham's monument was part of this anti-union campaign. On March 11, 1894, an editorial appeared in a Birmingham newspaper,

suggesting the creation of a Confederate monument.[11] The necessary funds were raised in days. The situation was so urgent that the organizers decided to put up just the base instead of waiting for a full monument to be carved.

The unveiling was set for April 26, 1894, a little more than a month after the monument was first proposed, during the United Confederate Veterans reunion the city was already scheduled to host. Just five days before the unveiling, more than 125,000 miners began their nationwide strike. Around 9,000 of these strikers were in Alabama.[12] They held a mass rally in Birmingham the same week as the unveiling. At this rally, a Black miner held up a sign that read WE, THE COLORED MINERS OF ALABAMA, ARE WITH OUR WHITE BROTHERS.[13]

Birmingham's strikers not only supported one another—they even showed signs of rethinking race relations as a whole. One white miner reflected that the next time someone asked him about the issue of social equality ("what are you going to do with the n****r?" is how he phrased the question), he was going to reply that "the best men we have today are negros."[14]

The leaders of Birmingham who spoke at the monument's unveiling did not mention the strike explicitly. But their speeches emphasized the differences between white and Black Alabamians. The owner of a local newspaper, who also commanded Alabama's Sons of Confederate Veterans, explained that Birmingham's white citizens had sprung from the seed of a race of Confederates planted by "the blood of our martyrs."[15] The image of an unbroken white line was reinforced by the mementos sealed inside a copper box in the monument's cornerstone, including "a baby shoe belonging to the son of a son of a Confederate."[16]

The speakers did not ignore the hardships faced by Birmingham's white workers. The commander in chief of the United Confederate Veterans acknowledged how "discouraged and cast down" his audience must feel when "mortgages and debts have pressed upon [you]."[17] But he urged them to think about the Civil War when they felt discour-

aged, so they could "rejoice that there is a country where honor is first, not wealth; where patriotic endeavor and duty are everything, riches only a secondary consideration."[18] In other words: when their wages were cut, they should have thought about the Confederacy instead of unionization.

Many of Birmingham's white workers ignored this call to Confederate complacency. But not enough. The Populist Party candidate who supported the strike was narrowly defeated in the race for Alabama's governorship later that year. The new governor declared martial law and called up the state militia to crush the strike. When it was over, only around a thousand Birmingham-area miners remained members of the United Mine Workers.[19]

As Birmingham's miners went back to work, the state's elites decided it was high time to prevent future interracial labor organization. In 1901, they held a convention to revise Alabama's state constitution to enshrine racial discrimination by disenfranchising Black voters, prohibiting interracial marriage, and requiring segregated schools. Their aim was not secret. The president of the convention opened the proceedings by explaining: "What is it that we want to do? Why, it is, within the limits imposed by the Federal Constitution, to establish white supremacy in this State."[20]

Once the strike was over, Birmingham's leaders seemed to feel little need to complete their Confederate monument.[21] The base remained empty for so long that a group of doctors asked to use it to hold a sculpture honoring a local medical pioneer.[22] But their request was denied when the authorities suddenly needed the monument once more. Birmingham's miners were again threatening to strike.

During the summer of 1903, a pair of United Mine Workers organizers, one Black and one white, traveled through Birmingham's countryside, recruiting nearly thirteen thousand new members.[23] In 1904, these workers went on strike for better wages. Again, the effort was

interracial. Black workers might not be able to vote, but they could still organize.

By the time the strike began, the United Daughters of the Confederacy, now in charge of the monument project, had raised enough funds to complete it. The mayor gave them the necessary permissions and then arranged what the local newspaper would hail as a "monster parade" for its unveiling on Confederate Memorial Day in April 1905, eleven years after the base went up.[24]

Railroads gave discounted fares to anyone coming to Birmingham for the ceremony from a hundred-mile radius around the city, ensuring as large of an audience as possible—and attracting the workers who lived in small mining or factory towns in this area.[25] On the day of the unveiling, thousands cheered as a band struck up "Dixie" and the coverings dropped off the shaft.

Again, the speeches at the ceremony instructed white audience members to value racial allegiance over financial security. One speaker insisted that the monument would remind Birmingham's citizens about the "pious aspirations of duty" toward the Confederacy's "sublime and unparalleled history."[26] He lamented that this duty was too often neglected "in the conflicts and competitions of industrial development," which caused "the nobler sentiments of our nature to sink unheeded and forgotten into the great vortex of money." Another speaker criticized those who in their "blind rush for material power and prosperity" did not emulate Confederate soldiers' "devotion to duty and patient sacrifice."[27]

The last speaker of the day, the commander of Alabama's United Confederate Veterans, linked race and class even more explicitly. He praised the veterans as men who would never "sacrifice principle for policy or moral health for material wealth" and commended them for protecting their families from "the hideous spectre of a threatened race equality."[28]

William Drennan, then the mayor of Birmingham, stood on the podium to accept the Daughters' gift of the monument to the city. Before becoming mayor, he had managed a coal company. At the time

of the dedication, he owned a department store. Large advertisements in the city's newspapers invited veterans and other visitors in town for the unveiling to "get thoroughly acquainted" with the store's products at a special sale put on for the occasion.[29]

In his speech, Drennan acknowledged that Birmingham had come into existence only after the Civil War. He took that as a point in Birmingham's favor. The city, he told his audience of Confederate veterans, was made up of people "from all sections of the United States." But "whether they were born in the North, South, East, or West, all with one accord recognize your courage and the devotion to the cause for which you fought."[30]

Drennan's claim that everyone in Birmingham unquestioningly honored the Confederate cause was ridiculous. For one thing, nearly 40 percent of the city's residents were Black. Drennan was not talking to them. Their political power had been shackled by Alabama's new constitution. He could ignore them, and even pretend that they were not present in the city—as long as he could persuade white Alabamians to abandon their alliances with them.

Drennan's praises of the veterans contained a veiled threat. Anyone who did not join in these praises—anyone who crossed the racial lines the Confederates had died to uphold—would vanish from his recognition, just as Birmingham's Black residents already had. The mayor's appeal to the Confederacy worked. The strike died. Organized labor would not gain another foothold in Alabama for more than a generation.

The Voting Rights Act of 1965 finally overturned Reconstruction-era literacy tests, poll taxes, and other Jim Crow barriers to voting. In 1979, Birmingham elected the first of what would become a line of Black mayors.

On June 30, 2015, Frank Matthews, a local activist, stood up during the public comment portion of a Birmingham city council meeting and addressed William A. Bell, who had been mayor since 2010.[31]

"Your name ain't Bell for nothing," Matthews declared. "Let that bell ring! Let freedom ring!" He asked the mayor to "stand up and take down" the city's Confederate monument. Wearing a white suit and a silver striped tie, Matthews told the council that every time he saw the monument, he thought not about the Confederate dead but about the Black Union soldiers they had killed. His time over, he walked away from the podium, chanting, "Let that bell ring!"

Matthews was mourning the deaths of those murdered in Charleston by Dylann Roof two weeks earlier. Before the shooting, Roof had visited a Confederate graveyard and the Museum and Library of Confederate History in Greenville, South Carolina. He also posed for a photograph holding a gun and a Confederate flag.[32] This image, along with the photographs he took of the Confederate sites, formed part of the white supremacist manifesto he posted online to justify his killings.

Public outcry over the murders turned into demands to remove the Confederate flag from official use.[33] Georgia, Florida, and Mississippi had all changed their state flags to pay homage to the Confederacy in reaction to the civil rights movement. Several states, including Alabama and South Carolina, had also begun flying the Confederate flag above their state houses or on the grounds of their state capitols.

Many citizens of these states protested these flags from the moment they went up, although fruitlessly. Courts repeatedly dismissed cases, holding that plaintiffs had not proven that the flags had caused them quantifiable monetary damages.[34] In 1990, one federal court's decision went so far as to lecture the NAACP, claiming the "judiciary is not empowered to make decisions based on social sensitivity" and holding that the real problem was not the Confederate flag, but the plaintiffs' "own emotions."[35]

In 1997, another court was more sympathetic, holding that "because the Confederate battle flag emblem offends many Georgians, it has, in our view, no place in the official state flag."[36] But the widespread nature of this offense defeated the case. The court opined that displaying the

flag would be unconstitutionally discriminatory only if Black citizens could show that the flag had a disparate impact, making life worse just for them, as opposed to everyone else who might also take offense.

The courts all said that flags were a matter for legislators to decide. But legislators who challenged the flags were voted out of office so quickly that few were willing to take on the issue.

Defenders of Confederate flags claimed that displaying them was a celebration of "heritage, not hate."[37] This claim seemed thin to many. James Forman Jr., later a professor at Yale Law School, remembered the groundskeeper at his Atlanta high school raising the Georgia state flag every morning in the early 1980s: "black children, in a largely black city, watch a black man raise the symbol of the Confederacy for us all to honor."[38] Forman would close his eyes, clench his fists, and "slowly force from my mind images of the flag, of the Ku Klux Klan, of Bull Connor and George Wallace—of black people in chains, hanging from trees, kept illiterate, denied the opportunity to vote." Forman succeeded in purging his mind every morning, but "overcoming the flag" took a piece of him—"a piece that I will not easily recover."

The night after the 2015 Charleston shooting, an activist named Bree Newsome could not force those images from her mind. "I sat awake in the dead of night," she would later write. "All the ghosts of the past seemed to be rising."[39] Thinking about Roof holding the flag he believed justified his actions, the flag she believed was "the banner of racial intimidation and fear," Newsome decided that if courts were unable and legislatures were unwilling to take it down, she would do it for them.[40]

On June 27, 2015, Newsome climbed a thirty-foot flagpole on the South Carolina state house grounds and removed its Confederate flag. Although she was arrested and the flag went back up in less than an hour, her actions inspired South Carolina to take down the flag permanently a few weeks later. Alabama's governor followed suit, ordering the removal of several Confederate flags from his state capitol's grounds.[41]

Newsome's flagpole climb had inspired Matthews to demand the

removal of Birmingham's Confederate monument. Mayor Bell was more than willing to listen. He thought the monument celebrated "the tradition of suppression of a race."[42] He just wasn't quite sure who had the authority to order it removed. Alabama's governor had promptly been sued by a plaintiff who thought he had overstepped his authority by ordering the removal of the capitol's Confederate flags.[43] Trying to avoid such lawsuits, Birmingham city attorneys began researching how to take down the monument, sending out feelers to the Daughters to see if they might want their shaft back.[44]

The delay gave those who wanted to protect the Confederacy their chance. In July 2015, a hundred people waving Confederate flags rallied in Linn Park to protest the planned removal.[45] The gathering was organized by a newly founded group, Save Our South. "There is no shame in preserving the history of the Confederacy," the group's attorney, Melvin Hastings, told his audience. "Absolutely no shame whatsoever."[46]

It was Hastings who had sued the governor for removing the flags. He was an attorney whose office was fifty miles from Birmingham. Despite his lack of connection with the city, he was busy preparing his next lawsuit. On July 20, less than a month from when Matthews asked the city council to remove the monument, Save Our South filed a lawsuit against Bell, the members of the city council, and other Birmingham officials, claiming that none of them had the authority to remove a monument commemorating what the complaint described as "the War Between the States."[47]

Save Our South was right about one thing. There simply was no clear legal route to the removal of the monument. Did the city council have the final say, or was it the parks and recreation board that oversaw the park, or should it be a historical commission of some sort? Did the public have a right to have a say, and if so, in what form?

With so many questions unanswered in state law, Save Our South and the city agreed to ask the court to dismiss the lawsuit in late 2015. In exchange, city officials promised to leave the monument up. Even

if the majority of Birmingham's residents wanted the monument to come down, the legal system was arranged so that a single plaintiff could make sure it stayed up.

And it was about to get even harder to remove monuments. While Roof's rampage inspired some politicians to take down Confederate monuments, it spurred many others to protect them. Decrying what he believed was a "politically-correct movement to strike whole periods of the past from our collective memory," Gerald Allen, an Alabama state senator, introduced the first version of what would become the Alabama Memorial Preservation Act on July 13, 2015, less than a month after the Charleston murders and Bell's first announcement that he would remove the Birmingham monument.[48] Allen pointed to Birmingham's as precisely the sort of monument he hoped his act would protect.[49]

Bell changed tactics. Instead of trying to remove the monument, he tried to add to the city's heritage. He campaigned for notable Birmingham civil-rights landmarks to become UNESCO World Heritage Sites and helped create a new national park, the Birmingham Civil Rights National Monument.[50] But in August 2017, after a rally to protect a Confederate monument in Charlottesville, Virginia, turned violent, Bell would realize that creating new monuments was not enough to take away the harm of the old.

In March 2016, Zyahna Bryant, a high school freshman, sent a petition to Charlottesville's city council.[51] She asked them to remove the bronze equestrian statue of Robert E. Lee from a park in the city's historic center. "I am offended every time I pass it," she wrote. "I am reminded over and over again of the pain of my ancestors."

Several hundred people signed her petition, and Bryant addressed a small rally in front of the monument. She told her audience of activists and counterprotesters holding Confederate flags that "things have changed, and they are going to change."[52] The city council took up Bry-

ant's cause, and soon Charlottesville's mayor appointed a commission, which held seventeen public hearings before recommending that the city's Confederate monuments be moved or "transformed in place." In February 2017, a proposal to relocate the Lee monument to a less prominent location passed in city council by one vote.[53]

The Sons of Confederate Veterans and a new organization dedicated to protecting Charlottesville's statues, the Monument Fund, immediately sued.[54] Under Virginia state law, municipal authorities could not "disturb or interfere with any monuments or memorials."[55] The city argued the law did not apply to their monuments, but the judge issued a preliminary injunction. The monuments had to stay in place while the lawsuit made its way through the courts.

The Lee monument was unveiled in 1924, three months after Virginia's Racial Integrity Act codified segregation and outlawed interracial marriage. To celebrate the statue's arrival, the Klan burned a cross and then marched through the city to the sound of a brass band.[56]

Although most Confederate monuments feature an anonymous, low-ranking solider, many memorials to General Lee also decorated the South.[57] During the war itself, Lee had been the target of frequent criticism for his military blunders. When his first field command ended in a retreat in late 1861, Confederate newspapers nicknamed him "Evacuating Lee" and "Granny Lee."[58] But by the late nineteenth century, Southern historians had reconceived Lee as a great hero.

These admirers saw Lee as the president of Washington and Lee College described him: "one of the world's noblest losers."[59] They praised the way that Lee "freely offered [himself] upon the altar of an abstract principle of right."[60] Lee had been a United States Army officer at the outbreak of the war. He was offered command of the Union forces, but instead resigned and headed back home, even though he knew that the war would mean "hopeless ruin."[61]

Lee was seen as someone who maintained his honor through sacrifice during a period of social turmoil and economic calamity. He was

not so different, after all, from the anonymous soldiers standing at parade rest on monuments. Lee, the leader so obedient to duty, was the perfect model to teach obedience.

The writers who created and polished the myth of Lee made it clear that his whiteness was the source of his dutiful greatness. A Pulitzer Prize–winning 1934 biography of Lee claimed "it took five generations of clean living and wise mating to produce such a man."[62] The author insisted that there were "not more than two or three instances" when one of Lee's ancestors married someone "not equal in blood and station."[63] The resulting "maintenance of the physical stamina and intellectual vigor of the stock" led to the line's "perfect flowering in one of the greatest human beings of modern times, Robert E. Lee."[64]

The dispute over Charlottesville's Lee monument would likely have stayed a local one if it were not for Corey Stewart. In early 2017, Stewart was campaigning in the Republican primary for governor of Virginia. He needed an issue to set himself apart from other candidates, and realized that protecting Charlottesville's monuments was a perfect stance to take.

"I can go up and down Virginia, I can talk pro-life, and every conservative Republican is going to say, 'Yeah, I've heard that, been there, done that. I agree with you, but it doesn't make you different,'" he told the *New Yorker*. "When I went around Virginia and talked about preserving the historical monuments, and the lunacy of taking them down, that generated the same amount of guttural reaction and concern that the pro-life movement generated forty years ago."[65]

Stewart's campaign rhetoric drew attention both from Virginia voters and white-supremacist groups looking for venues to hold dramatic public rallies. In May and June 2017, these groups staged marches in Charlottesville. They were small, but they did what they were designed to do: garner social media attention. The head of the

white-supremacist group Identity Evropa recalled that "once the pictures went out, everyone in our movement was kicking themselves that they weren't there. It looked cool."[66]

A conservative blogger from Charlottesville made sure that everyone would have the chance to look cool by organizing a large rally for August, dubbing it "Unite the Right." The Lee monument, as one of the rally's leaders explained, was "the focal point of everything," because removing it would be "white genocide. It's about the replacement of our people, culturally and ethnically."[67]

Clashes between white supremacists and those who had gathered to protest meant that Virginia's governor declared a state of emergency before the rally even began. As the crowds slowly dispersed, James Alex Fields Jr., a white nationalist, drove his car through a group of people, killing an anti-racist activist named Heather Heyer and injuring nineteen others.[68]

Charlottesville's mayor ordered the Lee and Jackson monuments shrouded in black tarps to mourn Heyer's death. After the plaintiffs of the lawsuit seeking to protect them complained that the public's right to view the statues was obstructed by "giant trash bags," the judge ordered the shrouds removed.[69]

In July 2020, a new state law went into effect in Virginia, allowing its municipalities to make their own decisions about what monuments they would display.[70] Charlottesville soon took down one of its three downtown Confederate monuments, a soldier standing before its courthouse. The city gave it to a Confederate heritage group to re-erect on a Civil War battlefield in the Shenandoah valley.[71] But the lawsuit about the Lee and Jackson monuments was still dragging its way through the courts. It would not be until April 2021 that the Virginia Supreme Court finally ruled that Charlottesville could remove them.[72]

Like Roof posing with the Confederate flag, the "Unite the Right" rally exposed the connections between Confederate celebration and

contemporary white supremacists. And just as the murders in Charleston inspired action in 2015, the violence in Charlottesville in 2017 did the same. Two days after Heyer's death, a group of activists in Durham, North Carolina, decided they could no longer tolerate the presence of their Confederate monument, a soldier in parade rest on a shaft in front of the courthouse.

Durham was the town where Julian Shakespeare Carr made his fortune and urged his employees to be loyal Confederate cogs. The activists gathered around the monument, chanting, *"No KKK—no fascists!"* They carried signs reading MAKE RACISTS AFRAID AGAIN and FUCK YO STATUE. An activist climbed a ladder up the monument's high stone base and looped a yellow strap around the soldier's neck. The figure tumbled down at the crowd's first tug, the thin metal shell of its body crumpling sideways when it landed. The activists rushed forward to kick the statue and spit on it. Then they dispersed, seemingly a little confused it had proven so easy to take down.

On August 15, 2017, the same day activists in Durham were preparing to pull down their Confederate statue, Birmingham once again determined to rid itself of its own. Birmingham City Council president Johnathan Austin asked Mayor Bell to take down the monument.[73] But Bell explained that he needed to obey a new law. After delays and revisions following its first proposal in 2015, the Alabama Memorial Preservation Act had been signed into law just three months earlier.[74] The legislation prohibited removing or altering public monuments over forty years old. Eighty percent of Alabama's more than one hundred Confederate monuments, including the shaft in Birmingham, were over forty years old. Suddenly, they were there for good.[75] Austin urged Bell to defy the law and take down the monument: "We will deal with the repercussions after that."[76] Bell responded that he was "not in the business of breaking the law that I swore to uphold."[77]

Bell did order workers to build a plywood box around the monument's base.[78] When they finished, they painted the box black. The

monument's shaft still sprouted high above the twelve-foot box, but its praise of the Confederate dead was hidden.

Austin did not think covering the inscription was enough. He reminded the mayor that Martin Luther King Jr., while imprisoned in a Birmingham jail, had laid out the difference between just and unjust laws. "Any law that degrades human personality is unjust," King had written. Austin argued that nothing is more degrading than slavery's "rejection of the fundamental principle that all men are created equal."[79]

Steve Marshall, Alabama's attorney general, thought that covering the inscription was far too much. The day after the box went up, he sued Birmingham and Bell for violating the provision of the new act that prohibited altering or otherwise disturbing a monument.[80] The act imposed a $25,000 fine on each violation.[81] Marshall asked the court to make Birmingham pay this fine—not just once, but for every day the plywood screen remained up.

The nightly news might make you think that fights about American monuments are carried out by crowds of protesters clashing with counterprotesters, battling to pull down or prop up statues. But most protesters have lost before they even begin. The real battle for control over American monuments is fought politely and out of the public view in legislative hearings. As a result, invisible force fields of legal protections cover our monuments. These laws impose harsh penalties on people who damage them, return them to their pedestals even if they are unwanted by their communities, and even repel attempts to add new signage that might point out the racist beliefs of the authorities who erected them. We think our monuments celebrate our democracy, but really, they are held in place by some of America's least democratic uses of power.

Besides Alabama, five other former Confederate states have enacted similar laws that protect monuments (not counting Virginia, which

loosened its strict protective law in 2020).[82] All of these were either created or strengthened in reaction to protests about monuments after Charleston or Charlottesville. Some of these laws prohibit removal entirely. Others outline a process whereby communities can ask a state historic preservation committee for a waiver to allow them to take down a monument. Requesting a waiver is onerous, time-consuming, and generally pointless, since they are almost always denied.

If you want to remove a monument in these states, you don't just need a majority of the people who live nearby to agree that the monument needs to go. You need a majority of the state legislature to agree to change the law. That's an uphill battle. In Alabama, for example, the state's population is heavily Republican. They elect a majority Republican, majority white state legislature. If this legislature agrees on the fate of Alabama's monuments, even a consensus among Birmingham's citizens, mayor, and city council is meaningless. They are powerless to change the law.

If some politicians have their way, more and more citizens will lose their power to decide. Nearly every state legislature has entertained bills proposing strengthening monument-protection laws in recent years. Just since the most recent protests began in the summer of 2020, legislators in at least eighteen states proposed bills that would increase the criminal penalties for damaging a monument.[83] In the same period, at least thirteen state legislatures considered bills that would make even the official removal of monuments more difficult, ranging from adding a few bureaucratic hurdles to flat-out prohibitions.[84]

Republican-controlled legislatures are more likely to pass laws protecting controversial monuments and prevent efforts to remove them.[85] But Democratic control of a state is no guarantee that its monuments will be easier to take down. Existing historic preservation laws favor keeping monuments up. Oftentimes, there is simply no established procedure for citizens to even ask for the removal of monuments, meaning that petitions get mired in bureaucratic hesitation. And if there is enough protest to spur authorities to create a process to determine the

fate of a monument, these proceedings are generally slow and unwill-
ing to recommend broad changes. It took six months, five public hear-
ings, and thousands of public comments before various New York City
mayoral commissions allowed the relocation of just one monument in
2018—a portrait of J. Marion Sims, a gynecologist whose unanesthe-
tized experimental surgeries on enslaved women no one was especially
eager to see honored. The authorities simultaneously denied requests
to move all the other monuments they had been asked to consider.[86]

Stone Mountain is an example of the durability of legal protections.
After years of controversy over the image of the Confederate battle
flag the segregationist governor put on the Georgia state flag, the leg-
islature reached a compromise in 2002. They agreed to remove the
Confederate symbolism from the flag—but the bill also mandated that

> the memorial to the heroes of the Confederate States of America
> graven upon the face of Stone Mountain shall never be altered,
> removed, concealed, or obscured in any fashion and shall be pre-
> served and protected for all time as a tribute to the bravery and
> heroism of the citizens of this state who suffered and died in
> their cause.[87]

The Georgia legislature removed Stone Mountain from the reach
of democratic discussion. It even tried to dictate exactly how its citi-
zens should feel about the Confederacy. You might be someone whose
ancestors' continued enslavement was the very cause over which the
only men allowed to be citizens of Georgia during the Civil War fought.
And yet you must forever preserve and protect a monument to their
suffering, without even altering it to add any mention of the suffering
of those they enslaved.

Birmingham's monument sat in its box for a year and a half while the
judge deliberated. Seemingly aware of the possible controversy over

his decision, the judge issued it on January 14, 2019, twenty minutes before midnight on his last day in office before retirement. He wrote that the "overwhelming majority" of Birmingham's citizens were "repulsed" by the monument, but the Alabama Memorial Preservation Act meant that the city had no way to reject the monument's "message of white supremacy."[88] He granted summary judgment in favor of the city, declaring the act unconstitutional and thus null and void in its entirety.

There was not much time to rejoice. Attorney General Marshall filed an appeal within a week, and the appeals court found that the lower court judge had erred, because only individuals, not cities, have a constitutional right to free speech.[89] The appeals court also decided that Bell's plywood coverings violated the act, because they prevented the public from knowing what the monument was intended to memorialize.[90] They did not consider whether the Birmingham public in fact wanted their attention drawn to this fact.

The decision was unanimous. Birmingham's attempts to use the Constitution to argue against displaying a Confederate monument had failed, just as so many similar lawsuits about Confederate flags had done before.

The sole part of the decision in the city's favor was about the fine. The court held that the act authorized only a single, not a daily, $25,000 fine.[91] The court ordered Birmingham to pay the fine for putting up the plywood. But that was it. The court did not think it had the authority to order the city to remove the box.

The appeals court decision came down in January 2020. Five months later, surrounded by protesters trying to topple Birmingham's monument, Mayor Woodfin decided he could turn defeat into victory. Yes, the act prohibited the removal of the monument—but the penalty for doing so would be just another $25,000 fine.

Woodfin called a press conference the morning after the protest. It was June 1, 2020, Jefferson Davis's 212th birthday, a state holiday in Alabama. "Birmingham has had enough history of unrest," Woodfin

said. He had already called the attorney general and the governor's office, telling them he had decided paying the fine would be well worth it to prevent more unrest.

Woodfin's decision was not universally welcomed. He received death threats, including a bomb threat that temporarily evacuated city hall.[92] Attorney General Marshall made it clear that he would sue, despite the promise to pay the fine voluntarily.[93] (Marshall would soon also issue a statement calling Floyd's death tragic but denying that the law-enforcement system as a whole was systemically racist or structurally biased.)[94]

Woodfin was determined. For him, it was hypocritical to claim to celebrate racial harmony or protect citizens of color while celebrating and protecting Confederate monuments. And so, as dark fell, a crane lumbered toward the park. Soon, the pieces of the monument were lashed onto a flatbed truck and driven away.[95]

The next morning, the attorney general filed a lawsuit to seek the

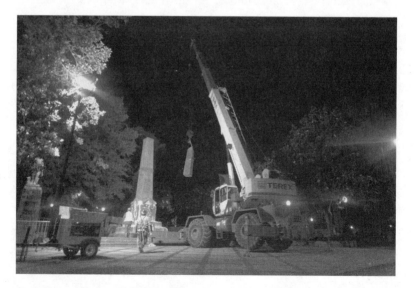

Removal of the Birmingham Confederate monument. *Courtesy Daniel J. Roth and City of Birmingham.*

$25,000 fine.[96] As the year went on, Marshall would also sue the cities of Mobile, Huntsville, and Hayneville for making similar decisions. The exasperated Marshall even released a video, speaking "directly to the people of Alabama, as the chief law enforcement officer of our state" to describe elected officials who removed monuments as lawbreakers who violated their oath of office "out of fear." Marshall claimed that disregard of the state's laws "quickly devolves into utter lawlessness" and mob rule.[97]

The state legislature, for its part, was busy trying to ensure that Alabama's mayors would no longer be able to break the law, even if they wanted to. In February 2021, a new version of the act was proposed.[98] It eliminates the possibility of asking for a waiver to remove any monument on public land, regardless of its age. It also prohibits officials, whether elected or appointed, from "dishonoring, disparaging, or reinterpreting" a monument; this includes adding "competing signage, wording, symbols, objects, or other types of means of communication" to a monument site. Any officials who violate this act, or even vote in favor of putting up a sign, can be fined $10,000 for every day their violation continues. They can also be liable for the costs of restoring or replacing the monument. The proposed revisions allow private citizens to sue to enforce the act, in case a future Alabama attorney general might not care as much about monuments as Marshall. For anyone who wants to take down a monument in Alabama, the clock is ticking once again.

Too Damn Beautiful

The very first monument Americans put up to honor a woman shows its subject, Hannah Duston, holding a hatchet in one hand. In the other, she clutches what looks like a bouquet of drooping poppies. They are scalps—little curled pucks of skin gathered together by their hair.

In 1697, during King William's War, raiders from the Abenaki people took Duston, her newborn daughter, and one of her servants captive from their home in Haverhill, Massachusetts. A month later, Duston rowed back into town in a stolen canoe. Her baby had either died or been killed on their forced march north. Duston, her servant, and an adolescent boy were given by the warriors to an Indigenous family. Duston plotted their escape. They killed the four adults in the camp—and their six children—and cut off their scalps to prove their deaths. Given this proof, a grateful Massachusetts voted Duston a reward of £25.

The monument went up nearly two hundred years later, in 1874, on the site of the killings, a tiny island in Boscawen, New Hampshire. Although Cotton Mather, among others, popularized Duston's story during her lifetime, she had fallen into obscurity. This changed when the westward expansion of American settlement meant renewed conflict with Indigenous Americans. From the 1820s until the 1870s, Duston's story was retold in history books, children's books and textbooks, and multiple biographies.

Hannah Duston Memorial, dedicated 1874, with traces of red paint.

Her monument filled the same purpose as Greenough's 1837 *Rescue* at the United States Capitol. They were both lenses through which white Americans could examine and excuse their violence on the frontier. Duston had killed Indigenous people in cold blood, as so many soldiers and settlers were doing in the West. But her violence could be interpreted as both self-defense and vengeance for the death of her child. Duston was a model for how white Americans wanted to see themselves: not as unprovoked, land-greedy oppres-

sors but as people sternly yet regretfully dealing with a problem they did not start.

Duston's story was told only as long as there was a reason for telling it. When Indigenous Americans were no longer able to contest the expansion of settlers by the late nineteenth century, Duston largely disappeared from popular memory. But statues have a way of sticking around long after everyone forgets why they're even there.

Well, almost everyone. Duston's monument lost its nose after taking a shotgun blast to the face some time in the past few decades, and the marble still bears ghostly outlines of scrubbed-off graffiti painted on it by people who saw her as a tool of genocide. "Through Indigenous eyes," Denise K. Pouliot, a spokesperson for the Cowasuck Band of the Pennacook-Abenaki people told me, "we see a statue honoring a murderer."

After someone again splashed red paint over the statue in May 2020, the New Hampshire Division of Historical Resources started working with the Cowasuck Band, historians, and some of Duston's descendants to reconsider the site's future.[1] Should visitors see her as a "famous symbol of frontier heroism," as the monument's historical marker explained? Or should people be told that she was a participant in the devastating effects of European settlement in New England, whose tribes lost an estimated 60 to 80 percent of their population in the twenty years preceding her kidnapping?[2]

The participants in the project agree on one thing: they will keep Duston's statue up, but change its context and the reaction of visitors by adding signage. Pouliot told me that people have used Duston's life for their own purposes through "decades of storytelling, art, and education," and that her goal is to use these same means to "reconstruct the colonial narrative into one that includes a broader, more accurate historical perspective."

I visited the monument nearly a year later, but the only thing that had changed about the site was the removal of its historical marker. Nothing else was different; even the paint remained, dripping from

the carved names of the statue's donors, splattered on its base, and even smeared on the ground around it. Some visitors had pushed miniature American flags into the grass in front of the monument, along with artificial flowers. A plastic rose with red, white, and blue petals showed that community was still debating how Duston should be remembered.

The monument stands on a narrow strip of land between overhead power lines and abandoned, disintegrating railroad tracks, surrounded both by birdsong and the drone of traffic from the highway across the river. It's a desolate spot, miles from the center of town. It's probably not where the Pennacook-Abenaki people would want to honor their history if they had a free choice. Instead, though, they are chained to a disintegrating, isolated monument, simply because it is already there.

It took nearly 150 years for most Americans to catch up with Frederick Douglass in seeing that there is something deeply wrong in a country whose monuments represent some of its citizens as less than human or simply ignore their very existence. Now many local authorities have recognized that America has a problem with monuments—hatred hardened into marble and bronze. But these officials do not want to take the risks they would incur by removing them. So, they try to solve the problem by adding rather than subtracting.[3] Few people who have proposed such additions have looked at the evidence to see if they can actually change how viewers experience monuments.

Laurajane Smith, a professor who directs a center for heritage and museum studies, spent years interviewing thousands of visitors to historical sites to figure out what's really going on when we stand in front of a monument. When I interviewed her, she explained that overcoming a monument's intended messages isn't as simple as tacking on a sign.[4]

Smith conducted research at several prominent American histori-

cal homes that had recently added information about slavery to their signage and tours. At Monticello, Thomas Jefferson's home in Charlottesville, for example, an exhibition was added to tell the stories of six enslaved families, questioning how the man who wrote "all men are created equal" could have owned more than six hundred people.

When Smith talked to visitors to this exhibition, many insisted they had learned things far different from what the curators intended. They told Smith that Jefferson was a good master and that the lives of enslaved people were better than they had thought. One visitor told Smith that the exhibition demonstrated that Jefferson "gave the slaves a chance, and that is what this country is about, giving people a chance and creating equality." Another visitor thought Americans should "move past" Jefferson's ownership of people because "we should be focusing on what he did for this country as a statesman."

These visitors rejected the exhibition's attempts to question Jefferson's status as a great man. If visitors encountered information that contradicted what they believed, Smith found they would either "brush it off as irrelevant" or twist the facts until they fit in with their existing views. The vast majority of people visit historical sites to reinforce what they already believe.

Smith's research results wouldn't surprise people who work as interpreters at former plantations. Visitors have reacted aggressively to attempts to make slavery more visible at sites like Monticello. Some make their thoughts known in negative online reviews, like the visitor who complained that a tour guide talking about the lives of people enslaved by Jefferson made the president seem like "a bad person" and thus "just ruined it for me."[5] Visitors even argue with site staff. Michael W. Twitty, who considers his work as an interpreter demonstrating Black culinary traditions at plantation sites to be an homage to his ancestors, has written about being challenged by visitors who told him that enslaved people were "well fed" and had "nothing to complain about."[6]

Despite the sites' attempts to shake up visitors' ideas of history, fewer than 3 percent of the people Smith interviewed, in all her years of research, said they had learned something substantial, as opposed to minor information, from their visit to a historical site. And if an entire exhibition can't change visitors' minds, what hope is there for a sign installed at the base of a monument?

Today, relatively few Americans would recognize Duston. But just because visitors have fewer preexisting beliefs about a particular historical episode doesn't mean they will accept the information on contextualizing signage. Monuments are designed to invoke particular reactions, and it can be impossible to escape them.

Duston's statue, for instance, shows her with a haunted expression. In her haste to reach home, she does not notice that her flowing, delicate dress has slipped off her shoulder, nearly exposing her breasts. By emphasizing her femininity and vulnerability, the sculptor made her look like a victim, not a killer. A few lines of text on a placard will not be enough to overcome the emotional pull of this statue—of Duston and her handful of scalps.

What about putting controversial monuments in museums? Many have proposed this solution, thinking this will provide a more controlled atmosphere and give a greater chance of dictating visitors' reactions than merely adding a sign without moving a monument. I talked to John Guess Jr., the CEO of the Houston Museum of African American Culture, to find out how difficult it really is to recontextualize a monument.[7] In 2020, Guess volunteered the museum as a new home for *The Spirit of the Confederacy*, a twelve-foot statue of a winged, muscular, nude man who clutches a palm frond and sword to cover his genitals.

The monument was erected in Sam Houston Park in downtown Houston on Robert E. Lee's birthday in January 1908, after years of fundraising that began when the legislature amended the state consti-

John Guess Jr., CEO of the Houston Museum of African American Culture, with *The Spirit of the Confederacy. Courtesy the Houston Museum of African American Culture.*

tution in 1902 to impose a poll tax that helped disenfranchise Black and Mexican American voters.[8] The statue, one of two public Confederate monuments in Houston, had been criticized over the years, including during the national reappraisal of monuments after the events in Charleston in 2015 and Charlottesville in 2017. Finally, in June 2020, ten days after Randall Woodfin removed Birmingham's monument, Houston's mayor took the statue down—and offered it to the museum.

Guess eventually put it in the museum's courtyard, but not before he got enough funding to pay for new fencing so the statue would not be visible from the street. He did not want the statue to be seen either by those who wanted to avoid it or by those who wanted to see it without the museum's framing. Part of this framing is accomplished by eye-shaped sculptures by the Black artist Bert Long Jr. These eyes surround *Spirit*, keeping watch. "There's no stealth of the night" to cover the hatred symbolized by the statue, Guess explained. "We're on you all of the time."

The museum may have rearranged its courtyard, but it did not touch the statue. "There was a suggestion to us that we shine it up," Guess said. "That's the last thing we're going to do."[9] The museum hasn't even wiped off the cobwebs *Spirit* came with, much less restored its deteriorating patina.[10] Still, "it's too damn beautiful," Guess was warned by a skeptic. "You let people see it, and all they're going to do is be consumed by it."

A beautiful monument is as attractive as a beautiful person. We react to their beauty immediately, unconsciously, and unstoppably. Beautiful bodies, whether living or sculpted, can cover odious hearts. If we are to stop ourselves from acting on our attraction, we need to keep reminding ourselves of what these attractive bodies conceal.

The museum is doing its best. It has already held a daylong symposium where academics and community members discussed the statue's history and debated its future. Some suggested renaming it "Karen."[11] The museum also asked the artist Willow Curry to create an artwork in response to the monument, in what they plan to be the first of many invitations to artists in residence.

"Your hatred, like your body, is naked and unashamed," Curry told the *Spirit* in a video work in which she addresses it directly.[12] She diagnoses the statue's sword as a threat to Houston's Black citizens, warning them that they would be killed if they dared to speak as freely as Curry can now. She tells *Spirit* that it will never again escape scrutiny: "We will ensure that you never rise again."

For Guess, the possible danger of *Spirit* continuing to attract the type of adoration it was designed to get is outweighed by the possibilities it offers. For one, it's evidence. "I like to keep the evidence," Guess told me, because "down the road, people might suggest there was never a crime." More importantly, Guess wanted the monument precisely because of its power. He hopes the emotional reaction it evokes in viewers will add to the conversations the museum wants to have about race.

The museum is known for its willingness to make its visitors uncomfortable. Its exhibitions and events have taken on topics rang-

ing from police brutality to voter support for racist politicians. Guess thinks that the emotional charge caused by the physical presence of *Spirit* will heighten such conversations. He is especially eager to use the monument to talk about the history of resistance to racism. He wants museum visitors to remember everyone who worked to push back on voter suppression, economic disparity, and discrimination of all types. Whether they led national campaigns or made a difference in their own community, they carried on under the gaze of monuments like *Spirit*—monuments that signaled that those who ran America were confident these resisters would never succeed.

Guess wants to inspire museum visitors to keep working toward justice. He hopes *Spirit* will help. In his museum, the monument will still inspire viewers—but this time, to resist discrimination instead of enact it. For Guess, preserving the past is meaningless unless it helps us come together to make a better future.

Even with all the museum's programing, even under the scrutiny of Long's eyes and Curry's oration, *Spirit* continues to honor the Confederacy. It will always do so. The museum understands this, and is working hard to channel viewers' reactions. This treatment of the monument goes against the general approach of American museums, which seek to impose as few barriers as possible between the visitor and their experience of art. This goal of neutrality can have dangerous consequences if museums become shrines for martyred monuments instead of places for transformation.

Besides, in the words of critic La Tanya S. Autry, museums are not neutral.[13] They have historically been, and often remain, white-dominated places, where mainly white staff curate the work of mainly white artists for mainly white visitors.[14] Museums rely on donations, either from these visitors or from their boards of directors—an even higher percentage of whom are white.[15] Very few museums are as willing as the Houston Museum of African American Culture to make their donors uncomfortable with frank discussions of white supremacy.

And these donations will be even more necessary if museums are

to display removed monuments. Preservation is expensive. Arguably, preservation budgets should address different priorities when important sites of African American history are crumbling for lack of funds.[16] And we're already paying enough to save the Confederacy. A 2018 *Smithsonian* investigation found taxpayers spent at least $40 million over the preceding decade on maintaining Confederate statues, homes, parks, museums, libraries, cemeteries, and heritage organizations.[17]

The Spirit of the Confederacy was the first Confederate monument to be moved to a specifically African American cultural institution.[18] For Guess, the museum's ownership of the monument is crucial. With ownership comes control. The museum is not bound to honor and preserve *Spirit*. Instead, they now have power over something that once symbolized their powerlessness.

Some people seem to think of museums as containment systems, able to trap and disarm the hateful messages given off by monuments. They think visitors can learn history without the risk of being inspired to repeat it. At the very least, they argue, museums can provide an alternative to destruction, as if museums were a national attic for storing away our racist past.

This is wishful thinking. Monuments that honor white supremacy draw their power from their surroundings. Standing in front of a legislature that ignores minority issues or a courthouse that disproportionately punishes people of color, monuments boast that white people control America. The Houston Museum of African American Culture disproves its monument's core claim simply by owning and controlling it. But this museum looks very different from most others in our country. Displaying a monument that claims white people control America in an institution that actually is controlled by white people merely reinforces its message.

What about adding other images, then, to tug viewers in other directions? This, too, has been a frequent proposal in recent years, although

the much greater expense of adding a statue instead of just a sign means that it has not often been carried into action. The story of the Women's Rights Pioneers Monument shows that new monuments, no matter how well intentioned, often fall into the same traps as the old ones.

August 26, 2020, saw the unveiling of the first new statue in New York City's Central Park in decades. The new monument honored Susan B. Anthony, Elizabeth Cady Stanton, and Sojourner Truth. They were the first historical women to be honored in the park, unlike Alice in Wonderland, Shakespeare's Juliet, or the park's other sculptures of fictional or allegorical females.

The statue was a gift to the city from Monumental Women, a non-profit organization formed in 2014 to raise the $1.5 million necessary to "break the bronze ceiling" in Central Park. The unveiling occurred on the centennial anniversary of the 1920 ratification of the Nine-teenth Amendment, which granted women the right to vote. When deciding whom their monument should honor, the organization had judged Anthony and Stanton to be "most deserving" because of their "fifty year commitment to fighting arduously and tirelessly for the rights of women and their many successes."[19] The group asked an art-ist to design a monument with portraits of Anthony and Stanton that would also honor the memory of other women's rights activists.[20] The resulting model showed Anthony standing beside Stanton, who was seated at a writing desk from which a scroll listing the names of other activists unfurled.

Gloria Steinem soon suggested that the design made it look as if the white suffragists were "standing on the names of these other women."[21] Similar critical responses followed. In early 2019, Monu-mental Women responded by removing the scroll from the design. Critics then challenged what the New York Times' Brent Staples called the monument's "lily-white version of history."[22] Historian Martha S. Jones wrote an opinion piece criticizing the way the planned monu-ment promoted the myth that the fight for women's rights was led by Anthony and Stanton's "narrow, often racist vision."[23] Jones argued

that the monument should also honor one of the many suffragists of color, like Sojourner Truth, who escaped from slavery and spent the rest of her life advocating for equality.

Monumental Women added a portrait of Truth to the planned monument, then modified it once again after criticism of her depiction. The sculptor changed the position of Truth's hands and body to make her a more active participant in the scene. In the earlier version, she was seated farther from the table, with her hands resting quietly, as if she were merely listening to the white suffragists.

Still, more than twenty leading scholars of race and women's suffrage sent a letter to Monumental Women, asking it to do a better job showing the racial tensions between the activists.[24] Truth had indeed been a guest in Stanton's home during a May 1867 Equal Rights Association meeting. This, the scholars insisted, was before white suffragists fully grasped the conflict between the fights for women's and Black citizens' political participation. Stanton and Anthony came to believe that women's votes—white women's votes—should take precedence.

Congress passed the Fifteenth Amendment in 1870, extending the vote to Black men. It was not until 1919 that Congress finally passed the Nineteenth Amendment. Its ratification remained uncertain. After working so hard to keep Black men away from the ballot box, Southern states were not eager to grant the vote to Black women.

During the summer of 1920, realizing that they still needed to convince one more Southern state to ratify, white suffragists began a campaign to remind white Southerners that the Jim Crow laws already on their books to keep Black men from voting would also disenfranchise Black women.[25] Reassured, Tennessee voted to ratify, and the Nineteenth Amendment went into effect.

The white suffragists' predictions proved all too accurate. When Southern Black women tried to exercise their new right to vote, they were foiled by discriminatory literacy tests, poll taxes, or violence. In 1926, for instance, a teacher named Indiana Little led a march of hun-

dreds to Birmingham's voter registration office. They were turned away, and Little was both beaten and sexually assaulted by a police officer.[26]

The 1965 Voting Rights Act finally gave teeth to what had been merely an illusion of a right to vote for Black women.[27] Like emancipation, the act was not a gift; Black women played crucial parts in the fight to make the legislation a reality. Amelia Boynton Robinson, the first Black woman in Alabama to run for Congress (her campaign motto: "A Voteless People Is a Hopeless People") even turned her husband's memorial service into Selma's first mass meeting for voting rights. She then became a key organizer of the 1965 march from Selma to Montgomery, during which an Alabama state trooper beat her brutally as she tried to cross the Edmund Pettus Bridge. A widely published photograph of her lying on the ground, bloody and unconscious, would form part of the campaign that led to the passage of the Voting Rights Act a few months later.[28]

The Women's Rights Pioneers Monument went up as other monuments fell. On the surface, it is exactly what protesters have been demanding. Its diverse honorees better reflect American's history and experience than the park's existing all-male cast. Yet its gentle, almost cartoonish portraits of Stanton, Anthony, and Truth could not be further from that photograph of a bloodied Robinson. The monument leaves out the pain and the struggle of the women's movement. Its calm, emotionless honorees seem triumphant, as if their fight were over.

This is far from true. A 2013 Supreme Court decision struck down one of the Voting Rights Act's key protections.[29] As a result, minority citizens have found it ever more difficult to exercise what once again seems more like a theoretical than a real right to vote. Meanwhile, feminists of color continue to find that many white feminists ignore racial issues and are reluctant to share control or credit for their activism.[30] The fight for equality is hardly over, no matter what the pioneers monument might have to say about it.

Meredith Bergmann, Women's Rights Pioneers Monument, dedicated 2020.

Traditional monuments put heroes on pedestals to tell us our troubles are all over. They are our nation's selfies—perfectly posed and cropped to show only our best angles. They cover over complications and give a too-rosy view of the past and the future. We need debates, not pieties. We need to question our past in order to remake our future. If monuments try to keep us where we are by holding up examples of impossibly perfect people, well, maybe we don't need them at all.

If we cannot see a place for ourselves on a monument, that monument will fail, in a very important way, to inspire us. And even if every new monument had the hundreds of figures that Gutzon Borglum once imagined covering Stone Mountain, that still would not be enough for every viewer to be able to see someone who looks like them.

Already in 1916, Freeman H. M. Murray recognized that showing a theme as broad as emancipation or the role of Black soldiers during the Civil War could not be adequately depicted by a monument that insisted on representing an actual moment in time or specific historical people.[31] He thought no single moment could show enough of the

concept and that viewers would inevitably be distracted by reflections, either positive or negative, on the personal lives of the people shown. Instead, Murray suggested using allegorical figures to represent intangible ideas.

Even as Murray wrote, artists were discovering that abstract forms could convey emotion and stir viewers without depending on the human form. Since then, artists have made powerful monuments by inscribing names on slabs of stone or projecting giant shafts of light into the night sky. Monuments have taken the form of gardens or of cork boards for community messages.[32] We no longer need to limit our imaginations to choosing a few people to put on a pedestal.

America certainly needs new monuments, even if they look nothing like our traditional ones. We need monuments to honor ideas and actions that would have horrified the makers of those older monuments. Adding new monuments is part of the process of change as we reconsider our country—but the removal of monuments must accompany the adding of new ones.

The Great Reshuffling

I n August 2018, David Ruffin knotted his fingers together and began to deliver the North Carolina Historical Commission's decision about the fate of the state's Confederate monuments, 153 years and one month after his ancestor Edmund Ruffin shot himself rather than accept Union rule.[1] Ruffin, the chair of the commission, was nearly as old as his ancestor had been when he died. He had his eyes: hooded except when tugged open by a hiked-up eyebrow. While Edmund wore his white hair flowing down past his shoulders, David's, equally white, was neatly trimmed. He wore a conservative gray suit and looked like the banker he was. He had been appointed to the historical commission, mostly stocked with professional historians, to represent North Carolina's public.

Ruffin and his commission had been arguing about the Confederacy since a few weeks after Charlottesville's "Unite the Right" rally, when the Democratic governor of North Carolina, Roy Cooper, petitioned them for permission to remove Confederate monuments from the state capitol grounds.[2] Cooper had watched the events in Charlottesville with horror and believed that the violence "started with a Confederate monument . . . inanimate, and yet more provocative now than ever."[3] When protesters toppled Durham's Confederate soldier shortly afterward, Cooper realized he needed to find "a better way" to address

the debate about monuments in North Carolina, before its citizens got hurt either trying to tear down or defend monuments.

The governor wanted to move three monuments. One was the North Carolina State Confederate Monument, with its huge bronze soldier standing at parade rest. Another was the 1914 Confederate Women's Monument, which shows a grandmother incongruously arrayed in what looks to be a ballgown from her antebellum youth, reading a history book to a young boy. He plays with his grandfather's sword and gazes stoically into a future where he will have to use it to defend once more what the Confederacy stood for. The third monument, a statue of Henry Lawson Wyatt, allegedly the first North Carolinian soldier to die in the Civil War, was yet another product of the prolific Gutzon Borglum. Julian Shakespeare Carr attended its 1912 dedication.[4]

Nearly a year went by while the commission pondered the governor's request, during which it seemed like every single resident of North Carolina expressed their opinions on the subject. A man with a pug dog strapped to his chest stood in front of the North Carolina State Confederate Monument, its bronze soldier looming nearly seven stories above him, waving a sign reading TREASON PARTICIPATION TROPHIES ARE REPUGNANT.[5] The same Raleigh newspaper that had once excoriated legislators for not funding the monument now ran opinion pieces about whether it should stay where it was erected in 1895 or, as the governor proposed, be relocated forty-five miles south to a state historical site commemorating North Carolina's largest Civil War engagement, the 1865 Battle of Bentonville. And when the commission asked the state's citizens to comment, they received over seven thousand responses.[6]

"I'm just a regular redneck," said one of the sixty people who filed up to microphones at a public hearing in March 2018, "and I think it's wrong to move these monuments."[7] The Confederate battle flag glinted from the Sons of Confederate Veterans membership pin on his lapel as he insisted that "the courthouse would be an eyesore without our ancestors."

The great majority of speakers at the hearing agreed with him. Among the opposing voices was a woman who asked the commission to put the monuments somewhere Black children would not have to see them. "You want to put them in an historical spot?" she asked exasperatedly. "Fine! So y'all can joke around with your Confederate flags." Another woman said she was a tenth-generation North Carolinian ("I hope my father's not listening") and then argued that the monuments "whitewashed over" her slave-owning ancestors' inhumanity. She asked that the monuments be "removed entirely, not even to Bentonville."

Ruffin and the other members of the commission listened in silence to the speakers. Ruffin's family had paid "reverential tributes" to Edmund while he was growing up in the 1950s in a small North Carolina town so segregated that Black shoppers were only allowed into the stores on Main Street one afternoon a week.[8] Edmund Ruffin had wrapped himself in the Confederate flag as his final act before picking up his shotgun. Now North Carolinians were looking to his descendent to decide whether it was finally time to disentangle their state from that flag and all it represented.

In August 2018, as he announced the commission's decision, Ruffin would tell his audience that he had realized that "civil rights needed to replace Civil War" as the centerpiece of Southern heritage.[9] He explained that the decision about the monuments was a decision about how to deal with "the original sin of the American experience": slavery. He was in favor of taking the monuments down.[10]

Ruffin's speech was moving. It was also futile. The members of the commission could have saved months of their time if they had listened to one of the very first people who had stepped up to the microphone at the March 2018 hearing, a man who identified himself as just "a private citizen" from Jacksonville, North Carolina. He pointed out that the state's law required that monuments be relocated somewhere equally prominent, and there was "no equal place in North Carolina other than the capitol grounds." The commission

could order the monuments moved only if it wanted to "circumventi-late [*sic*] the law."

The man from Jacksonville was right. Despite what he wished could happen with the monuments, Ruffin had to concede that the com-mission had no power to order them removed. His hands were tied by North Carolina's 2015 Historic Artifact Management and Patrio-tism Act.[11] It prohibits moving public monuments unless doing so is necessary for their preservation. If a monument is moved, it must be replaced within ninety days or relocated to "a site of similar promi-nence, honor, visibility, availability, and access." The act specifically prohibits moving a monument to a museum or a cemetery unless it was originally located in one.

Governor Cooper both called for the repeal of the act and argued that Bentonville fit its requirements for a similarly prominent new home for the monuments. The commission decided they had no authority under the act to grant his petition, because moving the monuments was not necessary to protect them.[12] Even if it were, the commission agreed with the commentator who had said that no alternate location could equal the prominence of the capitol grounds. Instead, the commission recommended adding signs near the monuments to give information about, among other things, the role of slavery in the Civil War and these monuments' role in attempts to control Black voting rights. The commission also called for the addition of new monuments to the capi-tol grounds to commemorate the civil rights struggles of North Caro-lina's Black and Indigenous citizens.

Ruffin did not like the law. But unlike his ancestor, he considered himself bound by it.

Two years later, however, in June 2020, the soldier on top of the North Carolina State Confederate Monument was finally laid to rest on the bed of a flatbed truck. Governor Cooper had ordered the monu-ment dismantled to preserve it and to protect public safety after pro-testers pulled two smaller statues off its base.[13] The pieces of the State

Confederate Monument, as well as the Confederate Women's Monument and the Wyatt Monument, disappeared into storage.

In all, North Carolina officials took nearly twenty controversial public monuments off their pedestals in 2020, claiming they needed to do so to protect the monuments and the public. And they weren't the only ones. For months, headlines shouted about the removal of monuments across America. Few journalists were asking where those trucks were headed after they collected a monument toppled by protesters or dismantled by authorities. Where did these monuments go? And did these removals actually change anything?

In North Carolina, Governor Cooper once again petitioned the commission to ask what to do with the three capitol monuments he had taken down. Ruffin, still the chair, opened the commission's next meeting by saying how disappointed he was that the state had not added the signage and additional monuments to the capitol grounds the group had recommended back in 2018. Then, he got to work forming a subcommittee to tell the governor exactly where he should reinstall each of the removed monuments.[14]

Under North Carolina law, monuments cannot be removed. They can only be reshuffled.

At the commission's March 2018 public hearing, a representative of the United Daughters of the Confederacy rose to say her organization was "totally against action by this body or any other to remove or relocate the memorials to our Confederate ancestors."[15] Having erected hundreds of Confederate monuments, the Daughters now fight to keep them there.

The Daughters' insistence that their monuments be placed in front of important public buildings or alongside high-traffic roads meant that a number of these monuments were displaced when the buildings were expanded or the roads widened. Rather than allowing displaced

monuments to languish in storage, the Daughters swooped in to direct relocations, raising the funds necessary to refurbish and reinstall the monuments.

For example, in 1988, a drunk driver smashed his van into an 1889 Confederate soldier monument in a traffic circle in Alexandria, Virginia, knocking it off its pedestal. The traffic circle, more suited to carriages than cars, was so small that several other cars had already scraped along the statue's base. Several city council members proposed moving the statue to a museum.[16]

Despite its placement on public property, the Daughters had retained ownership of the monument. They restored it using the payout from the driver's insurance—and said no to the relocation. "We feel it's our duty to see that it's put back," the president of the local branch declared.[17] The soldier went back up on his pedestal—and was hit again by a car in 2019. Once again, the Daughters repaired and replaced the monument.[18]

It was the same story for every other Confederate monument I could find that left its pedestal for one reason or another before 2015. (Here, as in the rest of this chapter, I'm discussing monuments on public land with figural imagery, not just text—think a soldier statue, not a historical marker.) Despite generations of protests, not a single one of America's hundreds of Confederate monuments had ever permanently come down.[19] If they moved, they were all replaced in different prominent locations.[20] And if the Daughters could, they improved the placement. Once, brushing off thoughts of heavenly displeasure, the Daughters replaced a monument that had been struck by lightning in a cemetery with a new monument in front of the town's courthouse.[21]

The first official removal of a Confederate monument motivated by its subject matter, not just its status as a potential traffic hazard, seems to have happened in Selma, Alabama.[22] In late 2000, a private pro-Confederate group installed a bust of Nathan Bedford Forrest in the back garden of a city-owned historic house. They had gotten per-

mission from Selma's long-standing mayor, who had spent thirty-five years in office. One of his first acts had been ordering the use of police force against civil-rights protesters marching from Selma to Montgomery in 1965. One of his last acts was approving the placement of the Forrest bust—a sort of poisoned parting gift to his successor, the city's first Black mayor.

The bust spent only a few months in place before being moved a few blocks away, to a section of the city's cemetery already dedicated to the memory of the Confederacy. The cemetery lies in the heart of Selma's historic downtown; ironically, the monument is probably more visible to the public there than in the museum's garden.

Dylann Roof's 2015 murders in Charleston spurred local authorities to take down eleven monuments, including four in New Orleans.[23] Just like Forrest's bust, these monuments did not stay down. Six quickly went back on view in different public locations, including cemeteries, battlefield sites, and a museum. In Rockville, Maryland, the Confederate statue ended up in private hands, although still visible to the public: its new owner, a ferry company, displayed it on the banks of the Potomac next to their embarkation point.[24]

The rest remain in storage, but almost all of these cities have indicated they are merely deciding on an alternate location for their monuments. For example, St. Louis has promised to reerect its stored monument in either a museum, battlefield, or cemetery.[25] New Orleans seems to be the furthest from coming to an agreement about what to do with its removed monuments, but many of the circulating proposals include relocating them to another public site.[26] Thus, despite widespread public outcry, not a single monument was definitely, permanently removed from public view after Roof walked out of the Mother Bethel Church.

At least twenty-eight Confederate monuments were dismantled in reaction to the events in Charlottesville in 2017, in cities including Savannah, Tulsa, Kansas City, Baltimore, and Austin. Only two of these monuments were pulled down by protesters (in Durham and at

the University of North Carolina at Chapel Hill).[27] These, too, were carted off to storage.

Six of these removed monuments were quickly reinstalled in cemeteries. Another seven were given to museums. The rest are still in storage, although, again, almost all of the relevant authorities have announced that they will go back on display at a cemetery, battlefield, or museum, or be given to a private owner, like the Daughters, who will be free to put them in locations visible to the public.

Thus Charlottesville, like Charleston, did nothing to remove monuments permanently. What about the monuments that came down in 2020, following protests over the death of George Floyd?

Those protests drew attention to the many ways in which life is different for white Americans and Americans of color, from disparities in rates of incarceration to life expectancy. The protesters saw the American present as deeply shaped by the American past. Monuments honoring people who helped create American systems of racial discrimination quickly became a focal point for demonstrations: statues of those who killed Indigenous Americans, those who kept Black citizens from voting, and those who conjured up wealth and power from the labor of the people they enslaved.[28] These were monuments whose unveilings had been greeted by crowds of thousands, who cheered their vision of an America controlled by rich white men. In the summer of 2020, crowds of thousands gathered around these monuments once again. This time, they wanted to see them fall.

The first to come down, on May 30, 2020, was a statue in Nashville of Sen. Edward Ward Carmack. In 1892, enraged at the anti-lynching investigations of pioneering investigative journalist and civil rights activist Ida B. Wells, Carmack wrote editorials demanding that "the black wench" be punished. A mob demolished the offices of her Memphis newspaper, the *Free Speech*, and Wells was forced to flee to Chicago.

The next night, May 31, incendiary devices were thrown through the windows of the Daughters' national headquarters in Richmond, Virginia. The same night, a second statue fell when the protesters in

Birmingham pulled down the monument to Charles Linn, the Confederate sea captain. When Mayor Woodfin ordered the removal of the city's main Confederate monument the next day, he became the first of many local officials who would soon make similar decisions.

In all, around a hundred Confederate monuments were taken down after Floyd's death. Only thirteen were torn down by protesters, while the rest were officially removed. An additional sixty-nine monuments to other controversial historical figures came down (nearly half were sculptures of Columbus). Of these, twenty-two fell to protesters.

These monuments suffered some damage, but none, judging from photographs and news reports, were left beyond repair. Indeed, some have already been repaired. A statue of Columbus, decapitated in July 2020, had its head reattached and was back on its pedestal in front of the Waterbury, Connecticut, town hall by the end of the year.[29]

So what happened to the rest? After Charleston and Charlottesville, not a single monument was permanently removed from view. Now, after millions of Americans marched to demand justice and the rooting out of inequalities, including those enshrined in monuments, the story is a little different.

In November 2020, a sculptor neatly chipped the face from a serving-platter-sized portrait of Columbus on a 1992 monument to Italian immigrants in Norwich, Connecticut.[30] Columbus's head had decorated one side of the monument's stone shaft. Instead of replacing the entire monument, the city's Italian Heritage and Cultural Committee thriftily ordered him smoothed down and replaced with a new plaque carved with American and Italian flags.[31]

But that's it. The sole irreversible removal stemming from the Floyd protests was not even a whole monument, just a piece of one.[32]

Of the hundred removed Confederate monuments, nineteen have been returned to the United Daughters of the Confederacy, the Sons of Confederate Veterans, or other affinity groups who are free to put them back on display. Fourteen monuments are either already back up in cemeteries or are scheduled to be moved there. Another nineteen

are headed to museums, battlefields, or other outdoor historical sites. The rest are still in storage.

The current status of the other, non-Confederate monuments removed in response to the 2020 protests follows a similar pattern. One has been moved to a cemetery, while seven others were given to private groups, mostly Italian American associations. Again, the remainder are in storage, although officials have already announced that the majority will be redisplayed, either back at their original sites or elsewhere.

Some of these monuments are in states, like North Carolina, whose law mandates they go back up. In other jurisdictions, officials are likely wary of lawsuits from private plaintiffs protesting treatment they deem insufficiently honorific. Lawsuits have already been filed seeking reinstallation of two statues taken down in 2020, honoring Columbus and a former mayor of Philadelphia.[33]

Shuffling statues around our cities is like moving an abusive priest to another parish. He might not be around as many children there, just like a monument might not be seen by quite as many people in a cemetery. But he is still in a position to abuse. Decreasing the harm is not the same as stopping it. Not a single child deserves to be molested, and not a single child deserves to grow up looking at a piece of stone or metal that tries to convince them they are not equal to other Americans.[34]

Maybe those New Yorkers who pulled down George III had the right idea. If we think a monument no longer represents the type of country we want to have, there's no need to pack it up in cottonwool and keep it around in case someday we change our minds and decide to ask Great Britain to rule us once more. It's better to melt that monument down and use it to get to our future.

There are some who want monuments to remain in place because they still believe in their core claims—that only white citizens should hold power in America. There are others who accept the stories the monuments spin about history—about bold explorers and tragic

heroes—and think these stories are worth more than the pain these monuments cause.

There are many people who are not fooled by monuments but still oppose their removal. They understand that monuments are the products of America's malignant past. They understand they are painful to see. But they are afraid that removing monuments will "erase history." They think that without monuments to remind us of our past, we will repeat it.

"If people are really interested" in historical erasure, "ask a Native woman." That's the advice of Kate Beane, director of Native American Initiatives at the Minnesota Historical Society, who "had the hardest time [even] finding the names of the women in my family."[35] Their lives were of little interest to governmental record-keepers, and boarding schools and other assimilationist policies did their best to destroy other forms of memory about them.

Beane's lost ancestors show that history can, indeed, be erased. But taking down a monument is not what erasing history looks like. Erasing history requires removing information not just from monuments but also from official records, books, classrooms, newspapers, television, and all other possible sources of communication. Erasing history looks like preventing people from teaching their children their language, religion, or culture. Erasing history looks like what white Americans tried to do to Indigenous peoples, enslaved people, and immigrants pressured to renounce their previous identities.

Even the most vigorous attempts to scrub away all traces of a history will not work if people are unwilling to forget. These cultures survived centuries of official attempts to eradicate them. Removing just one venue for the communication of information will not wipe entire histories from our memories.

Taking down a monument doesn't erase history—but it does remove honor. It shows that the version of history put forward by the monument is no longer the one to which the community wants to signal its allegiance. Look at the examples of toppled or removed monuments

discussed earlier: George III and Greenough's *Washington* and *Rescue*. Despite their fate, we still remember that America was a British colony, George Washington was our first president, and that settlers clashed with Indigenous Americans. The removals did not prevent us from remembering the negative parts of these histories. In fact, the mistreatment of Indigenous Americans has become much better known since the removal of *Rescue*. When I asked Mike Forcia if he thought toppling Columbus erased history, he was incredulous. "Tearing down our history?" he replied. "No—we're exposing it."

I suspect that some of those who say they are worried about erasing history are really objecting to decisions about monuments being taken down by a small group of people, whether protesters or officials. Ideally, communities as a whole should decide. But you cannot impose this as a requirement without the existence of a real process for having these conversations.

Today, what we are truly in danger of losing is not history but rather the chance to use monuments, whether fallen or still standing, as paths to get to a better future. Zyahna Bryant, the activist who first petitioned to take down the Charlottesville Lee monument in 2016, made this clear when she spoke at the removal of the Confederate soldier monument from the city's courthouse in September 2020. "We are making the courthouse look more equitable," she said, "without reckoning with the institutional racism that takes place inside."[36] Taking action on a monument without taking action against the forces that put it up and kept it there is meaningless.

Some residents in Camden, New Jersey, understood this so well that they spent two nights sleeping on blankets next to a truck to prove it.[37] They had been calling for the removal of a statue of Columbus from a city park for decades. In June 2020, officials finally said they would take it down. The Reverend Levi Coombs III, pastor of the nearby First Refuge Progressive Baptist Church, asked them to wait for a few days, so he could plan a march to mark the occasion. But three days before the march, activists spotted workers dismantling the monument and

strapping its pieces to a trailer. Dozens of people rushed to the park to prevent its removal. They blocked the truck towing the trailer with a car. One man settled in on top of the pedestal.

Coombs and the others didn't want the statue simply to disappear. They wanted to make it clear why it had to come down. And so they guarded Columbus, in preparation for what they hoped would be one last public appearance. The march finally took place as planned, ending in the park. Activists spoke from atop the pedestal where Columbus had stood. And then, at last, the statue disappeared into storage.

Removing a monument alone does nothing to change our future. Change happens through the conversations we have when we talk about monuments and the history they embody. A removal without a conversation hides the problem. We need to acknowledge how and why our monuments were created. We need to reveal their secrets in order to take away this power.[38] As Forcia understood, the removal of a monument will send as strong a message about the values of a community as its erection only if this removal has the same attention, the same audience, the same celebration, even, that greeted the monument at its birth.

It's easy to take down a statue without touching the beliefs it embodies. America's current racial divisions are a product of centuries of messages to white Americans. These messages were communicated by monuments, among many other means. We will not reach equality and unity until white Americans are just as angry about being manipulated by these monuments as many Americans of color have long been. If not, removing statues will serve only to strengthen the convictions of those who still believe they should be there.

Epilogue

O
f all the things I discovered while writing this book, I will be thinking the longest about Easter on Stone Mountain. Stone Mountain State Park began hosting annual Easter-egg hunts soon after it opened. By the 1970s, more than twenty thousand eggs a year were hidden in the park.[1] In 1981, the Guinness Book of World Records declared the park's celebrations the world's largest Easter-egg hunt. The men who dyed these eggs were unpaid prisoners.

Convict labor was a crucial part of Georgia's plan for Stone Mountain. The Stone Mountain Prison Camp opened in 1958, as soon as the state acquired the land.[2] In its later years, the institution held mainly prisoners with shorter sentences. But when it opened, it housed some men expecting to spend life sentences within the boundaries of a park honoring the Confederacy.[3]

Wearing blue denim uniforms, the first batch of a hundred prisoners rebuilt the workshop where Borglum had smashed his models, turning it into a park office. They constructed picnic shelters and bathroom facilities, segregated for white and "colored" guests.[4] Using Stone Mountain granite, they built their own prison.[5]

The prisoners cleared brush and then landscaped the park. They constructed a sixty-four-foot dam to create the park's artificial lake. They built the stone wall near the park's visitor center and laid the concrete walkways in the courtyard of the park's motel.[6]

They constructed the park's internal roads, which are named after Confederate heroes.[7]

All able-bodied prisoners were required to work. Those who refused would lose privileges or face punishment that could include a delay of their release. During the 1960s, the warden at Stone Mountain placed anyone who claimed to be sick without running a temperature into solitary confinement.[8] One man imprisoned there during this time described it as "the pit," an underground hole teeming with mice.[9]

Although the prisoners on work detail were watched by guards, they often tried to escape.[10] One prisoner did so in 1976 by driving away in the dump truck he was using to collect the park's trash.[11] Escapes happened so frequently that the prison kept bloodhounds at the ready to track prisoners through the swamps, woods, and residential neighborhoods that surrounded the park.[12] Sometimes the guards got help from civilians: when a prisoner tried to escape from a work detail on the park's golf course in 1971, golfers tackled him as a guard ran in pursuit, firing his shotgun.[13]

Labor unions have long campaigned against unpaid or underpaid prison labor as a form of unfair competition that undercuts wages. Today, Georgia is one of only five states whose prisoners work without pay. All these states are in the South, where unions have remained relatively weak. The Southern factory owners who mixed together obedience and pride while using the memory of the Confederacy to fight unionization at the turn of the twentieth century would be proud that their strategy has continued to work for so long.

In 1984, 65 percent of the prisoners at Stone Mountain were Black.[14] It's an even higher percentage among the prisoners providing the backdrop for a 1992 campaign trail speech Bill Clinton delivered at the prison. They stand as stiffly and uniformly as soldiers on Civil War monuments.

Stone Mountain State Park paid for itself because its involuntary, largely Black labor force made the costs of its construction and main-

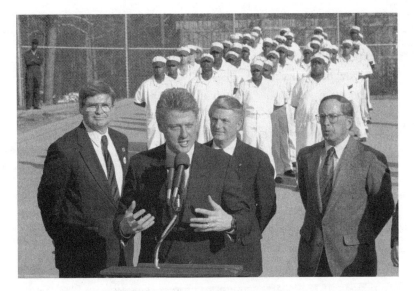

William Clinton on the campaign trail in March 1992, making an appearance at
Stone Mountain Correctional Institute with Sen. Sam Nunn, Rep. Ben Lewis Jones
(former star of *The Dukes of Hazzard*), and Georgia governor Zell Miller. *AP Photo/
Greg Gibson.*

tenance artificially low.[15] Philip Reed, the enslaved man who helped
make *Freedom* for the U.S. Capitol, got paid for working on Sundays.
The Black prisoners who helped create the world's largest Confederate
monument didn't get paid at all. Stone Mountain has long depended
on the labor of those whose lives were worth less to the authorities
than the lives of the men who ride across the mountain's face.

Stone Mountain held its 1981 record for the world's largest Easter-
egg hunt for just a few days. In 1982, prisoners added another ten
thousand eggs to their workload to recapture it. The park's assistant
general manager told reporters he wanted to do so to match the park's
other record, "for the largest single piece of sculptured art in the
world."[16] The prisoners, unable to see their own children hunt for eggs,
worked to let other people's children find a little joy in the shadow of
the Confederacy.

Although prisoners lived and worked in the park until the mid-1990s, Stone Mountain's dependence on prison labor has been nearly forgotten. The monument itself ignores the existence of these men, even though they made its creation possible. Thinking about them, and about the Klan and Borglum's scams and all the other stories of Stone Mountain, should change how we see the monument. I wrote this book to uncover stories like this—stories to startle us out of our assumptions.

Our monuments hide so many stories. Indeed, these monuments often were built as part of a war of stories; they remain as fortresses guarding interpretations of the past. Take the elaborate Confederate monument in Augusta, Georgia, for example. Dedicated to the memory to the Confederacy—"No nation rose so white and fair: none fell so pure of crime," as its inscription puts it—the monument went up in Augusta in 1878 as part of a fight to protect the city from Black joy.[17]

In the years after the Civil War, Black citizens in Augusta, as well as many other towns across the South, celebrated emancipation and their newly recognized freedoms with annual parades on New Year's Day and the Fourth of July. In Augusta, they marched up the city's main commercial street, Broad Street, toward city hall. In April 1870, when thousands of Black Georgians came together to celebrate the passage of the Fifteenth Amendment, the celebrants carried banners reading WE ARE RISING and GEORGIA, OUR NATIVE STATE, WITH ALL THY FAULTS WE LOVE THEE STILL. The parade included a decorated wagon filled with Black women dressed in white and wreathed in greenery, symbolizing the states of the Union. In their midst sat a "Goddess of Liberty," wearing a "brilliant golden papered crown, studded with variegated stars" and a dress whose fabric "glittered in the sunlight."[18]

After listening to hours of speeches and music, the celebrants marched back down Broad Street in a torchlit procession. As historian Kathleen Clark points out, enslaved people had been sold in the market houses lining the upper end of Broad Street. The participants were

"parading in celebration of freedom on the very street where they had once been led to auction."[19]

John Hope, who would become the first Black president of Atlanta's Morehouse College, remembered the excitement of these celebrations in the Augusta of his childhood: "We small boys wormed our way among the listening crowds mindful more of uniforms and drums than speakers' words. Yet every little while such words as emancipation, freedom, liberty would lodge in our ears."[20] The city's white residents often preferred to absent themselves rather than risk hearing these words from these speakers. "Many of our people left town," sniffed Augusta's newspaper in July 1866, and so "we are unable to inform our readers what the freedmen did"—except, the editor concluded, he had learned it "was a highly colored affair."[21] In 1868, the same newspaper claimed that the celebrating crowd had a "peculiar aroma."[22] In 1869, they offered a mocking "sanitary suggestion," asking city authorities to issue a bottle of perfume to every "man, woman, and child" for future Fourth of July celebrations.[23]

The city's monument provided an even better way to keep Black citizens in their place. It was built right in the middle of Broad Street. After the monument's erection in 1878, Black celebrants had to break their parade to march around it. The soldier who stood atop the monument, seventy feet in the air, loomed over them, reminding them of who would really be in charge of the city once their day of celebration was over.

Concerted attacks on Black freedoms meant that emancipation celebrations got smaller as celebrations of the Confederate past got bigger. By the time Hope was a teenager, the "immense multitude" he remembered from boyhood emancipation celebrations "had shrunk into a hall," and when he visited as an adult, the occasion had "shriveled into a church."[24] It was the same across the South, where Emancipation Day parades came under attack in the 1880s. By the close of the nineteenth century, white Southerners succeeded in forcing Black celebrations off public streets altogether.

In churches or other indoor spaces, Black celebrants could show their pride to one another and talk about the importance of Black people to America's past and present. But unlike public monuments, which made their arguments every day of the year, Black Americans' view of history was hidden from the public, unlikely to persuade anyone who did not already believe it.

We must all decide which stories we want to hear about the past and whose celebrations we want to join. Our monuments were created to influence these decisions. No longer can we afford to look at them passively, accepting their view of history as given without questioning it.

Each of America's thousands of public monuments has its own story. These monuments stay in place as long as their communities want to hear the accepted versions of these stories about themselves. Sometimes, this version of the story is the true, complete one. Often, it is not.

We can all do our part to uncover the histories of the monuments in our communities. We can search digital archives of local newspapers to find out what monuments' organizers, donors, and artists had to say about the messages they hoped to send. We can ask libraries and historical societies for help finding letters, diaries, and other records of monuments' influence on the community. We can talk to our neighbors to find out what monuments mean to them.

And then, we can help make these stories public. You don't have to be a history teacher or an activist carrying a sign to talk about monuments. People are doing it through unofficial guided tours, social-media posts, and even T-shirts. We can all find our own ways to talk about what matters.

Many observers have reacted to recent protests by insisting that monuments should only be removed by a democratic process. If a community agrees it no longer wants a monument, they say, it should simply vote to get rid of it. If a monument falls to a small group of

protesters, democracy suffers. What these commenters fail to realize is that people who held political power long ago have often firmly tied the hands of everyone who follows. A small minority—sometimes, just one person—can prop up a monument through deploying protective legislation or private lawsuits. If protesters who topple a statue are not stopping to ensure democratic community consensus, it is often because any route to doing so has been blocked.

When writing this book, I found many stories of people doing inspiring things. People who realized that unless they dared to commit acts of civil disobedience, change would never come. People who were brave enough to use their official powers in unexpected ways to achieve justice. But I wish I did not have to admire these people for their extraordinary acts. Few of us have the courage required to risk our careers, finances, or even freedom to take down a harmful monument.

I wish the biggest hero of the story of the Birmingham monument was Frank Matthews, the man who asked the city council to remove it in 2017. When Matthews spoke, the mayor decided it was time to act. That should have been it. I shouldn't have had to write a chapter about Randall Woodfin's unprecedented decision in 2020, because the monument should have been long gone. Instead, litigants and legislators struggled for years to force Birmingham to keep it. In the end, they succeeded in doing nothing more than imposing expenses and headaches on a city that has better things to worry about than the ghosts of other peoples' pasts.

We should all have a voice in what monuments go up and which come down. State laws like Alabama's are unjust restraints on our ability to ensure that our communities reflect our values. States without explicit prohibitions on removing or modifying public monuments are little better. As Forcia's years of attempts to use a process that didn't actually exist to protest St. Paul's Columbus monument show, the lack of a process usually means that removal will never happen.

Americans deserve clear, transparent processes around our public art. We need to be able to lodge complaints and check that our

responses to monuments are really being considered by people with the power to take action. Otherwise, we will only see more unofficial toppling of statues. This type of civil disobedience should be the very last resort; instead, it is all too often the only real option for those convinced of the harm of a monument.

We also deserve to make decisions about where these monuments end up. Communities should have the power not only to decide whether a monument stays or goes, but what happens to it. The process should not assume that preservation is the only acceptable goal.

I am an art historian. I have spent years studying the deliberate destruction of art as a tool of intimidation, war, and genocide. But I do not think that every monument needs to exist forever. Societies change and their monuments change too. Sometimes, destruction is the form this change needs to take. When the Taliban and the Islamic State exploded priceless works of cultural heritage, that destruction was an unjust abuse of power. But preservation can be just as unjust if it forces a community to retain a monument they agree is harmful.

Of course, getting to a place where the majority of a community agrees about what to do with a monument can be a lengthy and fraught process. We saw this after the fall of the Berlin Wall, when there was much debate about the many massive Communist monuments in the public spaces of the former East Berlin. Many residents wanted to keep them. For instance, one commentor argued that the nearly seven-story-tall statue of Lenin carved from red Ukrainian granite that stood in Berlin's Friedrichshain neighborhood should be left standing, since this would be a good defense against the return of Communism.[25] Others argued that the removal of the monuments would repress both individual and collective memories, preventing psychologically necessary mourning as well as stymieing historical research.

The official commission established by the Berlin Senate in 1992 to deal with Communist monuments cautiously recommended adding signage or making modifications and only moving monuments if truly necessary.[26] The dispute about the fate of the Friedrichshain Lenin

monument went on for months.[27] An artist planted ivy to let it be naturally concealed by leaves, but someone ripped up the plants. Hundreds of neighborhood residents declared that they wanted it to stay. Finally, the neighborhood assembly decided to remove the statue, but only by a seven-vote margin.

The fight continued even after the vote. The monument was put on, and then removed from, a list of protected historical artifacts. The artist's widow sued, claiming that the removal would violate her husband's rights, but the court held that he had forfeited these rights by "plac[ing] his art in the service of a propagandistic hero cult."[28] People attached protest posters to the scaffolding that went up as the monument was disassembled. One poster asked WHEN DO BOOKS BURN?[29]

Even the statue itself resisted, proving much more difficult to take apart than had been expected. Finally, its pieces were buried in a sand pit on the outskirts of Berlin. For months afterward, graffiti near where the monument had stood continued to question the decision to remove it. And as late as 2015, when Lenin's head was dug up to go on temporary display at a historical exhibition, one Friedrichshain resident told a reporter that doing so was "great idea" because "it was a shame to take it away in the first place."[30]

Talking about monuments is not easy. But we need to do it. We need to come together as communities to make sure our monuments leave room for everyone's life, liberty, and pursuit of happiness. More than a century ago, Freeman H. M. Murray told us what questions we should ask a monument while we make these decisions:

> *What does it mean? What does it suggest?*
> *What impression is it likely to make on those who view it?*
> *What will be the effect on present-day problems, of its obvious and also of*
> * its insidious teachings?*[31]

It is beyond time to ask these questions about every American monument. We need to discuss them without assuming that generations

of pain can be fixed by adding a couple of signs or reshuffling where monuments are displayed. We need to discuss them democratically, without the interference of laws that nail monuments to their pedestals or policies that mire reconsiderations in Kafkaesque bureaucracy. And we have a lot of work to do. Even with all the recent removals, thousands of monuments, place names, and other symbols commemorative of divisive ideologies remain in public spaces across America.

Monuments are powerful sources of inspiration. America's traditional monuments—majestic presidents, galloping officers, and gesticulating politicians—have had lifetimes to prove that they really do make us better. But despite their presence, America is still scarred by discrimination on the basis of race, class, gender, and so many other factors that make life easier for some and so much harder for others. We need to ask more of our monuments. No longer should they lift up just a few of us while pushing everyone else down. We need monuments to inspire us all.

There have always been people who cared deeply about public art's power to inspire or harm us. What has changed in recent years is that so many more people are now paying attention to monuments, and that they have realized that we are not stuck with the monuments we have. Our monuments, like so many other aspects of our nation, are open to change and improvement.

We are now in a crucial moment. Even the Stone Mountain Confederate Memorial, carved to last as long as the mountain itself, is beginning to stir. The first chairman of the Stone Mountain Memorial Association was a Klansman. In April 2021, a Black man, the Reverend Abraham Mosley, took his place. Perhaps, at last, freedom will ring from Stone Mountain in Georgia.

But the sound of freedom might end up even more muffled than before. There's no certainty where this moment of change will take us. Things changed in 2015, after Charleston, and 2017, after Charlot-

tesville. But although a few monuments came down, after the protest-ers went home, the real change was in the tightening of protections for monuments. Now, again, Americans are questioning our monu-ments. Again, we might forget to keep paying attention, allowing a small number of people to make our decisions for us.

To continue dragging "a heavy weight, the dead, dead corpse of the Confederacy," one former Confederate leader told his son in 1886, "is stupid and daily suicidal. Let us live *in* the present and *for* the future."[32] Our monuments were put up by people who wanted to freeze American society into place, with themselves at the top. But we, unlike the stone and metal figures on a monument, can decide that it is time to move.

ACKNOWLEDGMENTS

The editors of the shorter pieces where I developed some of my thoughts for this book, including Evette Dionne, Christine Emba, Tom Engelhardt, Kaitlyn Greenidge, Seph Rodney, Hrag Vartanian, and Brian Wolly, pushed me to be both more careful and more daring. My agent, Sandy Dijkstra, and my editor at Norton, Matt Weiland, gave me crucial criticism and encouragement. I am all the more appreciative for their aid, knowing that they offered it during a pandemic and months of national turmoil.

Thank you to the International Coalition of Sites of Conscience and the Center for Latin American and Caribbean Studies at the University of Michigan for inviting me to speak about monuments, and to my co-panelists at these events, whose thoughts proved formative to my developing project: Melanie Adams, Ana Lucia Araujo, Alissandra Cummins, Olivia Chilcote, Vanessa Fonseca-Chavez, and Andrea Queeley.

I am grateful for the generosity of Mike Forcia, John Guess Jr., Lyra D. Monteiro, Denise Pouliot, Laurajane Smith, Randall Woodfin, and the others I spoke to for the book. They shared emotional, intense memories, and I can only hope I have done justice to their work. Thank you as well to Rick Journey, Sarah Parcak, and Jack Rice for helping arrange these interviews.

I could not have written this book without a great number of people

whose interest in the topic cheered me on and who provided answers to my many questions about matters ranging from bronze casting and Birmingham history to ornamental plaster and the diagnosis of "mania." Thank you especially to M. T. Anderson, Ellen Belcher, Guthrie Beyer, Sarah Bond, Patrick Browne, Elise Capron, Brett Chapman, James Doherty, Adam H. Domby, Sonja Drimmer, Todd Fine, Jami Floyd, Gary Francis, Stanislav Ginzburg, Hilary Green, Alice Gregory, Christopher W. Jones, Kristina Killgrove, John Lowe, Adrienne Mayor, John Morse, Howard Norman, Bill Pahlka, Miranda Rectenwald, Roko Rumora, Roslyn Schloss, Huneeya Siddiqui, Nicholas Smith, Emily Van Alst, Jennifer Vanasco, Roberto Visani, Karl Zahn, Rachel Zimmerman, and my Macaulay Honors College students, who always teach me more than I teach them.

Richard Relkin, the head of my college's media relations department, cheerfully coached me through waves of negative reactions after I began to speak about controversial monuments. Mackenzie Priest, who tracked down legislative proposals to increase protections for monuments, was indispensable. I am a grateful patron of Still North Books in Hanover, New Hampshire, whose staff aided me with many special-order requests, and believed me when I said I was not asking for a book called *Why Every American Should Honor Confederate Soldiers and Their Memorials* because I agreed with the author (although they still handed it to me covered in a plain brown paper wrapper).

This is a book of stories, and nothing in its writing was more important to me than telling these stories over lunch to Sara Bershtel, Krista Christophe, and Celeste LeCompte. If their plates went cold while they listened, I knew I had the makings of a chapter. They also read drafts, gave invaluable comments, and then often took my children on adventures while I used these comments to make this book better. It could not exist without them.

Most of all, this book has shown me how much it takes to draw attention to the harmfulness of a public monument. I stand in awe of

those who have written, spoken, and marched to do so, knowing that their message would likely be met with indifference at best and attacks on their careers, freedom, and even lives at worst. I hope, someday, all Americans will acknowledge their fight.

NOTES

Introduction

1. "The Statue of Freedom for the Dome of the Capitol," *Greensboro Times* (Greensboro, NC), June 9, 1860, gives enough details to identify the process used to make *Freedom* as loam molding, a form of sand casting.

2. "Casting a Section of the Statue of Freedom," *Daily Exchange* (Baltimore, MD), November 28, 1860 (reprinting a report from *The Washington Star*).

3. Petition of Clark Mills, June 20, 1862, Records of the Accounting Officers of the Department of the Treasury, 1775–1978, National Archives and Records Administration, Record Group 217.6.5, Microcopy 520, Reel 5, Arc Identifier 4644616.

4. In June 2020, protesters damaged the cannons surrounding the sculpture and painted the word "killer" on its base, referring to Jackson's cruel treatment of Indigenous inhabitants of the Southeast: Fredrick Kunkle, Susan Svrluga, and Justin Jouvenal, "Police Thwart Attempt by Protesters to Topple Statue of Andrew Jackson Near White House," *Washington Post*, June 23, 2020.

5. For the history of the Jackson monument, see John Philip Colletta, " 'The Workman of C. Mills': Carl Ludwig Richter and the Statue of Andrew Jackson in Lafayette Park," *Washington History* 23 (2011), and Kirk Savage, *Monument Wars: Washington, D.C., the National Mall, and the Transformation of the Memorial Landscape* (Berkeley: University of California Press, 2009), 78–80.

6. "Clark Mills and Houdon," *Weekly Raleigh Register* (Raleigh, NC), July 1, 1857 (reprinting an article from *The Richmond Whig*).

7. Shortly after Mills received a $20,000 bonus payment from Congress for the Jackson monument, he purchased Lettie Howard, her child Tilly, and a married couple, Levi and Rachel Thomas. At this time, he already owned Philip Reed and Ann Ross, who had belonged to his first wife. Howard would have five more children while owned by Mills (Tom, Ellick, Jackson, George, and Emily), so, in April of 1862, Mills owned eleven people. Petition of Clark Mills, June 20, 1862, Records of

the Accounting Officers of the Department of the Treasury, 1775–1978, National Archives and Records Administration, Record Group 217.6.5, Microcopy 520, Reel 5, ARC Identifier 4644616.

8. Mills, who was serving as a juror in a court case, got special permission to take a few hours off to attend the statue's inauguration (his fellow jurors, along with the judge and the lawyers, climbed up to the courthouse roof to watch through binoculars): "The Statue on the Dome of the Capitol," *Baltimore Sun*, December 3, 1863. Whether Reed saw the dedication is unknown.

9. Vivian Green Fryd, *Art and Empire: The Politics of Ethnicity in the United States Capital, 1815–1860* (Athens: Ohio University Press, 2001), 177–208.

10. Jefferson Davis to Captain Montgomery Meigs, January 15, 1856, Meigs Letterbook, Office of the Architect of the Capitol, quoted in Fryd, *Art and Empire*, 193. Meigs, who supervised the expansion and decoration of the Capitol under Davis, would have conveyed these instructions to Crawford.

11. "Alarm Movements in Maryland," *Liberator* (Boston), November 18, 1859.

12. In 1862, Mills owned three women, but the *Liberator* article points to a woman whose husband was not owned by Mills. He owned both Rachel Thomas and her husband. Lettie Howard would have been either heavily pregnant or recovering from childbirth in November 1859, and would have had to leave behind her four other children. Thus, it seems most likely that Ann Ross was the one who escaped, since Mills's list does not include any children or a husband of hers. It is also possible that the woman was someone else entirely, no longer owned by Mills in 1862.

13. John Eaton, *Grant, Lincoln, and the Freedman* (New York: Longman Green, 1907), 89.

14. Megan Smolenyak, "Philip Reed, the Slave Who Rescued Freedom," *Ancestry Magazine* (May/June 2009), 54–56.

15. Of the eleven people Mills owned in April 1862, Reed was worth the most. Mills claimed the least, $50, for Emily Howard, "3 months old, all black color, sound and healthy," asking for a total of $5,250. Petition of Clark Mills, June 20, 1862, Records of the Accounting Officers of the Department of the Treasury, 1775–1978, National Archives and Records Administration, Record Group 217.6.5, Microcopy 520, Reel 5, ARC Identifier 4644616.

16. Smolenyak, "Philip Reed"; see also Sarah Fling, "Philip Reed: Enslaved Artisan in the President's Neighborhood," The White House Historical Association, December 8, 2020, https://www.whitehousehistory.org/philip-reed.

17. Reed's role in the creation of *Freedom* was not entirely forgotten, but the stories told about him rarely mentioned his name and moved further and further away from the facts of his life. Even today, when organizations like the Office of the Architect of the Capitol explain Reed to the public, they repeat fictions made up by nineteenth-century journalists and guidebook writers. The most enduring of these stories is that Reed, using unexpected skills, "saved" *Freedom* by foiling a sabotage attempt at some crucial point during its creation.

The earliest version of this type of story I could find was printed in the *New*

York Tribune. Mills's foundry superintendent is said to have gone on strike during the casting, demanding his wages be raised from $8 to $10 a day and claiming that "nobody in America, except himself, could complete the work." Mills "felt that the demand was exorbitant, and appealed in his dilemma to the slaves who were assisting in the molding." One, a "black master-builder," took the striker's place, and *Freedom* was saved. W.A.C. ["Washington Correspondent"?], "The Statue of Freedom," *New York Tribune*, December 10, 1863. This story, although printed just a few days after *Freedom*'s dedication, is contradicted by historical records. The article mentions "slaves," but Reed was the only enslaved person working at Mills's foundry. The daily payroll records Mills submitted to Congress to justify the reimbursement he received for his expenses do not show anyone being paid $8 a day. And while Mills did notoriously clash with the expert European foundry workers he hired to help him understand how to cast statues, when one left he would simply hire another, going through at least four while working on the Jackson monument: Colletta, "'The Workman of C. Mills.'" Even today, foundries and their workers jealously guard their casting secrets, including the exact mix of metals and temperatures used. Even if Reed were very observant, it seems impossible for him to have learned enough for Mills to have relied on him instead of hiring another expert. The article thus seems to be a characteristic product of an era when many journalists refused to let truth get in the way of a good story. Another early example of a story of a strike during the bronze casting, although this time with Reed replacing multiple white workmen who quit when they heard the news that Southern states were succeeding from the Union, occurs in James Jackson Jarves, *Art Thoughts: The Experiences and Observations of an American Amateur in Europe* (New York: Hurd and Houghton, 1870), 313.

The version of the story of Reed saving *Freedom* most popular today seems to have first occurred in an 1869 guidebook, Samuel Douglas Wyeth's *The Rotunda and the Dome of the United States Capitol* (Washington, DC: Gibson Brothers, 1869), 194. Here, an Italian sculptor who assembled the five sections of the model when it went on display in the Capitol before the casting refused to explain how to take it apart again unless he was given a pay raise. He had covered the seams with plaster and claimed "he alone" knew how to find them. But Reed suggested attaching a pulley to the lifting ring on top of the model, then gently lifting up to reveal the seams. This story was repeated on the floor of Congress in 1928 and is still told to visitors to the Capitol: Finis James Garrett, remarks on "Statue of Freedom," on January 9, 1928, 17th Congress, 1st Session, *Congressional Record* 69, part 2: 1199–1200; "Philip Reid and the Statue of Freedom," Architect of the Capitol, https://www.aoc.gov/explore-capitol-campus/art/statue-freedom/philip-reid. But it is also too good to be true. The similarities to the 1863 version, down to the striking workman claiming he was the only one in America who knew the required secret, are suspicious. And while the model, which survives, does indeed have a lifting ring on top, the story's logic is questionable. The model was on display for only a

year, which seems too a short a time for everyone else involved in its assembly to have forgotten the details. And the expert plasterer I consulted pointed out that there are many ways to find hidden joints, including spritzing water on the surface to see differences in the suction pattern, or simply choosing an area that can be repaired and sawing out a portion to reveal the internal armature. Wyeth claims he heard the story from Fisk Mills, the sculptor's son. But he was away at school during the disassembly of the model. He may well have told the story, perhaps inspired by the earlier versions of a strike during the casting, in an attempt to change the public perception of his father from a known slave owner and rumored Confederate sympathizer into someone who respected the knowledge of a skilled Black worker.

These stories about Reed were created and embellished by tellers who wished to give Reed a heroic role in making *Freedom*. But Reed worked seven days a week, performing backbreaking labor whose health hazards probably shortened his life. His life was heroic, and tragic, enough.

18. Larry Buchanan, Quoctrung Bui, and Jugal K. Patel, "Black Lives Matter May Be the Largest Movement in U.S. History," *New York Times*, July 3, 2020.

19. These protesters are continuing a long history of taking action against monuments. For example, Mamie Garvin Fields, who was born in 1888, recalled how Black Charlestonians "used to carry something with us," if they knew they would be passing the city's 1887 statue of the rabidly pro-slavery politician John C. Calhoun, "in order to deface that statue—scratch up the coat, break the watch chain, try to knock off the nose." Fields thought "white people were talking to us about Jim Crow through that statue" and imagined that the statue was speaking to her, saying, "You may not be a slave, but I am back to see you stay in your place": Mamie Garvin Fields and Karen Fields, *Lemon Swamp and Other Places: A Carolina Memoir* (New York: The Free Press, 1983), 57; discussed in Karen L. Cox, *No Common Ground: Confederate Monuments and the Ongoing Fight for Racial Justice* (Chapel Hill: University of North Carolina Press, 2021). For more on these histories of protest, see, e.g., Joan Marie Johnson, " 'Ye Gave Them a Stone': African American Women's Clubs, the Frederick Douglass Home, and the Black Mammy Monument," *Journal of Women's History* 17, no. 1 (2005); Derek H. Alderman, "Surrogation and the Politics of Remembering Slavery in Savannah, Georgia (USA)," *Journal of Historical Geography* 36, no. 1 (2010); Robert Hodder, "Redefining a Southern City's Heritage: Historic Preservation, Planning, Public Art, and Race in Richmond, VA," *Journal of Urban Affairs* 21 (2016); Ashleigh Lawrence-Sanders, "Removing Lost Cause Monuments Is the First Step in Dismantling White Supremacy," *Washington Post*, June 19, 2020. Cox identifies the first demonstration against a Confederate monument in the modern era as the result of Tuskegee Institute students protesting the acquittal of a white man who had killed the student activist Samuel Younge Jr. for demanding to use a "whites only" public bathroom. The night following the verdict, Tuskegee students converged around a Confederate monument, splashing

it with black paint, adding a yellow stripe to its soldier's back, and writing "Black Power" and "Sam Younge" on its base. "When the paint hit, a roar came up from those students. Every time the brush hit, wham, they'd roar again," a participant recalled. "Let's get all the statues—not just one," one woman shouted. "Let's go all over the state and get all the statues": James Forman, *Sammy Younge, Jr.: The First Black College Student to Die in the Black Liberation Movement* (Seattle: Open Hand Pub, 1986), 254.

20. "Executive Order 13933 of June 26, 2020, Protecting American Monuments, Memorials, and Statues and Combating Recent Criminal Violence," Code of Federal Regulations, title 85 (2020): 40081–40084. Trump also ordered the creation of a "National Garden of American Heroes" to enshrine figures like Columbus, Antonin Scalia, and Billy Graham: "Executive Order 13934 of July 3, 2020, Building and Rebuilding Monuments to American Heroes," Code of Federal Regulations, title 85 (2020): 41165–41168. President Joe Biden revoked both of these executive orders in May 2021.

21. Many public artworks that honor the Confederacy are called memorials, as they are supposedly dedicated to the memory of the Confederate dead. For reasons that will become clear, I instead classify them as monuments that celebrate the success of elite white Southerners.

22. In mid-June 2020, 52 percent of Americans supported the removal of Confederate monuments—a 19 point increase since just two and a half years ago, when only 39 percent of respondents were in favor of removal. However, only 14 percent of Republicans support their removal, and only 32 percent of people without a four-year college degree. The older the respondent, the less likely they were to support the removal of Confederate monuments. And while 84 percent of Black Americans supported removal, only 44 percent of white Americans did. "68% Say Discrimination Against Black Americans a 'Serious Problem,' Quinnipiac University National Poll Finds; Slight Majority Support Removing Confederate Statues," Quinnipiac University Poll, June 17, 2020, https://poll.qu.edu/images/polling/us/us06172020_unob16.pdf.

Chapter 1: Melted Majesty

1. Peter Orlando Hutchinson, ed., *The Diary and Letters of His Excellency Thomas Hutchinson*, vol. 2 (Boston: Houghton, Mifflin, 1884), 167. The diary entry begins "Lady Townshend asked me if I had a mind to see an instance of American loyalty? and going to the sopha, uncovered a large gilt head. . . ." Some commenters have thought that the head was on or under the sofa itself, but it seems much more likely that it was on a table nearby. Unless otherwise noted, information in this chapter on the statue of George III and its fate comes from Wendy Bellion, *Iconoclasm in New York: Revolution to Reenactment* (University Park: Pennsylvania State University Press, 2019).

2. Gideon Delaplaine Scull, ed., *The Montresor Journals* (New York: New-York Histori-
 cal Society, 1882), 124.

3. James P. Gilchrist, *A Brief Display of the Origin and History of Ordeals: Trials by Battle;
 Courts of Chivalry or Honour; and the Decision of Private Quarrels by Single Combat: Also, a
 Chronological Register of the Principal Duels Fought from the Accession of His Late Majesty
 to the Present Time* (London: W. Bulmer and W. Nicol, 1821), 105–106.

4. See, e.g., Historical Manuscripts Commission, Great Britain, *The Manuscripts of the
 Earl of Dartmouth*, vol. 2 (London: His Majesty's Stationary Office, 1895), 361, 396.

5. Sir Joshua Reynolds, *Portrait of Anne, Viscountess Townshend, Later Marchioness Town-
 shend*, c. 1780, Legion of Honor Museum, San Francisco, 75.2.13.

6. Brian E. Hubner, "Fort Anne, New York, Skirmish at (July 8, 1777)," in *The Ameri-
 can Revolution 1775–1783: An Encyclopedia*, vol 1., ed. Richard L. Blanco (New York:
 Garland, 1993).

7. Bellion, *Iconoclasm in New York*, 62.

8. The marble statue of Pitt stood at the intersection of Wall and William Streets
 until 1788; its battered remains are now in the New-York Historical Society.

9. Bellion, *Iconoclasm in New York*, 75 n. 60.

10. It is commonly thought that the statue was removed in 1827, but the 1812 removal
 was reported in a contemporaneous newspaper.

11. Scull, *Montresor Journals*, 124.

12. Worthington Chauncey Ford, ed., *Writings of George Washington*, vol. 4 (New York:
 Putnam, 1889–93), 226.

13. Ford, *Writings of George Washington*, 226.

14. Ben Crair, "The Fate of a Leg of a Statue of Saddam Hussein," *New Yorker*, January
 29, 2017.

15. Charles S. Desbler, "How the Declaration Was Received in the Old Thirteen,"
 Harper's New Monthly Magazine 85 (July 1892), 172.

16. "Huntington, July 23," *New-York Journal*, August 8, 1776, discussed in Bellion, *Icon-
 oclasm in New York*, 104.

17. Ebenezer Hazard to General Horatio Gates, July 12, 1776, reproduced in Peter
 Force, ed., *American Archives: Consisting of a Collection of Authentick Records, State
 Papers, Debates, and Letters and Other Notices of Publick Affairs*, vol. 1 (Washington: M.
 St. Clair Clarke and Peter Force, 1843), 228.

18. George C. Woodruff, *The History of the Town of Litchfield, Connecticut* (Litchfield, CT:
 Charles Adams, 1845), 46.

19. "Passing through Franklin Street," *Berkshire County Whig* (Pittsfield, MA), May 20,
 1847, quoted in Bellion, *Iconoclasm in New York*, 113.

20. "Lead Hand, Wrist, and Forearm Likely from the Statue of King George III at
 Bowling Green, New York City," Skinner Auctions, 2019, accessed March 25, 2021,
 https://www.skinnerinc.com/auctions/3305M/lots/204?fbclid=IwAR2dwfAVw4
 tLocUm-0wA81CqITY-IDK8hLU6ngBWruxnJ7wO40yaeu2oJM4.

21. David W. Dunlap, "Long-Toppled Statue of King George III to Ride Again, from a

Brooklyn Studio," *New York Times*, October 20, 2016.

22. *Weyman's The New York Gazette*, June 30, 1766, quoted in A. J. Wall, "The Statues of King George III and the Honorable William Pitt Erected in New York City 1770," *New-York Historical Society Quarterly Bulletin* 4 (1920): 42.

23. Joan Michèle Coutu, *Persuasion and Propaganda: Monuments and the Eighteenth-Century British Empire* (Montreal: McGill-Queen's University Press, 2006), 182–194, 232–233. The remains of the bust were fished out of the well in 1834 and are now on display in Montreal's McCord Museum.

24. For the long history of iconoclasm, see, among many interesting studies, Zainab Bahrani, "Assault and Abduction: The Fate of the Royal Image in the Ancient Near East," *Art History* 18 (1995): 363–382; David Freedberg, "Idolatry and Iconoclasm," in *The Power of Images: Studies in the History and Theory of Response* (Chicago: University of Chicago Press, 1989); and Dario Gamboni, *The Destruction of Art: Iconoclasm and Vandalism since the French Revolution* (London: Reaktion Books, 1997).

25. Martin Warnke, *Bildersturm: Die Zerstörung des Kunstwerks* (Frankfurt am Main: Fischer-Taschenbuch, 1988).

26. Olivier Christin, "Les iconoclasts savent-ils ce qu'ils font? Rouen, 1562–1793," in Simon Bernard-Griffiths, Marie-Claude Chemin, and Jean Ehrard, eds., *Révolution Fraçaise et "Vandalisme Révolutionnaire"* (Paris: Voltaire Foundation, 1992).

27. Gamboni, *Destruction of Art*, 27.

28. Today, you can see fragments of the George III statue in the New-York Historical Society and the Museum of the American Revolution; others are in private art collections.

29. "Beaux-Arts Ball to Be Held Tonight," *New York Times*, January 22, 1932; "Costumes Adhere to Colonial Style," *New York Times*, January 23, 1932; both are discussed in Bellion, *Iconoclasm in New York*, 169–171.

30. *Pageant of Old New York* (1932), quoted in Bellion, *Iconoclasm in New York*, 170.

31. See, e.g., Suzan Shown Harjo, "Threatened and Damaged: Protecting Sacred Places," *Expedition Magazine* 55, no. 3 (2013); Robert Charles Ward, "The Spirits Will Leave: Preventing the Desecration and Destruction of Native American Sacred Sites on Federal Land," *Ecology Law Quarterly* 19, no. 4 (1992).

Chapter 2: Chain of Being

1. Emerson to Margaret Fuller, *The Letters of Ralph Waldo Emerson*, vol. 3, ed. Ralph L. Rusk (New York: Columbia University Press, 1939), 121–122; quoted in Nathalia Wright, "Ralph Waldo Emerson and Horatio Greenough," *Harvard Library Bulletin* 12, no. 1 (Winter 1958): 96.

2. Emerson to Fuller, *Letters of Ralph Waldo Emerson*.

3. Ralph Waldo Emerson, *The Complete Works of Ralph Waldo Emerson*, vol. 5, ed. Edward Waldo Emerson (Boston: Houghton, Mifflin, 1903–04), 5–6, quoted in Wright, "Ralph Waldo Emerson and Horatio Greenough," 94.

4. *Letters of Ralph Waldo Emerson*, vol. 3, 120–121, quoted in Wright, "Ralph Waldo Emerson and Horatio Greenough," 96.

5. *Letters of Ralph Waldo Emerson*, vol. 3, 120–121, quoted in Wright, "Ralph Waldo Emerson and Horatio Greenough," 96.

6. *Letters of Ralph Waldo Emerson*, vol. 3, 120–121, quoted in Wright, "Ralph Waldo Emerson and Horatio Greenough," 96.

7. On the proposal for this statue and other proposals for what would ultimately become the Washington Monument, see Savage, *Monument Wars*, 25–60.

8. C. M. Harris, "Washington's Gamble, L'Enfant's Dream: Politics, Design, and the Founding of the National Capital," *William and Mary Quarterly*, 3rd ser., 56, no. 3 (1999).

9. Annals of Congress, House of Representatives, 6th Congress, 2nd Session, December 5, 1800, 803, quoted in Savage, *Monument Wars*, 1.

10. Annals of Congress, House of Representatives, 6th Congress, 2nd Session, December 5, 1800, 803, quoted in Savage, *Monument Wars*, 42.

11. For the history of the Washington Monument, see Savage, *Monument Wars*.

12. R.D.W. Connor, "Canova's Statue of Washington," *Publications of the North Carolina Historical Commission* 8 (1910), 14–27.

13. Unless otherwise stated, information about the facts of Greenough's life come from Nathalia Wright, *Horatio Greenough: The First American Sculptor* (University Park: University of Pennsylvania Press, 1963). Wright does not offer much interpretation of the facts she carefully collected, so the conclusions I offer on the meaning of Greenough's works and actions are mine.

14. Thomas Jefferson to Nathaniel Macon, January 22, 1816, *The Papers of Thomas Jefferson*, vol. 9, J. Jefferson Looney, ed. (Princeton: Princeton University Press, 2012), 384–387. North Carolina followed Jefferson's recommendation to commission Antonio Canova. His statue was installed in 1822 and was destroyed by fire in 1831.

15. E.g., in an 1830 letter, Greenough wrote to a patron, who had arranged a loan of $1,000, about his hopes of carving a statue of Washington, "which when done would I doubt not, pay my debt in America and give me assistance in my art besides": Greenough to Robert Gilmore Jr., April 25, 1830, reproduced in Natalia Wright, ed., *Letters of Horatio Greenough: American Sculptor* (Madison: University of Wisconsin Press, 1972), 58.

16. Before his commission for the Capitol statue, Greenough had modeled variations of a bust of Washington in college and in 1827 and 1832: Wright, *Letters of Horatio Greenough*, 118, 48, 95. New York newspapers announced his proposal to erect a statue of Washington in that city in December 1831, but the project was soon abandoned for lack of support: Wright, *Letters of Horatio Greenough*, 84–85. In early 1832, Greenough was negotiating with an American he had met in Paris to execute a colossal head of Washington, but this project also fell through: Wright, *Letters of Horatio Greenough*, 96.

17. Greenough to James Fenimore Cooper, December 20, 1830, reproduced in Wright, *Letters of Horatio Greenough*, 66–67. Greenough described his plan for this monument in another letter to Cooper a few months later; it was to include statues of Columbus "seated pondering on the globe," "a mother clasping her infants while an Indian steals behind her," "King Philip seated amid the bones of his fallen brethren," and "Civilization as a Female seated with the implements of industry in her hands while a boy is represented at her side as reading." Relief panels would represent "four points in the history of the Rev[olution]—Oppression—Remonstrance—Resistance—Independence." The monument was to be topped with "a statue of Washington in the act of resigning his authority as a General in chief": Greenough to James Fenimore Cooper, March 7, 1831, reproduced in Wright, *Letters of Horatio Greenough*, 63–74. The figures of Washington, Columbus, and a threatened mother would reappear in Greenough's later works.

18. Greenough to James Fenimore Cooper, in Wright, *Letters of Horatio Greenough*, 63–74.

19. Greenough to Samuel Morse, undated (between March 25 and April 23, 1832), reproduced in Wright, *Letters of Horatio Greenough*, 113.

20. Greenough to Samuel Morse, undated, in Wright, *Letters of Horatio Greenough*, 113.

21. Fryd, *Art and Empire*, 45, 66.

22. Greenough to Samuel Morse, June 3, 1832, reproduced in Wright, *Letters of Horatio Greenough*, 129.

23. Greenough to James Fenimore Cooper, May 15, 1833, reproduced in Wright, *Letters of Horatio Greenough*, 159.

24. See, for example, Greenough to Washington Allston, March 7, 1835, reproduced in Wright, *Letters of Horatio Greenough*, 187 ("I have made about 15 busts this winter") and Greenough to Romeo Alton, September 23, 1836, reproduced in Wright, *Letters of Horatio Greenough*, 202 ("I have been very busy employed in modeling portraits since I arrived here"). By the time he had been commissioned both for *Washington* and for his next monument, *Rescue*, Greenough was writing to his brother that he had raised his prices for portraits and now "refused to make busts at less than one hundred napoleons": Greenough to Henry Greenough, February 25, 1839, reproduced in Frances Boott Greenough, ed., *Letters of Horatio Greenough to His Brother, Henry Greenough* (Boston: Ticknor and Company, 1887), 129.

25. Greenough to William Dunlap, December 1, 1833, reproduced in Wright, *Letters of Horatio Greenough*, 168–169.

26. Wright, *Letters of Horatio Greenough*, 119.

27. The public interest in the statue was so great that even ten years after it arrived in the United States, newspapers were reporting that one Allen Wright, of Warren County, Ohio, had grown a stalk of wheat from a seed found in the straw in which the statue was packed for its journey from Italy. "It is said to have a stalk of great length and luxuriance, standing full six feet on the ground, and ears and berries nearly twice the size and weight of ordinary wheat": "Miscellaneous," *Sunbury*

Gazette (Sunbury, PA), August 10, 1850; see also "Farmers' Club," *Pittsfield Sun* (Pittsfield, MA), August 27, 1846.

28. *Congressional Globe*, House of Representatives, 27th Congress, 2nd Session, May 11, 1842, 490–491.

29. "Washington's Statue," *Raleigh Register* (Raleigh, NC), January 11, 1842.

30. Both quoted in Fyrd, *Art and Empire*, 76.

31. Boxer: "Statue of Washington," *Post* (Knoxville, TN), December 29, 1841. Winding sheet: Wright, *Letters of Horatio Greenough*, 144.

32. Elizabeth Slattery Clare, "The President's Monumental Woes," *Washington Post*, February 12, 1988.

33. Wright, *Letters of Horatio Greenough*, 298.

34. Wright, *Letters of Horatio Greenough*, 298; Greenough to Lady Rosina Wheeler Bulwer-Lytton, undated (before May 8, 1841), reproduced in Wright, *Letters of Horatio Greenough*, 309. Greenough's explanations of Washington's pose and the meaning of the statue's figures of Columbus and a Native American were also reported in some American newspapers, e.g. "Statue of Washington," *Southron* (Jackson, MS), August 26, 1841. Samuel Morse explained the meaning of Washington's posture similarly in a letter reprinted in a newspaper in 1843, claiming that the statue showed "all those great qualities of body and soul, which God vouchsafed to Washington as his chosen instrument to achieve our independence": "Greenough's Statue of Washington," *Evening Post* (New York, New York), January 31, 1843.

35. Greenough's plans for these decorations went through several changes. In December 1833, he was writing that Washington would sit "on a massive chair ornamented with fruits flowers and Naval and Military trophies—the large spaces on the back of which are filled by bas reliefs representing virtues personified. The hind posts of the chair are surmounted on each side by an Eagle": Greenough to Washington Allston, December 8, 1833, reproduced in Wright, *Letters of Horatio Greenough*, 171. But by 1837, he was convinced that the space "would require somewhat more of ornament in the accessories than I had at first intended" and thus wrote to the secretary of state about his plans to carve six allegorical figures in low relief: "on the one side I represent Agriculture with the Trade and Facture on each side of her, on the other Legislation, the Land and Marine forces": Greenough to John Forsyth, June 6, 1837, reproduced in Wright, *Letters of Horatio Greenough*, 212–213.

36. Greenough to Lady Rosina Wheeler Bulwer-Lytton, undated (before May 8, 1841), reproduced in Wright, *Letters of Horatio Greenough*, 309. The figure of the Native American is too generic to be able to distinguish what culture he may have been supposed to be from, although his hair style is somewhat similar to images of Osage men that were circulating while Greenough was sculpting.

37. Greenough to Lady Rosina Wheeler Bulwer-Lytton, undated (before May 8, 1841), in Wright, *Letters of Horatio Greenough*, 309.

38. Fryd, *Art and Empire*, 83.

39. Fryd, *Art and Empire*, 80.

40. Greenough to Lady Rosina Wheeler Bulwer-Lytton, undated (before May 8, 1841), reproduced in Wright, *Letters of Horatio Greenough*, 309.

41. Greenough to Lady Rosina Wheeler Bulwer-Lytton, undated (before May 8, 1841), reproduced in Wright, *Letters of Horatio Greenough*, 309.

42. Greenough to Charles Sumner, November 16, 1839, reproduced in Wright, *Letters of Horatio Greenough*, 267.

43. Horatio Greenough, *The Travels, Observations, and Experience of a Yankee Stonecutter* (Gainesville, FL: Scholars' Facsimiles & Reprints, 1958), 74.

44. Greenough, *Yankee Stonecutter*, 74.

45. Greenough, *Yankee Stonecutter*, 74–75; 89; for similar thoughts, see also Greenough to Robert Cassie Waterson, July 7, 1845, reproduced in Wright, *Letters of Horatio Greenough*, 364.

46. Greenough to Elizabeth Bender Greenough, undated (August 1843?), reproduced in Wright, *Letters of Horatio Greenough*, 339.

47. Greenough, *Yankee Stonecutter*, 75.

48. Greenough, *Yankee Stonecutter*, 75.

49. Greenough, *Yankee Stonecutter*, 76.

50. Greenough, *Yankee Stonecutter*, 77–78.

51. Greenough, *Yankee Stonecutter*, 82.

52. Greenough, *Yankee Stonecutter*, 83.

53. Messages like these would have been palatable to critics like Henry A. Wise, who was a fervent supporter of slavery. As governor of Virginia, he signed John Brown's death warrant, ignoring pressure to commute his sentence to life imprisonment.

54. Greenough's letters, the best surviving record of his thoughts during the time he was creating his *Washington*, almost never mention slavery. This is probably not surprising, given that he lived in Italy and, when he visited the United States, only went as far south as Washington, D.C. But there are hints that he held beliefs similar to those he expressed in his later writing much earlier on. In 1839, for example, he wrote to a friend about meeting an American: "I like and admire him though we had some pretty sharp discussions—he being somewhat bitten with . . . Antislavery": Greenough to George Washington Greene, September 15, 1839, reproduced in Wright, *Letters of Horatio Greenough*, 263.

55. Congress's attention had turned to decorating the eastern front of the Capitol Building in 1836. The Senate resolved to commission two statuary groups to flank the entrance staircase from an Italian sculptor who had already done several sculptures for the building. But John C. Calhoun, then a senator, objected to considering only a foreign-born artist and recommended Greenough. In 1837, the government divided the commission; the Italian sculptor would make one group and Greenough would make the other.

56. Greenough to John Forsyth, November 15, 1837, reproduced in Wright, *Letters of Horatio Greenough*, 221. Unless otherwise noted, information on *Rescue* comes from Wright, *Horatio Greenough* or Fyrd, *Art and Empire*.

57. Greenough's original design included a wound in the side of the Native American. The Secretary of State demanded Greenough remove the wound, probably judging it too gory, but did not otherwise seek to change his design: Wright, *Horatio Greenough*, 161–162.

58. Greenough to Henry Greenough, February 25, 1839, reproduced in Greenough, *Letters of Horatio Greenough to His Brother*, 129.

59. Greenough, *Yankee Stonecutter*, 85.

60. Greenough to Henry Greenough, February 25, 1839, reproduced in Greenough, *Letters of Horatio Greenough to His Brother*, 129.

61. Greenough, *Yankee Stonecutter*, 88.

62. Greenough to Henry Greenough, February 28, 1828, reproduced in Greenough, *Letters of Horatio Greenough to His Brother*, 29–30.

63. E.g., Samuel George Morton was then in the final stages of producing his work *Crania Americana; or, A Comparative View of the Skulls of Various Aboriginal Nations of North and South America* (Philadelphia: J. Dobson, 1839). On Morton, see Ann Fabian, *The Skull Collectors: Race, Science, and America's Unburied Dead* (Chicago: University of Chicago Press, 2010). Several decades later, during the Indian Wars that *Rescue* helped support, Washington's Army Medical Museum would begin to collect thousands of Indigenous remains from burials, battlefields, and massacre sites in an attempt to bolster theories of white biological supremacy: Samuel J. Redman, *Bone Rooms: From Scientific Racism to Human Prehistory in Museums* (Cambridge: Harvard University Press, 2016).

64. John Gadsby Chapman, who was then working on his painting of *The Baptism of Pocahontas*, which still hangs in the Capitol Rotunda.

65. Greenough is quoting the words of a French visitor to his studio, which he records as "la douce fermeté de cette nature superieure, qui, tout en conquerant, sent la compassion": Greenough to Henry Greenough, October 10, 1850, reproduced in Greenough, *Letters of Horatio Greenough to His Brother*, 225.

66. "Our Sculptors in Italy," *Daily Constitutionalist and Republic* (Augusta, GA), November 11, 1848.

67. *Bulletin of the American Art-Union* (September 1851): 97, quoted in Vivien Green Fryd, "Two Sculptures for the Capitol: Horatio Greenough's 'Rescue' and Luigi Persico's 'Discovery of America,'" *The American Art Journal* 19, vol. 2 (1987): 34.

68. *Bulletin of the American Art-Union* (September 1851): 97, quoted in Fryd, "Two Sculptures for the Capitol," 34.

69. Vincent Schilling, "The Traumatic True History and Name List of the Dakota 38," *Indian Country Today*, December 26, 2020, https://indiancountrytoday.com/news/traumatic-true-history-full-list-dakota-38; Scott W. Berg, *38 Nooses: Lincoln, Little Crow, and the Beginning of the Frontier's End* (New York: Pantheon, 2012).

70. United States Congress, House, 76th Congress, 1st Session, April 26, 1939, House Joint Resolution 276, quoted in Fryd, "Two Sculptures for the Capitol," 17.

71. United States Congress, House, 77th Congress, 1st Session, April 14, 1941, House Resolution 176, quoted in Fryd, "Two Sculptures for the Capitol," 17. The resolu-

tion proposed that *Rescue* be replaced with a monument to "one of the great Indian leaders famous in American history."

72. There has been much outstanding recent writing on the ways the American monumental landscape shapes the lives of citizens of color, including: Renée Ater, "Slavery and Its Memory in Public Monuments," *American Art* 24, no. 1 (Spring 2010); Ana Lucia Araujo, *Shadows of the Slave Past: Memory, Heritage, and Slavery* (London: Routledge, 2014); Samuel Sinyangwe, "I'm a Black Southerner. I Had to Go Abroad to See a Statue Celebrating Black Liberation," *Vox*, August 17, 2017; Chelsey R. Carter, "Racist Monuments Are Killing Us," *Museum Anthropology* 41, vol. 2 (Fall 2018); Kali Holloway, " 'Loyal Slave' Monuments Tell a Racist Lie About American History," *The Nation*, March 25, 2019; Caroline Randall Williams, "You Want a Confederate Monument? My Body Is a Confederate Monument," *New York Times*, June 26, 2020; Eddie Chambers, "In the Absence of Statues We See the Falsehoods We Were Sold," *Austin American-Statesman*, July 1, 2020; Chelsey R. Carter and Allison Mickel, "Statues Memorialize Everything in a Person's History, Including Torture," *St. Louis Post-Dispatch*, September 10, 2020; Nausikaä El-Mecky, "Don't Call It Vandalism," *Image* (2000); Andrea Douglas and Jalane Schmid, "Marked by These Monuments," accessed March 23, 2021, https://www.thesemonuments .org/; and Jalane Schmid, "Where America First Went Wrong on Confederate Monuments," *Slate*, April 6, 2021.

73. Wright, *Letters of Horatio Greenough*, 265.

Chapter 3: Shafts

1. David F. Allmendinger Jr., *Ruffin: Family and Reform in the Old South* (New York: Oxford University Press, 1990).

2. Edmund Ruffin, *Slavery and Free Labor, Described and Compared* (n.p., ca. 1860).

3. Gaines M. Foster, *Ghosts of the Confederacy: Defeat, the Lost Cause, and the Emergence of the New South* (New York: Oxford University Press, 1987), 15–17, and Daniel E. Sutherland, "Exiles, Emigrants, and Sojourners: The Post–Civil War Confederate Exodus in Perspective," *Civil War History* 31 (1985).

4. This statue was removed and placed into storage by local authorities on July 1, 2020: Aimee Ortiz, "Richmond Removes Confederate Statues From Monument Avenue," *New York Times*, July 2, 2020.

5. Francis L. Williams, *Matthew Fontaine Maury: Scientist of the Sea* (New Brunswick: Rutgers University Press, 1965).

6. Matthew Fontaine Maury to his wife, May 29 and June 11, 1865, quoted in Foster, *Ghosts*, 16.

7. C. H. Cary to William Walthall, December 25, 1865, William T. Walthall Papers, Mississippi Department of Archives and History; John Q. Anderson, ed., *Brokenburn: The Journal of Kate Stone, 1861–1868* (Baton Rouge: Louisiana State University Press, 1972), 363–364; Susan Bradford Eppes, *Through Some Eventful Years* (Macon,

GA: J. W. Burke Company, 1926), 278; all quoted in Foster, *Ghosts*, 13.

8. Josiah Gorgas Journal, May 4, 1865, section III, page 29, Southern History Associa-
 tion; George A. Mercer Diary, typescript volume "1860–1865," page 230, Southern
 History Association; both quoted in Foster, *Ghosts*, 13.

9. H. Cassidy to O.J.E. Stuart, August 23, 1871, Oscar J. Stuart and Family Papers,
 Mississippi Department of Archives and History, quoted in Foster, *Ghosts*, 29.

10. Robert L. Dabney, "The Duty of the Hour," Robert L. Dabney Papers, Library,
 Union Theological Seminary, Richmond, Virginia, quoted in Foster, *Ghosts*, 29.

11. For this period, when the main focus was on establishing cemeteries to provide
 permanent resting places for Confederate troops in temporary battlefield graves,
 see Catherine W. Bishir, " 'A Strong Force of Ladies': Women, Politics, and Confed-
 erate Memorial Associations in Nineteenth-Century Raleigh," in *Monuments to the
 Lost Cause: Women, Art, and the Landscapes of Southern Memory*, eds. Cynthia Mills and
 Pamela H. Simpson (Knoxville: University of Tennessee Press, 2003).

12. Foster, *Ghosts*, 40, 273.

13. Foster, *Ghosts*, 158 and Appendix 1, page 273.

14. Foster, *Ghosts*, 158 and Appendix 1, page 273.

15. "Arkansas Confederate Monument," *The Confederate Veteran* 13 (August 1905):
 350–357, quoted in Foster, *Ghosts*, 158.

16. On the Daughters, see, Karen Cox, *Dixie's Daughters: The United Daughters of the
 Confederacy and the Preservation of Confederate Culture* (Gainesville: University Press
 of Florida, 2003).

17. Bridges Smith, "Woman's Monument Movement in Macon," *Confederate Veteran*
 13.6 (June 1905); 272, quoted in Cynthia Mills, "Gratitude and Gender Wars:
 Monuments to the Women of the Sixties," in *Monuments to the Lost Cause: Women,
 Art, and the Landscapes of Southern Memory*, eds. Cynthia Mills and Pamela H. Simp-
 son (Knoxville: University of Tennessee Press, 2003), 186.

18. "The Lawn Party," *Raleigh News and Observer*, September 7, 1892, quoted in Bishir,
 "A Strong Force of Ladies," 12. The occasion also included "a perfect gem" of an
 oration on "the unexcelled record and bravery of the troops of the Confederacy
 [and] of the hardships they endured in defense of the South." Besides barbecue
 and other "delicacies of the season," there was "a fine cake" to be awarded to "the
 prettiest baby"—an example of the types of links often made between a Confeder-
 ate past and the children charged with maintaining it.

19. "The Ladies Yesterday Took the House by Storm," *Raleigh News and Observer*, Febru-
 ary 24, 1893; "The General Assembly," *Raleigh News and Observer*, February 24, 1893.
 One speaker remarked that "ninety-eight per cent of the Southern army was com-
 posed of men who were war-like by inheritance. Their ancestors came from north-
 ern Europe and can be traced back to the brave lines that faced Caesar's legions."

20. "For Ladies to Read," *Raleigh News and Observer*, February 23, 1895.

21. "No Money for Monuments," *Raleigh News and Observer*, February 24, 1895.

22. Eric Anderson, *Race and Politics in North Carolina, 1872–1901: The Black Second* (Baton

Rouge: Louisiana State University Press, 1981).

23. "No Money for Monuments," *Raleigh News and Observer*.

24. Opinion piece in *The Caucasian*, a Populist Party newspaper, February 19, 1895, quoted in "An Atonement That Comes Too Late," *Raleigh News and Observer*, March 9, 1895.

25. "No Money for Monuments," *Raleigh News and Observer*.

26. *Raleigh News and Observer*, February 24, 1895, discussed in Bishir, "A Strong Force of Ladies," 15–16.

27. "The Douglass Adjournment," *Raleigh News and Observer*, February 24, 1895, quoted in Bishir, "A Strong Force of Ladies," 15.

28. The newspaper that ran the cartoon credited it with causing a sudden "change over the spirit of the dreams of the Fusionists": "An Atonement That Comes Too Late," *Raleigh News and Observer*.

29. "The City Still Ours," *Raleigh News and Observer*, May 7, 1895, quoted in Bishir, "A Strong Force of Ladies," 17.

30. For more on the use of race to fight populist movements, see Tom Frank, *The People, No: A Brief History of Anti-Populism* (New York: Metropolitan Books, 2000).

31. "A Perfect Success," *Raleigh News and Observer*, May 21, 1895, quoted in Bishir, "A Strong Force of Ladies," 19.

32. See, e.g., the Southern Poverty Law Center's report "Whose Heritage? Public Symbols of the Confederacy," accessed March 31, 2021, https://www.splcenter .org/20190201/whose-heritage-public-symbols-confederacy.

33. Of course, these forms of intimidation could merge. When lynchings happened on courthouse lawns, their memory became entwined with the sight of the monuments installed on the same lawns: Sherrilyn Ifill, *On the Courthouse Lawn: Confronting the Legacy of Lynching in the Twenty-First Century* (Boston: Beacon Press, 2007).

34. Adam H. Domby, *The False Cause: Fraud, Fabrication, and White Supremacy in Confederate Memory* (Charlottesville: University of Virginia Press, 2020), 34.

35. "For White Supremacy: State Democratic Ticket," *Weekly Star* (Wilmington, NC), July 13, 1900, quoted in Domby, *The False Cause*, 36.

36. Julian Shakespeare Carr, untitled speech in Folder 21, Addresses, 1896–1899, Carr Papers, Southern Historical Collection, University of North Carolina, Chapel Hill, quoted in Domby, *The False Cause*, 44.

37. Julian Shakespeare Carr, untitled speech in Folder 21.

38. Domby, *The False Cause*, 20–61.

39. Julian Shakespeare Carr, *The Issues of the Campaign Stated: An Open Letter to Van B. Sparrow, Patterson Township, Durham County* (1898), 12, quoted in Domby, *The False Cause*, 37.

40. Historian Heather Cox Richardson has carefully traced the wider context of the manipulation of working-class racial prejudices and fears by elite Southerners to win elections and discourage unionization in *How the South Won the Civil War: Oli-*

garchy, Democracy, and the Continuing Fight for the Soul of America (New York: Oxford University Press, 2020).

41. There were still whippings and lynchings. In the months before the 1868 elections, the Klan murdered nearly a thousand white Southerners who had indicated they would support new state constitutions that enfranchised Black citizens: Richardson, *How the South Won the Civil War*, 80. But by the turn of the century, lack of prosecution for such acts taken against white citizens could no longer be depended on.

42. Only a little more than 20 percent of the Confederate monuments erected in the first twenty years after the war included a figure of a soldier. But nearly 80 percent of monuments erected after 1886 did: Foster, *Ghosts*, Appendix 1, page 273. Foster notes that although there were hundreds of monuments to the typical private soldier, "precious few were dedicated to a specific enlisted man": Foster, *Ghosts*, 143. If a monument portrayed an identifiable individual, this was almost always an officer.

43. E.g., in Martha S. Gielow, "Woman's Monument—Plan Suggested," *Confederate Veteran* 14, no. 4 (April 1906), quoted in Mills, "Gratitude and Gender Wars," note 6.

44. Emory Upton, *New System of Infantry Tactics, Double and Single Rank, Adapted to American Topography and Improved Fire-Arms* (New York: D. Appleton, 1867), 34. This manual described commands used by both sides during the Civil War. Parade rest was also used during ceremonial parades and reviews, when soldiers were similarly expected to pay motionless attention to higher-ranking officers: Upton, *New System of Infantry Tactics*, 14, 347.

45. Upton, *New System of Infantry Tactics*, 34.

46. The number of people living in what the U.S. Census defined as urban environments more than doubled from the end of the war to the beginning of the twentieth century: Foster, *Ghosts*, 79–80.

47. William H. Stewart, "The Private Infantryman: The Typical Hero of the South," *Southern Historical Society Papers* 20 (1892): 312, quoted in Foster, *Ghosts*, 122.

48. Foster, *Ghosts*, 114.

49. Clement A. Evans to J.L.M. Curry, July 25, 1896, Jabez L.M. Curry Papers, Library of Congress, quoted in Foster, *Ghosts*, 117.

50. The Daughters relentlessly criticized the use of textbooks they deemed critical to the South. For example, they passed a resolution at their 1911 annual meeting condemning a college textbook that argued that slavery had been a major cause of the Civil War (which it—even worse—called a "slaveholders' rebellion"). Although the Daughters campaigned against Southern colleges whose students were assigned such texts, they had little success in overturning professors' choices: Foster, *Ghosts*, 188–89. The Daughters had better luck in the more important field of primary education, using their influence over local school board members to steer their choice of textbooks. Among other priorities, they sought to persuade textbook publishers to replace "Civil War," which they thought implied an attempt to overthrow the government, with their preferred designation, "The War Between the States": E. Merton Coulter, "A Name for the American War of 1861–1865,"

The Georgia Historical Quarterly 36, no. 2 (1952): 128–129. They also protested any books that named slavery as a cause of the war or described enslaved people as ill-treated. The Daughters sometimes produced their own textbooks, like the *School History of the United States*, written by the daughter of Robert E. Lee's artillery chief, which claimed that it provided "an *Unprejudiced* and *Truthful* history": Susan P. Lee, *New School History of the United States* (Richmond: B. F. Johnson, 1900). In 1920, another Daughter wrote a textbook titled *Truths of History*, among which was the assertion that the South's racial strife was caused by "incendiary literature" from the North, and that "all that the South asks is to be let alone in her management of the Negro, so that friendly relations may occur": Mildred Lewis Rutherford, *Truths of History: A Fair, Unbiased, Impartial, Unprejudiced and Conscientious Study of History* (Athens, GA: n.p., 1920), 91, quoted in Domby, *False Cause*, 52. The Daughters asked libraries to stamp "Unjust to the South" in books that did not meet their requirements: Domby, *False Cause*, 52. As the historian Fred Arthur Bailey explained, the Daughters' ideal primary school textbook would inculcate in students "a veneration for the Confederate Cause, and intense resistance to black civil rights, and a deferential spirit toward their proper leaders": "The Textbooks of the 'Lost Cause': Censorship and the Creation of Southern State Histories," *Georgia Historical Quarterly* 75, no. 3 (1991).

51. Adjutant General, United Sons of Confederate Veterans, circular letter, n.d., United Sons of Confederate Veterans Papers, Louisiana Historical Association Collection, Tulane University, quoted in Foster, *Ghosts*, 119. Despite the objections of the United Confederate Veterans and the United Daughters of the Confederacy, some white Southerners continued to use "rebel" as a term of pride. When a speaker mentioned "rebels" during the 1909 United Confederate Veterans annual reunion, "pandemonium broke loose," with some veterans hissing and others cheering the term, "and above all reverberated the ear-splitting rebel yell": "Although He Declined Veterans Again Declare Gen'l Evans Their Chief," *Atlanta Constitution*, June 10, 1909, quoted in Foster, *Ghosts*, 247 n. 10. But after the socially elite leaders of Confederate organizations moved away from thinking of the war as a rebellion, taking pride in the South's rebellious heritage became a marker of lower-class status.

52. Speech, Tarboro, October 29, 1904, Carr Papers, Southern Historical Collection, University of North Carolina, Chapel Hill, quoted in Foster, *Ghosts*, 122–123.

53. For example, Leon Jastremski, one of the organization's founders, was a printer who became the head of the Louisiana Press Association. He served several terms as the mayor of Baton Rouge, thanks to his "effort to resist Radical and negro rule throughout the long period of Reconstruction," as a Louisiana paper put it in 1903 during his campaign for governor: "Biography of Gen. Leon Jastremski," *Lafayette Gazette* (Lafayette, LA), November 14, 1903. Another of the United Confederate Veterans' early organizers established factories in Chattanooga to manufacture pipes and furniture. Another headed a firm that hired out longshoremen.

54. Frederic Meyers, "The Knights of Labor in the South," *Southern Economic Journal* 6, no. 4 (1940).

55. "The 'Pauper Labor' of the South," *The Tobacco Plant* (Durham, NC), February 2, 1887.

56. The leaders of the United Confederate Veterans used history to support "an aristocratic social order resting on deference to leaders and duty to society": Foster, *Ghosts*, 60. Foster comments that it is "somewhat surprising" how little the anti-Black views held by many white Southerners in the postwar decades explicitly surfaced in the material they produced about the Confederacy, but this does not seem surprising if it is understood that the stories were directed at shaping the behavior of other white Southerners, not Black ones.

57. N.T.N. Robinson to Henry Garnett, April 7, 1892, N.T.N. Robinson Papers, Tulane, quoted in Foster, *Ghosts*, 133.

58. L. H. Harris, "The Confederate Veteran," *Independent* 53 (October 1901), quoted in Foster, *Ghosts*, 139.

59. Albert S. Morton, "Two Great Reunions," *Confederate Veteran* 4 (October 1896), quoted in Foster, *Ghosts*, 139.

60. Foster, *Ghosts*, 6.

61. Foster, *Ghosts*, 136, n. 19.

62. Historian Adam H. Domby has shown that the "Lost Cause" was not selective history—it was false history. The elite politicians who spread its messages did so to weld together white voters, convincing them to ignore their own self-interest in favor of "re-creating" an ideal state of white unity that had actually never existed: Domby, *False Cause*, 20–61. Domby further argues that believers in the "Lost Cause" reformatted history once again after overt white supremacy became socially unacceptable during the civil rights era. Then, the proudly racist motivations of those who put up Confederate monuments were hidden. Indeed, there was much work done to try to portray even the Confederates themselves as free of racism—a project that continues today.

63. On these monuments, see Sarah Beetham, *Sculpting the Citizen Soldier: Reproduction and National Memory, 1865–1917* (PhD Dissertation, University of Delaware, 2014), and Thomas J. Brown, *The Public Art of Civil War Commemoration: A Brief History with Documents* (Boston: Bedford, 2004).

64. Meanwhile, the Monumental Bronze Company of Bridgeport, Connecticut, produced at least eighty-six copies of a statue of an infantryman at parade rest, two of which went up in former Confederate cities. The sole change was in the figure's belt buckle, where "US" was changed to "NC" for North Carolina or "CS" for Confederate States: Beetham, *Sculpting the Citizen Soldier*, 135–136.

65. The composition is similar to that used on medallions and other paraphernalia related to the Grand Army of the Republic, the fraternal organization for Union veterans, except that a Black man has been substituted for the white woman and child who kneel in thanksgiving beneath the reuniting soldiers on the Grand Army design.

66. Kirk Savage, *Standing Soldiers, Kneeling Slaves: Race, War, and Monument in Nineteenth-*

Century America (Princeton: Princeton University Press, 2018).

67. Kevin O'Connor, "Memorial Vandalism Casts Attention on Vermont Minority Veterans," *VT Digger*, May 24, 2020, https://vtdigger.org/2020/05/24/memorial -vandalism-casts-attention-on-vermont-minority-veterans/; Brattleboro Historical Society, "Historic Discrepancies at Soldiers' Monument Should Be Remedied," *Brattleboro Reformer*, December 27, 2019, https://www.reformer.com/community -news/historic-discrepancies-at-soldiers-monument-should-be-remedied/ article_9d3b01ea-1b94-58d4-a74f-8fe65ba2f0bf.html.

68. On the Black experience of service during the Civil War, see, e.g., Ira Berlin, Leslie S. Rowland, and Joseph P. Reidy, eds., *Freedom: A Documentary History of Emancipation, 1861–1867: Series II, The Black Military Experience* (Cambridge: Cambridge University Press, 1982); Joseph T. Glatthaar, *Forged in Battle: The Civil War Alliance of Black Soldiers and White Officers* (Baton Rouge: Louisiana State University Press, 1990); James McPherson, *The Negro's Civil War: How American Blacks Felt and Acted During the War for the Union* (New York: Vintage Books, 1993); William Seraile, *New York's Black Regiments During the Civil War* (New York: Routledge, 2001); Keith P. Wilson, *Campfires of Freedom: The Camp Life of Black Soldiers During the Civil War* (Kent, OH: Kent University Press, 2002); Chandra Manning, *Troubled Refuge: Struggling for Freedom in the Civil War* (New York: Vintage Books, 2017); Brian Taylor, *Fighting for Citizenship: Black Northerners and the Debate over Military Service in the Civil War* (Chapel Hill: University of North Carolina Press, 2020); Deborah Willis, *The Black Civil War Soldier: A Visual History of Conflict and Citizenship* (New York: NYU Press, 2021); Holly Pinheiro Jr., *The Families' Civil War* (Athens: University of Georgia Press, 2022). On the Vermont troops, see James Fuller, *Men of Color, to Arms!: Vermont African-Americans in the Civil War* (iUniverse, 2001).

69. Jacob Metzer, "The Records of the U.S. Colored Troops as a Historical Source: An Exploratory Examination," *Historical Methods* 14, no. 3 (1981).

70. For Forrest's history and legacy, see Connor Towne O'Neill, *Down Along with That Devil's Bones: A Reckoning with Monuments, Memory, and the Legacy of White Supremacy* (Chapel Hill, NC: Algonquin, 2020).

71. Achilles V. Clark to "my dear sisters," April 14, 1864, quoted in John Cimprich and Robert C. Mainfort Jr., "Fort Pillow Revisited: New Evidence about an Old Controversy," *Civil War History* 28, no. 4 (1982): 297–299.

72. Testimony of Sgt. Henry F. Weaver, *Congressional Globe*, 38th Congress, 1st Session, June 24, 1864, quoted in Trichita M. Chestnut, "'Remember Fort Pillow': The 150th Anniversary of the Fort Pillow Massacre," April 8, 2014, Rediscovering Black History Blog (National Archives), https://rediscovering-black-history.blogs .archives.gov/2014/04/08/fort-pillow-150th-anniversary/.

73. Tonyaa Weathersbee, "Anonymous No More: Honoring African-American Fort Pillow Victims," *Memphis Commercial Appeal*, April 12, 2017.

74. Tonyaa Weathersbee, "In Time for Juneteenth, Fort Pillow Victims Get Their Story

Memorialized on a Marker," *Memphis Commercial Appeal*, June 19, 2018.

75. My thanks to Robby Tidwell, the park manager of the Fort Pillow State Historic Park, for answering my questions about the current state of its historic displays.

76. On the Freedmen's Memorial, see Savage, *Monument Wars*; Savage, *Standing Soldiers*; Renée Ater, "On the Removal of Statues: Freedmen's Memorial to Abraham Lincoln," July 1, 2020, https://www.reneeater.com/on-monuments-blog/2020/7/1/on-the-removal-of-statues-freedmens-memorial-to-abraham-lincoln; and Raul Fernandez, "A Monument to White Supremacy Stands Uncontested in Our Own Backyard," Medium, October 10, 2017, https://medium.com/@raulspeaks/a-monument-to-white-supremacy-stands-uncontested-in-our-own-back-yard-672f26db429c.

77. Congresswoman Eleanor Holmes Norton, "Norton to Introduce Legislation Removing Emancipation Statue from Lincoln Park," June 23, 2020, https://norton.house.gov/media-center/press-releases/norton-to-introduce-legislation-removing-emancipation-statue-from. Although Norton's proposal has so far had no effect, a copy of this monument in Boston was recently put into storage after extensive discussion between the city's art commission and members of the public: William J. Kole, "Statue of Slave Kneeling before Lincoln Is Removed in Boston," Associated Press, December 29, 2020.

78. Ater, "On the Removal of Statues."

79. Natalie O'Neill, "Barrier Installed to Protect DC Emancipation Memorial from Protesters," *New York Post*, June 26, 2020.

80. Ted Mann, "Lincoln Statue with Kneeling Black Man Becomes Target of Protests," *Wall Street Journal*, June 25, 2020; "Executive Order 13933 of June 26, 2020, Protecting American Monuments, Memorials, and Statues and Combating Recent Criminal Violence," Code of Federal Regulations, title 85 (2020): 40081–40084.

81. Phillip Lapsansky, "Graphic Discord: Abolitionist and Antiabolitionist Images," in *The Abolitionist Sisterhood*, eds. Jean Fagan Yellin and John C. Van Horne (Ithaca: Cornell University Press, 2018). The relationship between slavery and crouching was so ingrained that the sculptors John Rogers, Henry Kirke Brown, and Randolph Rogers, who also proposed monuments to Lincoln soon after his death, also represented the Black figure in their monuments in this way: Savage, *Standing Soldiers*.

82. Thomas Ball, *My Three Score Years and Ten: An Autobiography* (Boston: Roberts, 1892), 252–253.

83. Ball, *My Three Score Years and Ten*, 253.

84. Kirk Savage, "The Black Man at Lincoln's Feet: Archer Alexander and the Problem of Emancipation," Princeton University Press Blog, July 13, 2020, https://press.princeton.edu/ideas/the-black-man-at-lincolns-feet-archer-alexander-and-the-problem-of-emancipation.

85. Archer Alexander to the Provost Marshal General, Department of the Missouri (letter written on Alexander's behalf by W. G. Eliot), St. Louis, April 15, 1863,

National Archives and Records Administration, War Department Collection of Confederate Records, Record Group 109.14.4, Miscellaneous Records, 04-15-1863 (microfilm reel F1218), quoted in Miranda Rechtenwald, "The Life of Archer Alexander: A Story of Freedom," *The Confluence* (Fall/Winter 2014).

86. Indeed, enslaved people had worked to free themselves long before the Emancipation Proclamation. Historian Steven Hahn describes the actions of enslaved people during the Civil War as the "largest slave rebellion in modern history," which included myriad acts of resistance, from escaping to join the Union Army to organizing work slowdowns on plantations to sabotage the Confederate war effort from within: Steven Hahn, *A Nation Under Our Feet: Black Political Struggles in the Rural South from Slavery to the Great Migration* (Cambridge: Harvard University Press, 2003). Martin Robison Delany, a journalist who had helped recruit Black soldiers for the Union Army, told an audience of freedpeople in July 1865 that they had won their own freedom: "We would not have become free, had we not armed ourselves and fought out our independence": Philip S. Foner and Robert Branham, eds., *Lift Every Voice: African American Oratory, 1787–1901* (Tuscaloosa: University of Alabama Press, 1997).

87. Freeman Henry Morris Murray, *Emancipation and the Freed in American Sculpture: A Study in Interpretation* (Washington, DC: Murray Brothers, Inc., 1916), 198–199.

88. Frederick Douglass, "A Suggestion: To the Editor of the National Republican," *National Republican*, April 19, 1876. On this letter, see Jonathan W. White and Scott Sandage, "What Frederick Douglass Had to Say About Monuments," *Smithsonian*, June 30, 2020. For more on Douglass's insistence on commemorating the role of Black Americans in the Civil War, see, e.g., David W. Blight, "'For Something Beyond the Battlefield': Frederick Douglass and the Struggle for the Memory of the Civil War," *Journal of American History* 75 no. 4 (1989): 1167.

89. Lisa Farrington, *African-American Art: A Visual and Cultural History* (New York: Oxford University Press, 2016), 58–62.

90. Murray, *Emancipation and the Freed*, xix.

91. Murray, *Emancipation and the Freed*, 28.

92. Alternately, Murray notes that if the figure were modified to make his exertions to free himself "obvious, or, we may say, a little more obvious, visually, the acceptability of the group would be greatly enhanced": Murray, *Emancipation and the Freed*, 31.

93. Murray, *Emancipation and the Freed*, 44.

94. The Freedmen's Memorial was rotated in 1974 to face a new monument honoring Mary McLeod Bethune, a Black educator who gives the lie to the Freedmen's Memorial's claim that Black people cannot rise. Bethune's monument was Washington's first to an individual woman and to a Black person. In the sculptures, both Lincoln and Bethune stretch a paper out toward those they wish to help. But the two schoolchildren on the Bethune monument reach back to her, making themselves a part of their education: Kirk Savage, *Monument Wars*, 263–265.

95. The African American Civil War Memorial, a bronze statue titled *The Spirit of Free-*

dom by the sculptor Ed Hamilton, stands at the intersection of Vermont Avenue, 10th Street, and U Street NW: Renée Ater, "Commemorating Black Soldiers: The African American Civil War Memorial in Washington, D.C.," in *Tell It with Pride: The 54th Massachusetts Regiment and Augustus Saint-Gaudens' Shaw Memorial*, eds. Sarah Greenough and Nancy Anderson (Washington, DC: National Gallery of Art, 2013).

Chapter 4: A Shrine for the South

1. I have reconstructed the details of this scene from contemporary newspaper reports and photographs, especially the extensive reports in the February 26, 1925, edition of the *Atlanta Constitution*. I have taken the liberty of imagining that Borglum first attacked the head and then the larger group, but his order of operations is unknown. Borglum was accompanied by his site superintendent, who went on the run with him after the destruction, but Borglum always claimed that he bore full responsibility for destroying the models. It is true that he did so most emphatically while arguing that his superintendent should not be prosecuted for the destruction, but since Borglum was forever boasting of his strength, I believe he would not have delegated either the labor or the satisfaction of wielding the ax. My account differs substantially from that given by several major books on Borglum, which claim that both the Lee head and the master model were thrown over the cliff of Stone Mountain: David B. Freeman, *Carved in Stone: The History of Stone Mountain* (Macon, GA: Mercer University Press, 1997), 86; Howard Shaff and Audrey Karl Shaff, *Six Wars at a Time: The Life and Times of Gutzon Borglum, Sculptor of Mount Rushmore* (Sioux Falls, SD: The Center for Western Studies, 1985), 214. Neither of these cites a source for this story, which seems unlikely. Contemporary news reports did not mention this as the models' fate, and their photographs of the workshop after the destruction of the models show large parts of them still in place, with their broken parts on the floor below them. Although I am grateful for the research of Freeman and the Shaffs, it is because of mythmaking like this that I have cross-checked the information they provide. Where I found discrepancies, I followed newspapers and other contemporary reports. I have also arrived at very different interpretations of events, personalities, and motivations than these authors. A caveat: Borglum changed his story whenever convenient to him, and people associated with him often had their own reasons for accepting and propagating his alternate versions of reality. I have done my best to present the version of events I think most likely after extensive research, but Borglum has probably managed to fool me, too, at least in some of the details.

2. "Borglum and Tucker Are Sought on Warrants Following Destruction of Memorial Models," *Atlanta Constitution*, February 26, 1925.

3. Felix Frankfurter, *Felix Frankfurter Reminisces* (New York: Reynal, 1960), 55.

4. Borglum seemed to care about his debts only when people refused to loan him more. For example, Samuel Colt, founder of the United States Rubber Com-

pany, commissioned a sculpture from Borglum and lent him $10,000, but when he refused to give Borglum more, he received the vicious attacks the sculptor unleashed on many who dared cut him off. Borglum declared that his former friend "epitomized the Jewish character" because "greed was a part of his inborn nature": Shaff and Shaff, *Six Wars at a Time*, 106.

5. Shaff and Shaff, *Six Wars at a Time*, 55.

6. Borglum did not himself seek office, although he claimed he would "make a better president than 99% of the . . . incompetents who serve." But he considered that his artistic work was "much needed to make at least a record of what was intended to be a republic." Besides, he believed that if he were elected, he would "get rid of 95% of the professors and Drs." and destroy "80% of the laws" and in general "would effect such changes that would result in my getting shot": Shaff and Shaff, *Six Wars at a Time*, 176.

7. Ward's plaster model was eventually used to create a bronze Sheridan memorial that now stands in the Empire State Plaza, Albany, New York.

8. When Rienzi died, he had been taxidermized and put on display at the Military Museum on Governors Island, New York. (He is now displayed, more than a little worse for wear, at the National Museum of American History.) By 1907, it was high time that the general, who died in 1888, received more public honor than his horse.

9. It was displayed in the Rotunda until 1979, when it was moved, along with much of the room's other sculpture, into a new display space elsewhere in the Capitol Building. A bronze copy of the bust is also installed in the White House.

10. This monument, *Wars of America*, which features forty-two life-size figures and two horses, was dedicated before an audience of nearly fifteen thousand people in 1926. Borglum's usually dependable showmanship went awry at this event. He had covered the monument with a canvas tethered to balloons. They were supposed to lift the cover, but a steady rain had made the canvas too heavy to raise.

11. After a long separation, Borglum finally succeeded in divorcing his first wife. He remarried in 1909.

12. W. E. Beard, "The Confederate Government, 1861–1865," *Tennessee Historical Magazine* 1, no. 2 (1915).

13. Mark Hughes Cobb, "Digging up the Truth about the Jemison House," *Tuscaloosa News*, July 12, 2009.

14. Joseph T. Derry, *Confederate Military History: Georgia* (Atlanta: Confederate Publishing Company, 1899), 922. Many recent writers claim he was a doctor or a medic, although without any justification I could find.

15. Derry, *Confederate Military History: Georgia*, 923.

16. Helen Plane, letter to the Philadelphia *Public Ledger*, January 14, 1916, quoted in Freeman, *Carved in Stone*, 57.

17. Freeman, *Carved in Stone*, 47–48.

18. It is uncertain how Plane came to know about Borglum, but his hunger for public-

ity meant she could easily have read about his work in the newspapers. Additionally, the Daughters' Selma chapter had hired him in 1911 (the year he unveiled his Newark Lincoln memorial) to make a Confederate monument for the North Carolina State Capitol. Plane could well have remembered the praise the Selma chapter heaped on Borglum during their reports to the Daughters' national conventions: e.g., *Minutes of Fifteenth Annual Convention of the United Daughters of the Confederacy, North Carolina Division, October 25–27, 1911* (Newton, NC: Enterprise Print, 1911), 72.

19. Letter from Gutzon Borglum to Helen Plane, 1915, preserved in Helen Plane's scrapbook and quoted in "Family of Mrs. Helen Plane Issues Formal Statement on U.D.C. Memorial Work," *Atlanta Constitution*, March 22, 1925.

20. Letter from Gutzon Borglum to Helen Plane, 1915.

21. Minutes of the Georgia Division, United Daughters of the Confederacy, November 16–20, 1915, quoted in Freeman, *Carved in Stone*, 60–61.

22. James Ridgeway, *Blood in the Face: The Ku Klux Klan, Aryan Nations, Nazi Skinheads and the Rise of the New White Culture* (New York: Thunder's Mouth Press, 1996), 52.

23. Monroe N. Work et al., "Some Negro Members of Reconstruction Conventions and Legislatures and of Congress," *Journal of Negro History* 5, no. 1 (1921).

24. Helen Plane to Gutzon Borglum, December 17, 1915, quoted in Freeman, *Carved in Stone*, 61–62.

25. Helen Plane to Gutzon Borglum, December 17, 1915.

26. Freeman, *Carved in Stone*, 52. Membership was open to white Protestants, as long as they had been born in America and were over eighteen years old: Charles C. Alexander, "Kleagles and Cash: The Ku Klux Klan as a Business Organization, 1915–1930," *Business History Review* 39, no. 3 (1965): 350.

27. Alexander, "Kleagles and Cash," 350.

28. Venable was originally appointed secretary of the organization: James Venable, interview by James Mackay, May 28, 1982, DeKalb History Center, Decatur, Georgia. In 1923, Venable was apparently the Klan's treasurer: Alexander, "Kleagles and Cash," 362.

29. Some of Borglum's biographers believe his denials that he joined the Klan. Others admit he was a member but argue it was merely expedient, done to keep friendly relations with the many Klan members involved in funding the project. I believe it was his denials, rather than his membership, that were expedient. His most public and vigorous denials came in 1923, when he was named as a defendant in a lawsuit against the Klan's Grand Wizard and other high-ranking officials. The plaintiffs claimed Borglum was a member of the Kloncilium, the Klan's equivalent of an executive board. Borglum issued a statement denying he was a member of the Kloncilium or of the Klan at all, adding the caveat, "I say this as a matter of fact without any prejudice to the klan (sic) whatsoever": "Gutzon Borglum Denies that He Is Klan Member," Associated Press, May 31, 1923. Borglum would have good reason to deny his Klan affiliation if doing so meant he could escape a lawsuit. But

the plaintiffs who named him would have known, since they were Klan leaders themselves. They accused Borglum and the other defendants of using Klan funds to enrich themselves: "Wizard Denies Action Serious," Associated Press, June 1, 1923. Later, a journalist credibly claimed to have seen the minutes of a 1923 Imperial Kloncilium meeting that listed Borglum as a member of the council: "The Stone Mountain Memorial Controversy," *Tablet* (Brooklyn, NY) March 28, 1925.

Borglum's denials of Klan membership were widely mocked. In 1921, when Borglum was quoted in the papers claiming he hadn't joined the Klan because he did not have enough free time to participate in their ceremonies, the *Brooklyn Eagle* ran a satirical poem about how eagerly the Klan awaited his artistic services:

> The Emperor will flourish more
> When Borglum joins the Klan.
> More picturesque the costumes,
> And much less gloomy, too;
> With less of groans and skulls and bones
> The ritual will do –
> Yes, Gutzon's greatly needed
> To camouflage the plan . . .

—J. A., "Speed, Speed the Day," *Brooklyn Daily Eagle*, September 16, 1921. Another writer joked that Borglum's introduction of the Klan's Grand Wizard to President Harding made the sculptor, whose first name was Gutzon, "one of few with Gutzonough to admit to being a Klansman": Joe Sims, "Sims' Colm," *Enterprise* (McCracken, KS), December 22, 1922.

Borglum was well practiced at lying about himself to journalists. He called his mother by various first names, claims that he lost her through an illness, and never admitted his Mormon origins. Given enduring prejudices about polygamy, Borglum probably wished to avoid the bad publicity that would have greeted the truth about his family. Similar bad publicity would have attended any admission that he was in the Klan. And it is clear that Borglum lied about the Klan's involvement in Stone Mountain to reporters. For example, when the *New York World* telegrammed him in 1923 to ask if the Klan had taken over fundraising for the monument, Borglum replied, "They have raised no money nor contributed any money for the plans [or] the execution of the work": "Artist Borglum Indignant," *Brooklyn Daily Eagle*, April 25, 1923. But, among many other documented involvements, Borglum himself had suggested that the Association hire Edward Y. Clarke to raise funds, knowing that he was the mastermind of the Klan's recruitment efforts.

30. Mary Phagan, a thirteen-year-old employee of Atlanta's National Pencil Factory, was raped and murdered on Confederate Memorial Day in 1913. Leo M. Frank, Phagan's supervisor, was arrested after bloodstains were found in a workroom across from his office. A Jewish man who had moved to Atlanta from Brooklyn, Frank was the type of threat leaders of the United Confederate Veterans had been warning their employees about: an outsider whose better understanding of industrial manu-

facturing allowed him to steal a job from a white Southerner. Frank was sentenced to death. After civil liberty groups complained about the trial's tainted evidence and biased witnesses, the governor commuted the sentence to life imprisonment, saying, "I would be a murderer if I allowed that man to hang." He was right—decades later, a witness came forward and provided enough information for Frank to be issued a posthumous pardon. But the governor's decision enraged many Georgians. To protect himself and Frank, the governor declared a state of martial law and summoned the National Guard. (When the governor's term ended a few days later, the National Guard escorted him to the railway station; he would not return to Georgia for a decade.) But Frank still hanged. A group of men calling themselves the "Knights of Mary Phagan" abducted him from a prison farm on August 16, 1915. They drove him to Phagan's hometown, 175 miles away, and lynched him. Pieces of the rope were hawked as souvenirs on the streets of Atlanta: Leonard Dinnerstein, *The Leo Frank Case* (Birmingham, AL: Notable Trials Library, 1991).

31. Gutzon Borglum, "The Jewish Question," quoted in Shaff and Shaff, *Six Wars at a Time*, 104.

32. Shaff and Shaff, *Six Wars at a Time*, 329.

33. "Calls on Harding," *Journal News* (Hamilton, Ohio), December 22, 1922.

34. Shaff and Shaff, *Six Wars at a Time*, 202. The Klan candidate was David Curtis Stephenson. In one example of the close relationship between Stephenson and Borglum, Stephenson sent a telegram to an Indiana senator in 1923, demanding he ask President Coolidge for a pardon for a friend of the Klan. Stephenson instructed the senator to wire him about the results of this meeting at Borgland, where he was a guest: "Telegram Sought Aid for Rumely," *Daily Republican* (Rushville, IN), August 2, 1927. In the end, the closest the Klan came to a candidate was William McAdoo, who lost his bid for nomination as the Democratic candidate in the 1924 election when he was labeled "Ku Ku McAdoo."

35. The Reverend Francis R. Goulding saw this structure during an 1822 visit: "The only place of entrance was by a natural doorway under a large rock, so narrow and so low that only one man could enter at a time, by crawling on his hands and knees": *Sal-O-Quah; or Boy-Life Among the Cherokees* (New York: Dodd, Mead and Co., 1870), 123.

36. As Borglum's wife recalled: Robert Casey and Mary Borglum, *Give the Man Room: The Story of Gutzon Borglum* (New York: Bobbs-Merrill Company, 1952), 177.

37. Alexander, "Kleagles and Cash," 351.

38. Alexander, "Kleagles and Cash," 350.

39. Kenneth T. Jackson, *The Ku Klux Klan in the City: 1915–1930* (Chicago: Ivan R. Dee, 1992), 9–10.

40. Alexander, "Kleagles and Cash," 364. Alexander derives this estimate from a careful study of the reports of various Klan leaders on new initiations in their regions and from analysis of various financial reports provided by the central Klan organization.

41. Address by Gov. E. Lee Trinkle, June 18, 1923, Mary Carter Winter Collection, Georgia State Department of Archives, quoted in Freeman, *Carved in Stone*, 70.

42. "Dixie Leaders Gather Here for Lee Exercises," *Atlanta Constitution*, January 19, 1924.

43. "The Stone Mountain, Ga., Memorial," *Blue Rapids Times* (Blue Rapids, KS), February 12, 1925. Lorenzo Dow Grace, the uniformed man, gave his birthdate as October 29, 1813. When he died in 1928, he was hailed as the oldest Confederate veteran, supposedly 115 years old. His obituary in the *Atlanta Constitution* noted that in his later years "he was not certain of his own age, often having claimed to be 118 years old": "Lorenzo Grace, Oldest Veteran of Gray, Is Dead," *Atlanta Constitution*, July 25, 1928. He spent his last forty years living on a state pension, and his last years in the Soldier's Home of Georgia, whose secretary described him as "lively as a cricket," running errands for the other inhabitants and never using a cane. Dow attributed his longevity to eating an apple a day: "The Oldest Confederate," *Confederate Veteran* 34 (1926): 325. It's far more likely that he stretched his years to such impressive lengths not by eating apples at its end but by faking paperwork about his beginnings. A number of people committed fraud to claim Confederate pensions, leading to some embarrassment as the twentieth century marched on and they kept attaining more and more improbable life spans: Domby, *False Cause*, 101–134.

44. It is impossible to identify everyone who lent Borglum money. It seems that he borrowed money from Venable and Clarke on the pretext that he needed it to continue work on the memorial, since he would claim to an Atlanta newspaper, "I paid for scaffolding, dynamos, machinery, paid the cost of working out engineering difficulties. Samuel Venable, owner of the mountain, and E.Y. Clarke helped": " 'Right of Artist to Work He Created Inalienable,' Declares Gutzon Borglum," *Atlanta Constitution*, March 2, 1925.

45. Shaff and Shaff, *Six Wars at a Time*, 206.

46. Shaff and Shaff, *Six Wars at a Time*, 222.

47. Shaff and Shaff, *Six Wars at a Time*, 206.

48. "Battle to Return Borglum to State Will Begin Today," *Atlanta Constitution*, March 7, 1925.

49. Robert Coughlan, "Konklave in Kokomo," in *The Aspirin Age: 1919–1941*, ed. Isabel Leighton (New York: Simon & Schuster, 1949), 114.

50. M. William Lutholtz, *Grand Dragon: D.C. Stephenson and the Ku Klux Klan in Indiana* (West Lafayette, IN: Purdue University Press, 1991), 137.

51. Wyn C. Wade, *The Fiery Cross: The Ku Klux Klan in America* (New York: Oxford University Press, 1998), 215–216.

52. An Act to Authorize the Coinage of 50-cent Pieces in Commemoration of the Commencement on June 18, 1923, of the Work of Carving on Stone Mountain, 68th Congress, 1st Session, *Congressional Record* (March 17, 1924): S 684.

53. The Philadelphia Mint struck a total of 2,310,000 of the coins: Anthony Swiatek

and Breen Walter, *The Encyclopedia of United States Silver & Gold Commemorative Coins, 1892 to 1954* (New York: Arco Publishing, 1981), 228.

54. "Memorial Leaders Cancel Contract Held by Borglum," *Atlanta Constitution*, February 26, 1925.

55. "Association Gives Version of Dispute on Dixie Memorial," *Atlanta Constitution*, March 15, 1925.

56. *Atlanta Constitution*, "Association Gives Version of Dispute."

57. "Memorial Leaders Cancel Contract Held by Borglum," *Atlanta Constitution*, February 26, 1925.

58. *Atlanta Constitution*, "Memorial Leaders Cancel Contract."

59. *Atlanta Constitution*, "Memorial Leaders Cancel Contract."

60. "Borglum and Tucker Destroyed Memorial Models, Is Charged," Associated Press, February 26, 1925. Borglum, meanwhile, wrote to a friend to explain why he had not returned to Georgia to fight the charges, claiming he had been told that there was an assassination plan afoot, with "as many as 15 men were lying in wait around my place to destroy me." Of course, it was not that Borglum feared being killed, but "if I had gone to Atlanta and met with any kind of violence I should certainly have killed somebody . . . and I don't want to hurt anybody or destroy anybody": Shaff and Shaff, *Six Wars at a Time*, 219.

61. "Daughters of Confederacy Demand Voice in Control of Memorial Association," *Atlanta Constitution*, February 27, 1925.

62. "Gutzon Borglum Trial Is Set for Next Saturday," *Daily Times* (Wilson, NC), March 25, 1925. Borglum likely chose to go to ground in North Carolina because it was the closest state where he had important political connections, which he had first formed when, in 1911, he was commissioned by the Daughters to make a Confederate monument for the North Carolina State Capitol. In 1924, he had received another commission for the capitol grounds, for a statue of former governor Charles B. Aycock (notorious for his participation in violent suppression of Black political participation in the late nineteenth century).

63. Ralph T. Jones, "Memorial Depends on Borglum's Art, Declares McLean," *Atlanta Constitution*, March 9, 1925.

64. "Tar Heel Site Better than Stone Mountain," *North Wilkesboro Hustler* (North Wilkesboro, NC), July 29, 1925. Cameron died just a few months after he paid Borglum's bond, his mountainside remaining unadorned.

65. "Artist's Release Follows Action of Georgia Chief," *Atlanta Constitution*, March 8, 1925.

66. Georgia's governor had urged the association to give up its criminal charges. Sam Venable's nephew James Venable later claimed that Venable was "so powerfully and politically connected" thanks to his position in the Klan that he was responsible for brokering Borglum's freedom: James Venable, interview by James Mackay, May 28, 1982, DeKalb History Center, Decatur, Georgia.

67. During his rampage, Borglum did not touch the projector or any of the other equip-

ment in the workshop that would have been necessary for him to proceed with the project if rehired: "Borglum and Tucker are Sought on Warrants Following Destruction of Memorial Models," *Atlanta Constitution*, February 26, 1925.

68. "Gutzon Borglum Arrested in Greensboro, N.C., Freed on Habeas Corpus, Goes to New York," *Atlanta Constitution*, March 1, 1925.

69. "Battle to Return Borglum to State Will Begin Today," *Atlanta Constitution*, March 7, 1925.

70. *Atlanta Constitution*, "Association Gives Version of Dispute." Moreover, although the association had dropped the extradition request, the underlying charges still stood, meaning that Borglum would be arrested if he ever went back to Georgia: "Artist's Release Follows Action of Georgia Chief," *Atlanta Constitution*, March 8, 1925.

71. Before the association hired Lukeman, Venable accused Randolph of firing Borglum so that the association could collect funds from the sales of the coins without having to spend anything on the memorial during the delay required to find another sculptor. Venable's theory was that Randolph and his associates on the association board would start a bank, using the association's funds to guarantee its deposits when it opened, thus ensuring its success: "Hill Will Direct Campaign for Sale of Memorial Coins," *Atlanta Constitution*, March 20, 1925. Although this is an intriguing theory, which would have allowed Randolph to profit from the coin issue without directly stealing funds, it seems unlikely. Randolph was indeed one of several partners who had started a bank, the Atlanta Joint Stock Company, in 1922. But it seems that this bank was still in operation in 1925, and I could not find evidence of Randolph being involved in the subsequent founding of another bank.

72. Public statement by Sam Venable, January 26, 1929, Records of the Stone Mountain Confederate Monumental Association, quoted in Freeman, *Carved in Stone*, 119.

73. A similar argument is often made about historical individuals, whom, it is claimed, should be judged based on the standards of their time. This argument is often made to claim that a slave owner was merely following the morality of his or her society. I have little patience for this argument, because it ignores the fact that not everyone in the past saw slavery as morally acceptable. Certainly, enslaved people did not judge slavery to be an unquestioned good.

74. Swiatek and Breen, *Commemorative Coins*, 291.

75. For Oberholtzer's story, see Lutholtz, *Grand Dragon*; Richard K. Tucker, *The Dragon and the Cross: The Rise and Fall of the Ku Klux Klan in Middle America* (Hamden, CT: Shoe String Press, 1991); Karen Abbott, "'Murder Wasn't Very Pretty': The Rise and Fall of D.C. Stephenson," *Smithsonian*, August 30, 2012.

76. James Venable, interview by James Mackay, May 28, 1982, DeKalb History Center, Decatur, Georgia.

77. James Venable, interview by James Mackay.

78. In 1982, Venable claimed he held "no ill will against any race, color, or creed,"

pointing to his work defending "Communists, black people, people of all nationalities": James Venable, interview by James Mackay. Still, he explained that when he was paid for defending Black Muslims in a case in Louisiana, he had "taken that $25,000 and promoted the Klan." The transcript, at the end of this sentence, notes that he chuckled. Venable also proudly described his defense of a man accused of bombing Atlanta's Hebrew Benevolent Congregation Temple in 1958. The temple's rabbi was a prominent advocate of civil rights and integration, especially school desegregation. The explosion took place early in the morning, but the man who called a reporter shortly afterward to report it, calling himself "General Gordon of the Confederate Underground," said that "this is the last empty building I'll blow up in Atlanta": Claude Sitton, "Atlanta Synagogue Damaged by Blast; F.B.I. Aids Inquiry," *New York Times*, October 13, 1958. Venable called it "one of the hardest cases" he had ever worked on "because the Jewish people spent many thousands of dollars." No one was ever convicted of the bombing—not even the man who had initially confessed to being involved: Melissa Fay Greene, *The Temple Bombing* (Cambridge, MA: Da Capo Press, 1996).

79. The rallies stopped only when a Black Stone Mountain city council member struck a deal with the Venables: Kevin Sack, "Birthplace of Klan Chooses a Black Mayor," *New York Times*, November 22, 1997.

80. Amanda Holpuch, "KKK Denied Permit to Burn Cross Atop Symbolic Mountain in Georgia," *Guardian*, August 16, 2017.

81. Grace Elizabeth Hale, "Granite Stopped Time: The Stone Mountain Memorial and the Representation of White Southern Identity," *Georgia Historical Quarterly* 82, no. 1 (1998): 40.

82. Jamey Essex, "'The Real South Starts Here': Whiteness, The Confederacy, and Commodification at Stone Mountain," *Southeastern Geographer* 42, no. 2 (2002).

83. Press release, March 2, 1958, Marvin Griffin Papers, Richard B. Russell Library for Political Research and Studies, University of Georgia, Athens, Georgia.

84. Hale, "Granite Stopped Time."

85. Debra McKinney, "Stone Mountain: A Monumental Dilemma," Southern Poverty Law Center Report, February 10, 2018.

86. Richard Fausset, "Stone Mountain: The Largest Confederate Monument Problem in the World," *New York Times*, October 18, 2018.

87. James Venable, interview by James Mackay.

88. "Artist's Release Follows Action of Georgia Chief," *Atlanta Constitution*, March 8, 1925.

89. Shaff and Shaff, *Six Wars at a Time*, 210.

90. Shaff and Shaff, *Six Wars at a Time*, 211.

91. Shaff and Shaff, *Six Wars at a Time*, 211. For the story of Mount Rushmore, with special attention to the way the monument dismissed Indigenous claims to their stolen territory in the Black Hills, see Jesse Larner, *Mount Rushmore: An Icon Reconsidered* (New York: Thunder's Mouth Press/Nation Books, 2002); John Taliaferro,

Great White Fathers: The Story of the Obsessive Quest to Create Mount Rushmore (New York: PublicAffairs, 2002); and Teresa Bergman, Exhibiting Patriotism: Creating and Contesting Interpretations of American Historic Sites (Walnut Creek, CA: Left Coast Press, 2013). These books also describe the history of Indigenous protests and occupations of the monument, which continue today: Mary Annette Pember, "Treaty Defenders Block Road Leading to Mount Rushmore," Indian Country Today, July 3, 2020; Annie Karni, "Trump Uses Mount Rushmore Speech to Deliver Divisive Culture War Message," New York Times, July 3, 2020.

92. Borglum followed a very similar playbook on his two mountains, attracting huge amounts of press attention by staging elaborate ceremonies with prestigious guests. Borglum planned to carve more than just the heads of the presidents (traces of Washington's roughed-out torso are still visible). But he knew that unveiling a new figure was better news than finishing an existing one. So, he moved across the mountain, starting new heads every time he needed more publicity. The more Borglum's glorious monument was in the news, the easier it was to find new people willing to loan him money.

93. "Coolidge to Write History in Stone by Great Statues," Associated Press, January 17, 1930.

Chapter 5: Bring Your Drums

1. Unless otherwise noted, all quotes are from my March 31, 2021, interview with Mike Forcia.

2. "Richmond Protesters Topple Columbus Statue, Throw It in Lake," Associated Press, June 10, 2020.

3. It was the second time this Columbus lost his head, which had gone missing for nearly a week in 2006 before it was recovered and reattached: Spencer Buell, "Someone Beheaded the Christopher Columbus Statue in Boston . . . Again," Boston Magazine, June 10, 2020.

4. Rubén Rosario, "Circling the Square to Square the Circle: Restorative Justice and the Toppled Columbus Statue," Twin Cities Pioneer Press, December 7, 2020.

5. Minnesota v. Michael Anthony Forcia, Summons, Statement of Probable Cause (Ramsey County District Court, File No. 62-CR-20-5111, August 13, 2020) ("Forcia Summons").

6. Allie Shah, "Widening the Circle," Star Tribune (Minneapolis), May 16, 2011.

7. For the history of Indigenous resistance in the United States, see Nick Estes, Our History Is the Future: Standing Rock Versus the Dakota Access Pipeline and the Long Tradition of Indigenous Resistance (New York: Verso, 2019).

8. Ideological differences and conflicts led AIM to split into several factions. Forcia characterizes the Twin Cities AIM group as a "autonomous chapter," independent and unaffiliated with the national AIM organization.

9. Delilah Friedler, "What Will Replace the Minneapolis Police? The City's Native

American Community Has Some Ideas," *Mother Jones*, June 13, 2020. Forcia was eventually given $125,000 by the Minneapolis Police Department after his case settled in 2002: Jon Lurie, "The Eyes and Ears: AIM Patrol Returns to the Streets of Phillips after a Twenty-Year Absence," *Twin Cities Daily Planet*, November 19, 2010.

10. Lurie, "The Eyes and Ears."

11. Cydney Adams, "New Documentary Asks If the Focus on Removing Statues and Mascots Is a Distraction from True Racial Justice," CBS News, September 24, 2020, https://www.cbsnews.com/news/confederate-statues-removed-racist-team -mascots-symbolic-justice/.

12. "The Columbus Celebration," *Minnesota History* 13, no. 1 (1932). It marked the first year Minnesota celebrated Columbus Day as a state holiday.

13. "The Columbus Celebration," 83. The Italian-born population of Minnesota peaked at 9,688 in 1910: Peter DeCarlo, "Christopher Columbus Memorial, St. Paul," MNopedia, Minnesota Historical Society, http://www.mnopedia.org/thing/ christopher-columbus-memorial-st-paul.

14. "Columbus Statue Unveiled at Capitol," *Minneapolis Star*, October 12, 1931.

15. "St. Paul Statue of Columbus is Friendship Link," *Minneapolis Star*, October 13, 1931.

16. "State's Columbus Statue Unveiled," *Star Tribune* (Minneapolis), October 13, 1931.

17. Peter DeCarlo and Mattie Harper, "Minnesota, We Need to Talk about Our Colum- bus Monument," *MinnPost*, October 8, 2018.

18. Bob Collins, "Lawmakers Seek History Update on Capitol's Columbus Statue," Minnesota Public Radio, March 11, 2015.

19. Edmund S. Morgan, "Columbus' Confusion About the New World," *Smithsonian* (October 2009).

20. Theresa Machemer, "Christopher Columbus Statues Beheaded, Pulled Down Across America," *Smithsonian*, June 12, 2020. Washington Irving's popular 1828 historical novel about the life of Columbus solidified America's new origin story, while the country's westward expansion kept Columbus in the public's attention. He was seen as evidence of God's plan for people of European descent to bring civilization, Christianity, and democracy to the whole of North America.

21. "Winners in Columbus Statue Contest," *Minneapolis Star*, January 8, 1930.

22. This monument, erected in 1933, was put into storage by order of Chicago's mayor in July 2020: Gregory Pratt, Sophie Sherry, Armando L. Sanchez, and Kori Rumore, "Seeking to 'Protect Public Safety,' Mayor Lori Lightfoot Removes Christopher Columbus Statues Overnight from Chicago Parks 'Until Further Notice,'" *Chicago Tribune*, July 24, 2020. Another of Brioschi's sculptures was a life-size bronze pig, which continues to serve as a trophy exchanged between the Iowa Hawkeyes and Minnesota Golden Gophers after their annual game: Tom Snee, "The Pig and the Politician," *fyi* (2010).

23. *Minneapolis Star*, "Winners."

24. Columbus was never as popular a figure in Europe, where most of the existing

monuments went up later in the twentieth century, paid for by Italian Americans.

25. This statue stands near Milan's Public Gardens, on the Via dei Boschetti.

26. On the history of whiteness in America, see, e.g., Matthew Frye Jacobson, *Whiteness of a Different Color: European Immigrants and the Alchemy of Race* (Cambridge: Harvard University Press, 1998); Gary Grestle, *American Crucible: Race and Nation in the Twentieth Century* (Princeton: Princeton University Press, 2001); David R. Roediger, *Working Towards Whiteness: How America's Immigrants Became White* (New York: Basic Books, 2005); and Nell Irvin Painter, *The History of White People* (New York: W. W. Norton, 2010).

27. Peter DeCarlo, "Christopher Columbus Memorial."

28. DeCarlo and Harper, "Minnesota, We Need to Talk."

29. DeCarlo and Harper, "Minnesota, We Need to Talk."

30. The leaders of these campaigns were men like Angelo Noce, the publisher who in 1907 convinced Colorado to become the first state to declare Columbus Day a holiday, and Carlo Barsotti, the banker and newspaper editor responsible for the 1892 erection New York City's Columbus Circle monument.

31. Peter G. Vellon, *A Great Conspiracy Against Our Race: Italian Immigrant Newspapers and the Construction of Whiteness in the Early 20th Century* (New York: New York University Press, 2014); Laura E. Ruberto and Joseph Sciorra, "Recontextualizing the Ocean Blue: Italian Americans and the Commemoration of Columbus," *Process* (Blog), Organization of American Historians, October 4, 2017, accessed March 31, 2021, http://www.processhistory.org/recontextualizing-the-ocean-blue/.

32. Columbus was a crucial tool in the campaign to reclassify the race of Italians: Bénédicte Deschamps, "Italian-Americans and Columbus Day: A Quest for Consensus Between National and Group Identities, 1840–1910," in *Celebrating Ethnicity and Nation: American Festive Culture from the Revolution to the Early Twentieth Century*, eds. Jürgen Heideking, Genève Fabre, and Kai Dreisbach (New York: Berghahn Books, 2001); Timothy Kubal, *Cultural Movements and Collective Memory: Christopher Columbus and the Rewriting of the National Origin Myth* (New York: Palgrave Macmillan, 2008).

33. "The Columbus Celebration," 84.

34. Dean Albertson, "Portrait: Guy Stanton Ford," *American Scholar* 26, no. 3 (1957), 350.

35. Patrick Condon, "Free Speech, Vandalism—and Crossing the Line," *Star Tribune* (Minneapolis), June 25, 2020. After the monument fell, a spokesperson for the archbishop of Minneapolis and St. Paul bemoaned the celebrations over its "lawless removal," called the villainization of Columbus "fake history," and demanded that the monument be restored to its base: Lianne Laurence, "Minnesota Catholic Conference: Vandalized Christopher Columbus Statue Should be Restored," *Alpha News*, June 24, 2020.

36. Public Safety Commissioner John Harrington speaking at Governor Tim Walz's Press Conference, June 10, 2020, https://www.youtube.com/watch?v=IkJnoZ 8REXA.

37. Forcia Summons.

38. Unless otherwise noted, the description of the discussion between Forcia and Roeske comes from the Forcia Summons, a video posted to the "New Hughes Video Feed" Facebook page on June 11, 2020, and the video that accompanies an article by Darren Thompson, "Ramsey County Sentences Native Organizer for Columbus Statue Toppling," *Unicorn Riot*, December 15, 2020, https://unicornriot .ninja/2020/ramsey-county-sentences-native-organizer-for-columbus-statue -toppling/. Because the different videos show different parts of the conversation, I may be reporting exchanges out of order, although I have tried my best not to do so.

39. There are similar histories of Indigenous protest against monuments to others celebrated for discovering or settling America, not just Columbus. See, e.g., Michael L. Trujillo, "Onate's Foot: Remembering and Dismembering in Northern New Mexico," *Aztlan: A Journal of Chicano Studies* 33, no. 2 (2008); Nicholas A. Browne and Sarah E. Kanouse, eds., *Re-Collecting Black Hawk: Landscape, Memory, and Power in the American Midwest* (Pittsburgh: University of Pittsburgh Press, 2015); Andrew Denson, *Monuments to Absence: Cherokee Removal and the Contest over Southern Memory* (Chapel Hill: University of North Carolina Press, 2017); and Paul Farber, Interview with Chrissie Castro, Monument Lab Podcast, November 29, 2018, https:// monumentlab.com/podcast/taking-down-the-columbus-statue-in-downtown-la -with-organizer-chrissie-castro.

40. Bill Sorem and Michael McIntee, "Columbus Statue Celebrates Genocide, Should Be Removed from Capitol, Say Native Americans," *The Uptake*, April 19, 2015, https://theuptake.org/2015/04/19/columbus-statue-celebrates-genocide-should -be-removed-from-capitol-say-native-americans/.

41. Marianne Combs, "The Rise and Fall of the Statue of Christopher Columbus," Minnesota Public Radio News, June 12, 2020, https://www.mprnews.org/ story/2020/06/12/the-rise-and-fall-of-the-statue-of-christopher-columbus.

42. Paul S. Storch, "Ten Years of Sculpture and Monument Conservation on the Minnesota State Capitol Mall," *Objects Specialty Group Postprints* 9 (2002).

43. Brian Bakst, "Political Tension Rises after Columbus Statue Falls," Minnesota Public Radio News, June 11, 2020, https://www.mprnews.org/story/2020/06/11/ political-tension-rises-after-columbus-statue-falls.

44. Among many others, see David E. Stannard, *American Holocaust: The Conquest of the New World* (New York: Oxford University Press, 1992) and Tink Tinker and Mark Freeland, "Thief, Slave Trader, Murderer: Christopher Columbus and Caribbean Population Decline," *Wicazo Sa Review* 23, no. 1 (2008).

45. LaVonne Swenson, interview by Deborah Locke, February 17, 2011, Morton, Minnesota (Lower Sioux Community), 3.

46. Vincent Schilling, "The Traumatic True History and Name List of the Dakota 38," *Indian Country Today*, December 26, 2020, https://indiancountrytoday.com/news/ traumatic-true-history-full-list-dakota-38; Scott W. Berg, *38 Nooses: Lincoln, Little Crow, and the Beginning of the Frontier's End* (New York: Pantheon, 2012).

47. These were the St. Paul and Pacific, the Winona and St. Peter, and the St. Paul and Sioux City lines: James P. Shannon, *Catholic Colonization on the Western Frontier* (New Haven: Yale University Press, 1957).

48. For the history of these boarding schools in the United States, see David Adams, *Education for Extinction: American Indians and the Boarding School Experience, 1875–1928* (Lawrence: University Press of Kansas, 1995); Michael Cooper, *Indian School: Teaching the White Man's Way* (New York: Clarion Books, 1999); Margaret Archuleta, Brenda Child, and Tsianina Lomawaima, eds., *Away from Home: American Indian Boarding School Experiences, 1879–2000* (Phoenix: Heard Museum, 2000); Brenda Child, *Boarding School Seasons: American Indian Families, 1900–1940* (Lincoln: University of Nebraska Press, 2000); Clifford Trafzer, Jean Keller, and Lorene Sisquoc, eds. *Boarding School Blues: Revisiting American Indian Educational Experiences* (Lincoln: University of Nebraska, 2006); David Treuer, *The Heartbeat of Wounded Knee: Native America From 1890 to the Present* (New York: Penguin, 2019).

49. This was Richard Henry Pratt: Linda F. Witmer, *The Indian Industrial School, Carlisle, Pennsylvania, 1879–1918* (Carlisle, PA: Cumberland County Historical Society, 2002).

50. Linda LeGarde Grover, "From Assimilation to Termination: The Vermilion Lake Indian School," *Minnesota History* 58, no. 4 (Winter 2002–2003): 229.

51. Mary Annette Pember, "For Native Americans, Legacy of Trauma Poses Heavy Burden," Center for Health Journalism (Blog), September 23, 2015, https://centerforhealthjournalism.org/2015/09/22/native-americans-legacy-trauma-poses-heavy-burden.

52. Mary Annette Pember, "Death by Civilization," *The Atlantic*, March 8, 2019.

53. Pember, "Legacy of Trauma."

54. Nicole Martin Rodgers and Virginia Pendleton, *Missing and Murdered Indigenous Women Task Force: A Report to the Minnesota Legislature* (December 2020), https://dps.mn.gov/divisions/ojp/Documents/missing-murdered-indigenous-women-task-force-report.pdf, 5.

55. Rodgers and Pendleton, *Missing and Murdered Indigenous Women*, 44.

56. For example, around 10 percent of all American Indian youth in Minnesota were taken from their homes for at least a day in 2019: Rodgers and Pendleton, *Missing and Murdered Indigenous Women*.

57. Forcia, Facebook Post, September 6, 2018. In general, Forcia told me, he does not think Indigenous people should demand all land back, since "we know what that feels like when somebody comes and takes your home and you have no place to go." But he does advocate for the Catholic Church to return its land, and suggests that at least some state- and federal-owned public lands might be returned. He told me that he is especially saddened by St. Paul's Indian Mounds Regional Park, which contains six ancient burial mounds: "And people are having picnics over there. They have swing sets! That should be returned to the Dakota people as a sacred site. Get your goddamn swing sets off there."

58. Forcia, Facebook Post, September 5, 2018.

59. Roeske summoned these reinforcements at 4:52 p.m., but the statue had fallen by 5:01 p.m.: Forcia Summons. The delay was long enough that the Minnesota Public Safety Commissioner had to address rumors it was intentional: "There's a belief that the state patrol received an order or direction from Gov. Walz or Lt. Gov. Flanagan to disregard the criminal behavior. And I can tell you that that's not true," he told a state senate commission inquiring into the toppling. He explained that protestors had arrived in greater numbers and earlier than expected. "And I'll tell you," he also testified, "having watched the video, it came down way faster than I had any reason to believe a statue could possibly come down": Brian Bakst, "Three Could Face Charges in Columbus Statue Toppling," Minnesota Public Radio News, July 8, 2020, https://www.mprnews.org/story/2020/07/08/three-could-face-charges-in-columbus-statue-toppling.

60. Max Nesterak, "Native Activists Pull Down Christopher Columbus Statue at State Capitol," *Minnesota Reformer*, June 11, 2020.

61. Rodgers and Pendleton, *Missing and Murdered Indigenous Women*; Christine Stark, "Strategies to Restore Justice for Sex Trafficked Native Women," in *Palgrave International Handbook of Human Trafficking*, eds. John Winterdyk and Jackie Jones (London: Palgrave Macmillan, 2019); Abby Abinanti et al., *'To' Kee Skuy' Soo Ney-Wo-Chek': I Will See You Again in a Good Way: A Year 1 Project to Report on Missing and Murdered Indigenous Women, Girls, and Two Spirit People of Northern California* (Eureka, CA: Sovereign Bodies Institute, 2020). Traditionally, "two-spirit" refers to Indigenous individuals with a distinct, alternative gender status, neither male nor female.

62. Ginger Gibson et al., *Indigenous Communities and Industrial Camps: Promoting Healthy Communities in Settings of Industrial Change* (Victoria, BC: The Firelight Group with Lake Babine Nation and Nak'azdli Whut'en, 2017), https://firelight.ca/wp-content/uploads/2016/03/Firelight-work-camps-Feb-8-2017_FINAL.pdf; Kathleen Finn et al., "Responsible Resource Development and Prevention of Sex Trafficking: Safeguarding Native Women and Children on the Fort Berthold Reservation," *Harvard Journal of Law and Gender* 40, no. 1 (2017).

63. Rodgers and Pendleton, *Missing and Murdered Indigenous Women*, 65.

64. Indigenous women and girls are seven times more likely than Minnesota's white women to be murdered: Rodgers and Pendleton, *Missing and Murdered Indigenous Women*.

65. The factors that put them at such high risk are the results of a historical legacy of land theft, boarding schools, and uneasy assimilation, since poverty, housing insecurity, and childhood abuse drive many to fall victim to substance abuse or sex trafficking. For example, research conducted in 2018 indicated that American Indian women, girls, transgender, and two-spirit people accounted for 16 percent of Minnesota's homeless population: Rodgers and Pendleton, *Missing and Murdered Indigenous Women*.

66. Maura Judkis, "Controversial Memorials Are Surprisingly Easy to Pull Down. Fixing the World That Built Them Is Harder," *Washington Post*, June 13, 2020.

67. Tim Nelson, "Activist who Toppled Columbus Statue at Capitol Gets Community Service," *Minnesota Public Radio News*, December 7, 2020, https://www .mprnews.org/story/2020/12/07/activist-who-toppled-columbus-statue-at-capitol -gets-community-service; Stewart Huntington, "What's Old Is New: The Return of Peacemaking," *Indian Country News*, March 1, 2021.

68. Office of the Ramsey County Attorney, *Ramsey County Attorney's Office Files Charges in Columbus Statue Incident*, August 13, 2020.

69. Rosario, "Circling the Square."

70. *Minnesota v. Michael Anthony Forcia*, Suspended Prosecution Agreement (Ramsey County District Court, File No. 62-CR-20-5111, December 7, 2020).

71. Minnesota Senate Republican Caucus, "Senator Bill Ingebrigtsen Presents Bill to Restore Christopher Columbus Statue on Capitol Grounds," March 17, 2021, https://www.mnsenaterepublicans.com/senator-bill-ingebrigtsen-presents-bill-to -restore-christopher-columbus-statue-on-capitol-grounds/.

72. "Protesters Tear Down Columbus Statue at State Capitol," *WCCO News*, June 10, 2020, https://www.audacy.com/wccoradio/articles/protesters-tear-down -columbus-statue-at-state-capitol.

73. Forcia, Facebook Posts, August 16, 2019, and June 29, 2020.

74. Edward Benton-Banai, *The Mishomis Book: The Voice of the Ojibway* (St. Paul: Red School House Publishers, 1988).

Chapter 6: Hideous Spectre

1. Unless otherwise noted, information about the Birmingham protest comes from my February 11, 2021, interview of Randall Woodfin and the videos that accompany these articles: Jordan Highsmith, "Protesters Vandalize Confederate Monument in Linn Park," CBS42, May 31, 2020, https://www.cbs42.com/news/local/ protesters-vandalize-confederate-monument-in-linn-park/; Anna Beahm, "In Birmingham: Fires, Windows Shattered at Banks, Businesses as Reporters Attacked," AL.com, May 31, 2020, https://www.al.com/news/2020/05/protesters-trying-to -take-down-confederate-monument-in-birmingham.html.

2. Carol Robinson, "Jermaine 'FunnyMaine' Johnson's Inciting Riot Charge Dismissed," AL.com, June 17, 2020, https://www.al.com/news/birmingham/2020/06/ jermaine-funnymaine-johnsons-inciting-riot-charge-dismissed.html.

3. Davis used these words to describe the Confederate dead in connection with a slightly earlier monument: "Letter from Ex-President Davis," *Wilmington Morning Star* (Wilmington, NC), May 22, 1877.

4. Alex Morris, "An Interview from Birmingham City Hall: Mayor Randall Woodfin on Toppling Racist Monuments," *Rolling Stone*, July 9, 2020.

5. Birmingham Public Library, *Birmingham's Population, 1880–2000*, http://www .bplonline.org/resources/government/BirminghamPopulation.aspx.

6. On industrial change and early Birmingham, see Michael Davis, *In Remembrance:*

Confederate Funerary Monuments in Alabama and Resistance to Reconciliation, 1884–1923 (MA Thesis, Auburn University, 2008), 61–64, and Herbert R. Northrup, "The Negro and Unionism in the Birmingham, Ala., Iron and Steel Industry," *Southern Economic Journal* 10, no. 1 (1943).

7. *United Mine Workers Journal*, October 5, 1893, quoted in Daniel Letwin, "Interracial Unionism, Gender, and 'Social Equality' in the Alabama Coalfields, 1878–1908," *Journal of Southern History* 61, no. 3 (1995): 535.

8. See, e.g., *Birmingham Labor Advocate*, April 14, 1894, claiming that mining company officials trying to avert the strike "were no doubt surprised to see" the meeting they had arrived to address "half painted black and the other half white," since white miners had come to join the assembly of an all-Black mining crew: quoted in Letwin, "Interracial Unionism," 533.

9. H. R. Cayton and G. S. Mitchell, *Black Workers and the New Unions* (Chapel Hill: University of North Carolina Press, 1939).

10. Equal Justice Initiative, *Lynching in America: Confronting the Legacy of Racial Terror* (2017), https://eji.org/reports/lynching-in-america/, 41–42.

11. "The Monument to the Heroes Who Wore the Gray, as Suggested by Yesterday's *News*, Is Advocated by All the People," *Birmingham News*, March 12, 1894.

12. On the history of labor unions in Birmingham, see Northrup, "The Negro and Unionism"; Robert David Ward and William Warren Rogers, *Labor Revolt in Alabama: The Great Strike of 1894* (Tuscaloosa: University of Alabama Press, 1965); and Letwin, "Interracial Unionism."

13. *Birmingham Labor Advocate*, April 28, 1894, quoted in Letwin, "Interracial Unionism," 533.

14. *Birmingham Labor Advocate*, December 9, 1893, quoted in Letwin, "Interracial Unionism," 537.

15. "Laid: Corner Stone of Birmingham's Monument," *Birmingham News*, April 26, 1894.

16. *Birmingham News*, "Laid."

17. *Birmingham News*, "Laid."

18. *Birmingham News*, "Laid."

19. Letwin, "Interracial Unionism," 527–528.

20. *Official Proceedings of the Constitutional Convention of the State of Alabama, May 21st, 1901, to September 3rd, 1901* (Wetumpka, AL: Wetumpka Printing Company, 1940), 8.

21. The local United Daughters of the Confederacy chapter had resolved to put up a shaft in 1901: "Social," *Birmingham News*, May 30, 1901. But fundraising proceeded very slowly: "Five Hundred Dollars Appropriated for Monument," *Birmingham News*, July 4, 1904.

22. This monument, to Dr. W.E.B. Davis, was eventually placed elsewhere in Birmingham: "Davis Monument," *Birmingham News*, October 25, 1904.

23. Letwin, "Interracial Unionism," 528 and 550.

24. "Confederate Monument Unveiled at Capitol Park," *Birmingham News*, April 26, 1905.

25. "Preparing for Memorial Day," *Birmingham News*, April 3, 1905.

26. *Birmingham News*, "Confederate Monument Unveiled."

27. *Birmingham News*, "Confederate Monument Unveiled."

28. "Eloquent Oration by General Harrison at the Unveiling," *Birmingham News*, April 26, 1905.

29. *Birmingham News*, "Eloquent Oration."

30. *Birmingham News*, "Confederate Monument Unveiled."

31. Kelsey Stein, "Activist Asks Birmingham Mayor to Remove Confederate Monument; Decision Falls to Parks Board," AL.com, July 1, 2015, https://www.al.com/news/birmingham/2015/06/activist_again_calls_to_remove.html.

32. On Roof's use of Confederate history, see Lyra D. Monteiro, "How a Trump Executive Order Aims to Set White Supremacy in Stone," *Hyperallergic*, January 12, 2021, https://hyperallergic.com/614175/how-a-trump-executive-order-aims-to-set-white-supremacy-in-stone/ and Rachel Kaadzi Ghansah, "A Most American Terrorist: The Making of Dylann Roof," *GQ*, August 21, 2017.

33. See, e.g., Ta-Nehisi Coates, "Take Down the Confederate Flag—Now," *The Atlantic*, June 18, 2015.

34. James Forman Jr., "Driving Dixie Down: Removing the Confederate Flag from Southern State Capitols," *Yale Law Journal* 101, no. 2 (1991).

35. *N.A.A.C.P. v. Hunt*, 891 F.2d 1555, 1565 (11th Cir. 1990).

36. *Coleman v. Miller* 117 F.3d 527, 530-31 (11th Cir. 1997).

37. Logan Strother, Spencer Piston, and Thomas Ogorzalek, "Pride or Prejudice?: Racial Prejudice, Southern Heritage, and White Support for the Confederate Battle Flag," *Du Bois Review* 14, no. 1 (2017).

38. Forman, "Driving Dixie Down," 525.

39. Goldie Taylor, "Bree Newsome Speaks for the First Time After Courageous Act of Civil Disobedience," *Blue Nation Review*, June 29, 2015.

40. Taylor, "Bree Newsome Speaks."

41. Charles J. Dean, "Alabama Gov. Bentley Removes Confederate Flags from Capitol Grounds," AL.com, June 24, 2015, https://www.al.com/news/2015/06/confederate_flag_removed_from.html.

42. Stein, "Activist Asks."

43. Erin Edgemon, "Alabama Attorney Files Lawsuit against Gov. Bentley Challenging Confederate Flag Removal," AL.com, July 15, 2015, https://www.al.com/news/2015/07/alabama_attorney_files_lawsuit.html. This lawsuit was dismissed in November 2015, when a judge held that the plaintiff had not been harmed by the removal and thus had no standing to sue.

44. Kelsey Stein, "Lawsuit Filed to Keep Confederate Monument in Birmingham Park," AL.com, August 20, 2015, https://www.al.com/news/birmingham/2015/08/lawsuit_filed_to_keep_confeder.html; Joseph D. Bryant, "Birmingham City Officials Take Steps to Remove Confederate Monument at Linn Park," AL.com, July 1, 2015, https://www.al.com/news/birmingham/2015/07/finding_another_place_birmingh.html.

45. Melissa Brown, "'There Is No Shame in Preserving History': Protestors Rally Against Confederate Monument Removal," AL.com, July 18, 2015, https://www.al .com/news/birmingham/2015/07/c.html.

46. Edgemon, "Alabama Attorney Files Lawsuit."

47. *Save Our South v. Mitchell et al.*, 01-CV-2015-903224.00 (Circuit Court of Jefferson County, Alabama, 2015), Complaint at 5. The plaintiff organization Save Our South was organized so shortly before the lawsuit was filed that it had to describe itself as an "unincorporated nonprofit."

48. Mike Cason, "Alabama Senator Calls for Prohibition Against Moving Historic Monuments," AL.com, July 15, 2015, http://www.al.com/news/index.ssf/2015/07/ alabama_senator_calls_for_proh.html.

49. Cason, "Alabama Senator Calls for Prohibition."

50. Mayor's Office of Public Information, *Civil Rights Landmarks Proposed for World Heritage Status*, July 4, 2016, https://www.birminghamal.gov/2016/07/04/civil-rights -landmarks-proposed-for-world-heritage-status/.

51. Coshandra Dillard, "Charlottesville's Zyahna Bryant Shall Lead," *Teaching Tolerance*, August 10, 2018, https://www.tolerance.org/magazine/charlottesvilles -zyahna-bryant-shall-lead.

52. Benjamin Wallace-Wells, "The Fight Over Virginia's Confederate Monuments," *New Yorker*, December 4, 2017.

53. Chris Suarez, "Charlottesville City Council Votes to Remove Statue from Lee Park," *Daily Progress* (Charlottesville, VA), February 6, 2017.

54. *Payne v. City of Charlottesville*, No. 17-145 (Va. Cir. Ct. Feb. 2017).

55. VA Code Ann. § 15.2-1812.

56. Paul Duggan, "Charlottesville's Confederate Statues Still Stand—and Still Symbolize a Racist Legacy," *Washington Post*, August 10, 2019.

57. The Southern Poverty Law Center lists twenty-seven American monuments dedicated to Lee, more than any other Confederate except Jefferson Davis: Southern Poverty Law Center, "Whose Heritage? Public Symbols of the Confederacy," accessed March 31, 2021, https://www.splcenter.org/data-projects/whose -heritage.

58. Thomas L. Connelly, *The Marble Man: Robert E. Lee and His Image in American Society* (Baton Rouge: Louisiana State University Press, 1977), 16–17.

59. *Washington and Lee University Bulletin*, XXXII (May 1, 1933), quoted in Connelly, *Marble Man*, 134.

60. George Cary Eggleston, *A Rebel's Recollections* (New York: Hurd & Houghton, 1875), 6.

61. Eggleston, *A Rebel's Recollections*, 6.

62. Douglas Southall Freeman, "The Lengthening Shadow of Lee," quoted in Connelly, *Marble Man*, 143.

63. Douglas Southall Freeman, "The Cornerstones of Stratford," quoted in Connelly, *Marble Man*, 146.

64. Freeman, "The Cornerstones of Stratford."

65. Wallace-Wells, "The Fight."

66. Wallace-Wells, "The Fight."

67. Patrick Strickland, "Alt-Right Rally: Charlottesville Braces for Violence," Aljazeera .com, August 11, 2017, https://www.aljazeera.com/features/2017/8/11/alt-right -rally-charlottesville-braces-for-violence.

68. Terry McAuliffe, governor of Virginia during these events, has written a book describing the failures of planning by authorities that allowed the rally to turn deadly: *Beyond Charlottesville: Taking a Stand Against White Nationalism* (New York: Thomas Dunne Books, 2019). In 2019, Fields pleaded guilty to first-degree murder in exchange for the prosecutors not seeking the death penalty. He was sentenced to life in prison: Paul Duggan and Justine Jouvenal, "Neo-Nazi Sympathizer Pleads Guilty to Federal Hate Crimes for Plowing Car into Protesters at Charlottesville Rally," *Washington Post*, March 27, 2019. For more perspectives on the events in Charlottesville in August 2017, see Hawes Spencer and Sheryl Gay Stolberg, "White Nationalists March on University of Virginia," *New York Times*, August 11, 2017; Richard Fausset and Alan Feuer, "Far-Right Groups Surge into National View in Charlottesville," *New York Times*, August 13, 2017; and Emma Green, "Why the Charlottesville Marchers Were Obsessed with Jews," *The Atlantic*, August 15, 2017. Many authors have analyzed Charlottesville's importance for public memory in America, including Jacey Fortin, "The Statue at the Center of Charlottesville's Storm," *New York Times*, August 13, 2017; Keeanga Yamahtta Taylor, "No More Charlottesvilles," *Jacobin*, August 14, 2017; Annette Gordon-Reed, "Charlottesville: Why Jefferson Matters," *New York Review of Books*, August 19, 2017; Dell Upton, "Confederate Monuments and Civic Values in the Wake of Charlottesville," Society of Architectural Historians (Blog), September 13, 2017, https://www.sah.org/publications-and-research/sah-blog/sah-blog/2017/09/13/ confederate-monuments-and-civic-values-in-the-wake-of-charlottesville; Lyra D. Monteiro, "Power Structures: White Columns, White Marble, White Supremacy," Medium, October 27, 2020, https://intersectionist.medium.com/american-power -structures-white-columns-white-marble-white-supremacy-d43aa091b5f9.

69. Amy Held, "Shrouds Pulled from Charlottesville Confederate Statues, Following Ruling," NPR, February 28, 2018, https://www.npr.org/sections/thetwo -way/2018/02/28/589451855/shrouds-pulled-from-charlottesville-confederate -statues-following-ruling.

70. Nicholas Bogel-Burroughs, "Virginia Governor Plans to Order Robert E. Lee Statue Removed," *New York Times*, June 3, 2020.

71. Derrick Bryson Taylor, "Confederate Statue Near Site of White Nationalist Rally in Charlottesville Is Removed," *New York Times*, September 12, 2020.

72. Allyson Waller, "Charlottesville Can Remove Confederate Statues, High Court Rules," *New York Times*, April 1, 2021. For a detailed analysis of the legal maneuverings over these monuments, see "Case Study II: Litigating Robert E Lee," in

Contested Histories in Public Spaces: Principles, Processes, Best Practices, eds. Timothy Ryback et al. (London: International Bar Association, 2021).

73. Erin Edgemon, "Group Threatens to Sue Birmingham Again over Possible Confederate Monument Removal," AL.com, August 16, 2017, https://www.al.com/news/birmingham/2017/08/group_threatens_to_sue_birming.html.

74. Mike Cason, "Gov. Kay Ivey Signs Bill Protecting Confederate Monuments," AL.com, May 25, 2017, https://www.al.com/news/birmingham/2017/05/gov_kay_ivey_signs_bill_protec.html.

75. The act permits communities to ask for waivers to remove monuments between twenty and forty years old. Initially, Bell mistakenly thought that he could request a waiver under the new act. He was not the only one confused by the act's language. Even Allen, the senator who sponsored the act, told the press that Bell should seek a waiver: "If Mayor Bell believes his city is best served by the monument's alteration or removal, he should follow the law and apply for a waiver as outlined in the Memorial Preservation Act": Erin Edgemon, "AG Files Lawsuit Against Birmingham over Confederate Monument," AL.com, August 16, 2017, https://www.al.com/news/birmingham/2017/08/ag_files_lawsuit_against_birmi.html.

76. Erin Edgemon, "Birmingham Covers Confederate Monument as City Considers Removal," AL.com, August 15, 2017, https://www.al.com/news/birmingham/2017/08/defy_state_law_and_remove_conf.html.

77. Birmingham City Council Meeting, August 15, 2017.

78. Edgemon, "Birmingham Covers Confederate Monument."

79. Edgemon, "Birmingham Covers Confederate Monument."

80. Ala. Code §41-9-232(a). See *Alabama v. City of Birmingham*, Jefferson Circuit Court (CV-2017-903426).

81. Ala. Code §41-9-235(2)(d).

82. Alabama: Ala. Code §§ 41-9-231-236 (2017); Georgia: Ga. Code Ann., § 50-3-1 (2019); Mississippi: Miss. Code Ann. § 55-15-81 (amended 2018); North Carolina: N.C. Gen. Stat. § 100-2.1 (amended 2018); South Carolina: S.C. Code Ann. § 10-1-165 (amended 2018); Tennessee: Tenn. Code Ann. § 4-1-412 (amended 2018). For an overview of these laws, see Jess R. Phelps and Jessica Owley, "Etched in Stone: Historic Preservation Law and Confederate Monuments," *Florida Law Review* 71 (2019). Some local municipalities have also imposed restrictions on removals. For example, the mayor of Hazleton, Pennsylvania, reacted to a resident's campaign to remove the city's Columbus monument by enacting a new ordinance in July 2020. Now, anyone who wants a monument more than twenty years old to be removed from city property needs to collect signatures from 75 percent of the city's population, including children. That would require 25,000 signatures, which must be individually notarized: Sam Galski, "Hazleton Resident Says She Won't Stop Fighting to Remove Statue," *Citizen's Voice* (Wilkes-Barre, Pennsylvania), June 26, 2020.

83. Alabama HB 133 (2021) would establish the crimes of damaging a public monu-

ment in the first and second degrees, would provide criminal penalties, including a mandatory minimum sentence for a violation, and would provide for a mandatory holding period for an arrest; Arizona HB 2552 (2021) would make damaging a public monument the crime of aggravated criminal damage, while SB 1639 (2021) would make recklessly damaging a public monument a crime with punishments for different degrees; Arkansas HB 1313 (2021) would expand the existing offense of defacing or damaging a public building to include damaging a public monument; Florida SB 484 (2021) would make injuring or removing a monument a felony; Iowa SB 1140 (2021) would make acts that damage, deface, alter, or destroy any publicly owned property, including a monument or statue, chargeable as criminal mischief; Kansas HB 2028 (2021) would make the penalty for criminal desecration by damaging, defacing, or destroying any public monument or structure more severe; Maryland SB 443 (2021) would impose criminal penalties for damaging monuments; Massachusetts SB 883 (2021) would double existing fines and add community service for damaging a war or veterans' memorial or monument; Mississippi SB 2034 (2021) would create a punishment for defacing public monuments, while HB 83 (2021) would make damaging a public monument during "a violent or disorderly assembly" a felony, and SB 2043 (2021) would impose up to a year imprisonment and a $10,000 fine for defacing a war monument; Missouri HB 1018 (2021) would elevate the classification of monument destruction from a misdemeanor to a felony, and SB 66 (2021) would make the knowing damage or deface- ment of a public monument a crime of institutional vandalism; New Jersey A 1999 (2021) would criminalize the desecration of a military monument, while SB 3261 (2020) and 620 (2021) would each increase the penalties for desecrating a public monument; New York Bill No. A04020 (2021) would makes desecration of property commemorating a historical figure a class C felony; Pennsylvania SB 1321 (2020) would make the desecration of public monuments or their surrounding protective or decorative barriers punishable on a scale based on severity of damage; Tennessee SB 1288 (2021) would make the violation of heritage protection laws by a public official a misdemeanor; Texas HB 446 (2021) would increase the criminal penalty for the damage or destruction of a public monument; Virginia HB 1781 (2021) would make damaging a monument honoring war veterans or erected to mark the site of any engagement fought during the Civil War a misdemeanor; Washington SB 5059 (2021) would increase the penalty for defacing a public monument from a misdemeanor to a felony; Wisconsin (2020; bill proposed by Rep. Rob Hutton and Sen. Tim Carpenter) would make damaging a public monument a felony.

84. For Alabama HB242 (2021), see below. Georgia HB 238 (2/2021) would forbid authorities from removing or concealing any publicly owned monument to any military personnel, including those of the Confederate States of America; Idaho HB 65 (2021) would prohibit relocating, removing, disturbing, or altering monu- ments without approval of the legislature via concurrent resolution; Indiana SB 187 (2/2021) would withhold state support from political subdivisions that fail

to protect public monuments from destruction or vandalism; Kentucky SCR7 (2021) was a concurrent resolution requesting state and local officials and judiciary to dedicate resources to protecting public monuments; Mississippi HB 120 (2021) proposes that monuments located on public property shall not be relocated, removed, disturbed, altered, renamed or rededicated unless specifically authorized by an act of the legislature, while SB 2386 (2021) would strip local officials of authority to move monuments; Missouri HB 1751 (2020) would prohibit authorities from modifying, removing, or concealing any state historic military monument, while HB 55 (2021) would prohibit removing monuments without approval from the Missouri advisory council on historic preservation; New York Bill No. S00242 (2021) would classify military monuments and memorials as parkland and provide that they cannot be alienated, developed, leased, transferred, sold or discontinued for use as a memorial site without the approval of the legislature; New Jersey AR 116 (2021) would prohibit any reduction in size of, or level of protection afforded to, any currently designated national monument; Ohio SB 59 (2021) would prohibit certain war relics located on public property or cemetery association property from being disposed of; Pennsylvania SB 1321 (2020) would forbid the permanent removal of a public monument, except as specifically approved by an act of the General Assembly; South Carolina HB 3358 (2021) would prohibit local authorities from removing a monument and fine any member of a local governing body who votes for such removal $25 million, with HB 3249 (2021) and HB 3357 (2021) imposing similar prohibitions; Tennessee SB 1066 (2021) would require a joint resolution of the general assembly to approve any waiver granted by the Tennessee historical commission for the movement or alteration of a memorial, while SB 1288 (2021) would make the violation of heritage protection laws by a public official a misdemeanor.

85. Andrea Benjamin et al., "Set in Stone? Predicting Confederate Monument Removal," *PS: Political Science & Politics* 53, no. 2 (2000).

86. Mayoral Advisory Commission on City Art, Monuments, and Markers, "Report to the City of New York" (2018), https://www1.nyc.gov/assets/monuments/downloads/pdf/mac-monuments-report.pdf; William Neuman, "City Orders Sims Statue Removed from Central Park," *New York Times*, April 16, 2018. Sims's statue went up in 1894 to honor him as a medical pioneer for the surgical techniques he invented in the 1840s; they are still in use today to heal childbirth injuries. Sims's statue came down in 2017 after activists brought attention to the fact that these innovations came at the expense of the enslaved women on whom Sims experimented. He persuaded slave owners to lend him women with the conditions he wanted to cure. He kept six of these women in his hospital for four years, performing multiple operations on each until he finally succeeded on Anarcha Westcott. He performed a total of thirty operations on Westcott, all without anesthesia. After he perfected his techniques, he sent his cured patients back to work their owners' plantations.

87. GA Code § 50-3-1 (2015).

88. *Alabama v. City of Birmingham*, Jefferson Circuit Court (CV-2017-903426) at 3 and 6.

89. *State v. City of Birmingham*, 299 So. 3d 220, 236 (Ala. 2019).

90. *State v. City of Birmingham*, 299 So. 3d 220, 236 (Ala. 2019).

91. In January 2020, the local court followed the superior court's decision and ordered Birmingham to pay the $25,000 fine.

92. Morris, "An Interview from Birmingham City Hall."

93. Carol Robinson, "Birmingham Taking Down Confederate Monument," AL.com, June 2, 2020, https://www.al.com/news/2020/06/watch-live-birmingham-taking -down-confederate-monument.html.

94. Alabama Attorney General's Office, *Alabama Attorney General Steve Marshall and Louisiana Attorney General Jeff Landry Lead 11-State Attorney General Letter to Congress in Support of Law Enforcement*, June 23, 2020, https://www.alabamaag.gov/ newsviewer/ae509716-9829-42a1-9fe5-08936d2fbfb9.

95. Robinson, "Birmingham Taking Down Confederate Monument."

96. Chip Brownlee, "State Files Anticipated Lawsuit against Birmingham for Removing Confederate Monument," WZDX, June 2, 2020, https://www.wwltv.com/ article/news/local/state-files-anticipated-lawsuit-against-birmingham-for -removing-confederate-monument/525-fbe0b1e2-8288-43f6-83d2-2db4f016ff4e.

97. Beth Cann, "Steve Marshall Warns Cities/Counties and Pledges to Residents to Uphold the Alabama Memorial Preservation Act," *Alabama Today*, November 23, 2020; Steve Marshall, "A Message on the Illegal Actions of Local Officials Violating the Alabama Memorial Preservation Act," November 23, 2020, https://www .youtube.com/watch?v=x241-6plkxA.

98. Alabama HB242 (2021).

Chapter 7: Too Damn Beautiful

1. Nick Fiorellini, "Statue of White Woman Holding Hatchet and Scalps Sparks Backlash in New England," *Guardian*, August 23, 2020.

2. Barbara Cutter, "The Gruesome Story of Hannah Duston, Whose Slaying of Indians Made Her an American Folk 'Hero,'" *Smithsonian*, April 9, 2018.

3. For example, the Advisory Council on Historic Preservation, an independent federal agency created by the National Historic Preservation Act, adopted a "Policy Statement on Controversial Commemorative Works" in March 2018, holding that monuments honoring divisive historical figures or events generally "should not be destroyed since they have lessons to teach about difficult issues in the country's history." All their recommendations for dealing with these monuments, whether they are retained in place or moved to a less prominent location, involve adding contextualizing signage: Advisory Council on Historic Preservation, "Policy Statement on Controversial Commemorative Works," March 22, 2018, https://www.achp.gov/digital-library-section-106-landing/achp-policy-statement

-controversial-commemorative-works. Similarly, the United States National Park Service's position on the hundreds of Confederate monuments on its sites is that "these works and their inscriptions will not be altered, relocated, obscured, or removed, even when they are deemed inaccurate or incompatible with prevailing present-day values" unless they are directed to do so by legislation. Instead, the Parks Service will "provide historical context and interpretation for all of our sites and monuments in order to reflect a fuller view of past events and the values under which they occurred": National Parks Service, "Confederate Monuments," September 24, 2020, https://www.nps.gov/gett/learn/historyculture/confederate-monuments.htm.

4. Except where otherwise noted, information in this section comes from my September 28, 2020, interview with Laurajane Smith or her book, *Emotional Heritage: Visitor Engagement at Museums and Heritage Sites* (London: Routledge, 2020).

5. Hannah Knowles, "As Plantations Talk More Honestly About Slavery, Some Visitors Are Pushing Back," *Washington Post*, September 8, 2019.

6. Michael W. Twitty, "Dear Disgruntled White Plantation Visitors, Sit Down," *Afroculinaria*, August 9, 2019, https://afroculinaria.com/2019/08/09/dear-disgruntled-white-plantation-visitors-sit-down/.

7. Unless otherwise noted, quotes come from my April 8, 2021, interview with John Guess Jr.

8. For the campaign to erect the monument, see Kelly McMichael, *Sacred Memories: The Civil War Monument Movement in Texas* (College Station: Texas A&M University Press, 2013). For the "spectacular increase" in these voters' participation after the poll tax was finally abolished in 1966, see Dan Nimmo and Clifton McCleskey, "Impact of the Poll Tax on Voter Participation: The Houston Metropolitan Area in 1966," *Journal of Politics* 31, no. 3 (1969).

9. Valentina Di Liscia, "At This Museum of African American Culture, Displaying a Confederate Statue Is a 'Part of Healing,'" *Hyperallergic*, August 31, 2020, https://hyperallergic.com/583649/houston-museum-of-african-american-culture/.

10. Molly Glentzer, "'Spirit of the Confederacy' Statue Finds New Home in Houston's African American Museum," *Houston Chronicle*, August 19, 2020. Curator Tsione Wolde-Michael has argued that museums that accept controversial monuments should change their care guidelines, as "prioritizing the preservation of damage" is vital for "reclaiming these suppressed histories [of radical Black dissent to monuments] and marking monuments with visible evidence of contestation": Tsione Wolde-Michael et al., "'The Future of Archaeology Is Antiracist': Archaeology in the Time of Black Lives Matter," *American Antiquity* 86, no. 2 (2021): 230; see also Tsione Wolde-Michael, "We Should Think Differently About the Preservation of Racist Monuments," *Hyperallergic*, May 5, 2021, https://hyperallergic.com/643843/we-should-think-differently-about-the-preservation-of-racist-monuments/.

11. In 2020 Internet culture, "Karen" became a nickname for white women exercising their privilege at the expense of others.

12. Willow Curry, *This Is What Hatred Looks Like* (2020), https://www.youtube.com/watch?v=q5W8PX9DOJ0&t=84s.

13. La Tanya S. Autry and Mike Murawski, "Museums Are Not Neutral: We Are Stronger Together," *Panorama: Journal of the Association of Historians of American Art* 5, no. 2 (2019); Laura Raicovich, "Museum Resolution: Dismantle the Myth of Neutrality," *Walker Art Magazine*, January 8, 2019.

14. The latest comprehensive study of American museum staff diversity found that 80 percent of their "intellectual leaders" (curatorial, education, conservation, and leadership staff) identify as white: Mariët Westermann, Roger Schonfeld, and Liam Sweeney, "Report: Art Museum Staff Demographic Survey 2018," Mellon Foundation (2019). Another study of the collections of major American museums found that 84 percent of the works in their collections were made by white artists: Chad M. Topaz et al., "Diversity of Artists in Major U.S. Museums," *PLoS One* 14, vol. 3 (2019). A 2010 study estimated that nearly 80 percent of visitors to American museums were white: Betty Farrell and Maria Medvedeva, "Demographic Transformation and the Future of Museums," American Association of Museums (2010).

15. The most recent survey found that nearly 90 percent of American museum's board members were white, and 46 percent of museum boards were entirely composed of white members: BoardSource, "Museum Board Leadership 2017: A National Report" (2017).

16. Casey Cep, "The Fight to Preserve African-American History," *New Yorker*, February 3, 2020.

17. Brian Palmer and Seth Freed Wessler, "The Costs of the Confederacy," *Smithsonian* (December 2018).

18. Di Liscia, "At This Museum of African American Culture."

19. Monumental Women, "Meet Our Board of Directors," accessed March 31, 2021, https://monumentalwomen.org/board-of-directors/.

20. Ginia Bellafante, "Is a Planned Monument to Women's Rights Racist?," *New York Times*, January 17, 2019.

21. Bellafante, "Is a Planned Monument to Women's Rights Racist?"

22. Brent Staples, "A Whitewashed Monument to Women's Suffrage," *New York Times*, May 14, 2019.

23. Martha S. Jones, "How New York's New Monument Whitewashes the Women's Rights Movement," *Washington Post*, March 22, 2019.

24. Zachary Small, "Historians Raise Concerns over Central Park's Suffragist Monument," *Hyperallergic*, August 21, 2019, https://hyperallergic.com/514079/historians-raise-concerns-over-central-parks-suffragist-monument/.

25. See Martha S. Jones, *Vanguard: How Black Women Broke Barriers, Won the Vote, and Insisted on Equality for All* (New York: Basic Books, 2021).

26. Brent Staples, "When the Suffrage Movement Sold Out to White Supremacy," *New York Times*, February 2, 2019.

27. Jones, *Vanguard*.

28. Margalit Fox, "Amelia Boynton Robinson, a Pivotal Figure at the Selma March, Dies at 104," *New York Times*, August 26, 2015.

29. Adam Liptak, "Supreme Court Invalidates Key Part of Voting Rights Act," *New York Times*, June 25, 2013.

30. Jamilah Menieux, "Why I'm Skipping the Women's March on Washington," *Colorlines*, January 17, 2017, https://www.colorlines.com/articles/why-im-skipping -womens-march-washington-op-ed.

31. Murray, *Emancipation and the Freed*, 55–56.

32. I am thinking of Maya Lin's Vietnam Veterans Memorial, New York's annual "Tribute in Lights" to the victims of September 11, Hans Haacke's *DER BEVÖLKERUNG* for the German Bundestag, and Paul Ramirez Jonas's *The Commons*, but there are many other examples of new monuments that use abstraction to avoid at least some of the oppressive effects of traditional monuments.

Chapter 8: The Great Reshuffling

1. North Carolina Historical Commission, Confederate Monuments Study Committee meeting, August 22, 2018, https://www.youtube.com/watch?v=GmXAMFnHlR8.

2. Lynn Bonner, "NC Governor Has a New Site in Mind for 3 Confederate Monuments on Capitol Grounds," *News and Observer* (Raleigh, North Carolina), September 8, 2017.

3. Roy Cooper, "North Carolina Monuments," Medium, August 15, 2017, https://nc -governor.medium.com/north-carolina-monuments-b7ead3c471ee.

4. "Dedication of the Henry Wyatt Monument," *Confederate Veteran* 20 (1912): 506–507.

5. The man is a North Carolina comedian and activist known as Thor Dollar; when I tracked him down on Twitter, he told me the pug's name is Loki, and she frequently attends protests.

6. North Carolina Historical Commission, Confederate Monuments Study Committee meeting, August 22, 2018, https://www.youtube.com/watch?v=GmXAMFnHlR8.

7. North Carolina Historical Commission, Confederate Monuments Study Committee public hearing, March 21, 2018, https://www.youtube.com/watch?v=I2P3 doUxHuE. Leoneda Inge, "Most People at Raleigh Public Hearing Want to Keep Confederate Monuments," North Carolina Public Radio, March 22, 2018, https:// www.wunc.org/race-demographics/2018-03-22/most-people-at-raleigh-public -hearing-want-to-keep-confederate-monuments.

8. Joe Killian, "Another Historical Commission Member Weighs in on Monument Removal," NC Policy Watch, September 5, 2017, http://www.ncpolicywatch .com/2017/09/05/another-historical-commission-member-weighs-monument -removal/.

9. North Carolina Historical Commission, Confederate Monuments Study Commit-

tee Meeting, https://www.youtube.com/watch?v=GmXAMFnHlR8.

10. Killian, "Another Historical Commission Member Weighs In."

11. N.C. Gen. Stat. § 100-2.1. The Act was proposed in February 2015, before Roof's killings in Charleston, but was approved afterward, in July 2015.

12. David Boraks, "Commission Votes Against Removing 3 Confederate Monuments in NC Capitol," WFAE, August 22, 2018, https://www.wfae.org/politics/2018-08-22/commission-votes-against-removing-3-confederate-monuments-in-nc-capitol#stream/0.

13. Virginia Bridges and Josh Shaffer, "To Cheers and Music, Workers Dismantling 75-Foot Confederate Monument at NC Capitol," News and Observer (Raleigh, North Carolina), June 21, 2020.

14. Governor Cooper's petition also asked if the monuments could be classified as historic artifacts and be tucked away in the state archives, but the state's law does not give the commission the power to recommend this.

15. North Carolina Historical Commission, Confederate Monuments Study Committee public hearing, March 21, 2018, https://www.youtube.com/watch?v=I2P3doUxHuE. Inge, "Most People at Raleigh Public Hearing."

16. Kent Jenkins Jr., "Toppling of Alexandria Confederate Memorial Reopens Old Wounds," Washington Post, August 23, 1988.

17. Jenkins, "Toppling."

18. The Daughters removed the Alexandria monument in June 2020 without announcing their plans for it: Andrew Beaujon, "Alexandria's Confederate Statue Has Been Removed," Washingtonian, June 2, 2020.

19. It is true that the citizens of Elberton, Georgia, tore a granite Confederate soldier statue from its pedestal in the town square in 1900, breaking it into a number of pieces. But they objected to the statue, erected in 1898, because the artist had mistakenly carved him in a Union uniform. They buried the statue where it fell and soon put a more accurate Confederate soldier up to replace it. But even this disgraced statue, nicknamed "Dutchy" for his allegedly "Pennsylvania Dutch" appearance, has been rehabilitated. In 1982, the town dug Dutchy back up, ran him through a local car wash, and put him on display as a star exhibition in their new museum: Rebecca Brantley, "Meet Dutchy, A Confederate Monument Controversial for Other Reasons," Burnaway, June 29, 2018. In a parallel incident, after a 1893 statue of Columbus in Chicago's Grant Park was derided as an artistic failure, it was melted down and recast into a statue of President William McKinley: Katherine Nagasawa and Mary Hall, "As Chicago Debates Columbus Statues, Here's a Look at the One We Melted Down," WBEZ, September 1, 2020, https://www.wbez.org/stories/as-chicago-debates-columbus-statues-heres-a-look-at-the-one-we-melted-down/ae2549bc-e449-497a-a91f-42f5361fa7f1. Carlo Brioschi, who made the Columbus monument for the Minnesota capitol, provided a replacement Columbus for Grant Park in 1933.

20. Greenville, South Carolina's Confederate monument was moved in the early 1920s

to accommodate traffic, but its new location was still on Main Street, on public property: Haley Walters, "Mayor White: COVID-19, Police Accountability Slow Greenville's Confederate Monument Plans," *Greenville News*, August 7, 2020. A Baton Rouge Confederate soldier statue moved to a different outdoor display location in 2012 and then to a state museum sometime later: Walter Pierce, "That Time Baton Rouge Moved a Confederate Monument," *Independent* (Louisiana), March 15, 2016. Another Confederate monument in a traffic circle in Reidsville, North Carolina, was damaged after being hit by a car in 2011. Officials decided to move it to a local cemetery, although not without controversy and several lawsuits seeking its replacement: Justyn Melrose, "Artwork to Replace Confederate Monument Goes up in Reidsville," *News and Record* (Greensboro, NC), April 5, 2016; Cameron McWhirter "Fall of Confederate Statue Ignites Civil War in Its Home," *Wall Street Journal*, March 27, 2012.

21. Foster, *Ghosts*, 158.

22. For this bust, and for monuments to Forrest in Alabama more broadly, see O'Neill, *Down Along with That Devil's Bones*.

23. At least two other Confederate monuments were moved in this period, but to equally prominent sites that did not signal any decrease in public loyalty to the memory of the Confederacy.

24. Bill Turque, "New Spot for Confederate Statue: Site of Historic Ferry," *Washington Post*, February 28, 2017. In June 2020, the owners removed the statue and placed it in storage: Rebecca Tan, "A Confederate Statue Is Toppled in Rural Maryland, Then Quietly Stored Away," *Washington Post*, July 4, 2020. Austin's Jefferson Davis statue went on display in a history museum: David Courtney, "Jefferson Davis Is Back at UT," *Texas Monthly*, April 17, 2017. Two Confederate monuments were moved from the grounds of Charlotte, North Carolina's city hall to the city's Elmwood Cemetery. Another monument in Orlando, Florida, was also moved to a cemetery: Jeff Weiner, "Confederate Statue 'Johnny Reb' Dismantled for Move to Greenwood Cemetery," *Orlando Sentinel*, June 20, 2017. A monument moved from a Missouri courthouse lawn to a Civil War battlefield: Rudi Keller, "Confederate Rock Finds New Home at Centralia Battlefield Site," *Columbia Tribune*, September 24, 2015.

25. Yasmeen Serhan, "St. Louis to Remove Its Confederate Monument," *Atlantic*, June 26, 2017.

26. Mitch Landrieu, the mayor of New Orleans, promised activists who had long been campaigning for the removal of these statues that he would do so in 2015, although various legal challenges delayed the removal until mid-2017: Mitch Landrieu, "Truth: Remarks on the Removal of Confederate Monuments in New Orleans," published as "The Mayor's Speech," *New York Times*, May 24, 2017; Mitch Landrieu, *In the Shadow of Statues: A White Southerner Confronts History* (New York: Viking, 2018).

27. Kristina Killgrove, "Scholars Explain the Racist History of UNC's Silent Sam Statue," *Forbes*, August 22, 2018.

28. For the meaning of recent protests over monuments, see, e.g., Bree Newsome, "Go Ahead, Topple the Monuments to the Confederacy. All of Them," *Washington Post*, August 18, 2017; Bailey J. Duhé, "Decentering Whiteness and Refocusing on the Local: Reframing Debates on Confederate Monument Removal in New Orleans," *Museum Anthropology* 41, no. 2 (2018); Ashleigh Lawrence-Sanders, "Removing Lost Cause Monuments Is the First Step in Dismantling White Supremacy," *Washington Post*, June 19, 2020; Keisha N. Blain, "Destroying Confederate Monuments Isn't 'Erasing' History. It's Learning from It," *Washington Post*, June 19, 2020; Ana Lucia Araujo, "Toppling Monuments Is a Global Movement. And It Works," *Washington Post*, June 23, 2020; Morgan Jerkins, "The Defacement of Racist Statues Is a Renegotiation of Power: Interview with Chaédria LaBouvier," Medium, July 2, 2020, https://zora.medium.com/the-defacement-of-racist-statues-is-a-renegotiation-of -power-5b0ea2fcad8a; Camille Squires, "Defend History: Tear Down the Confederate Statues," *Mother Jones*, July 17, 2020; Patricia Eunji Kim, "(Un)making Monuments: Moving Towards Justice," *Caldera Magazine*, August 15, 2020; Kali Holloway, "American History Is Getting Whitewashed, Again," *Nation*, October 2, 2020; T. K. Smith, "Monumental Futures," *Art Papers* (Fall/Winter 2020); Lyra D. Monteiro, "How a Trump Executive Order Aims to Set White Supremacy in Stone," *Hyperallergic*, January 12, 2021, https://hyperallergic.com/614175/how-a -trump-executive-order-aims-to-set-white-supremacy-in-stone/.

29. Hector Ramirez II, "Controversial Waterbury Christopher Columbus Statue Has Head Reattached after Summer Incident," WTNH, December 3, 2020, https://www.wtnh.com/news/connecticut/new-haven/controversial-waterbury -christopher-columbus-statue-has-head-reattached-after-summer-incident/.

30. Claire Bessette, "Work Begins on Changes to Norwich Italian Heritage Monument," *Day* (Connecticut), November 3, 2020.

31. A passage of text referring to Columbus's 1492 voyage was also removed from the monument: Tina Detelj, "Norwich Rededicates Former Columbus Statue as Italian Heritage Monument in Saturday Ceremony," WTNH, November 20, 2020, https:// www.wtnh.com/news/connecticut/new-london/norwich-to-rededicate-former -columbus-statue-as-italian-heritage-monument-in-saturday-ceremony/.

32. At least one Confederate sculpture is owned by a private organization, Duke University, which has indicated it will not put it back on display. Additionally, some plaques or historical markers bearing texts celebrating the Confederacy have also been removed without being preserved for public view. Asheville, North Carolina, plans to demolish its Confederate monument and prohibit the contractor from reusing, selling, or giving away any of the pieces, but it is a nonfigural stone obelisk decorated only with the last name of its honoree, Zebulon Baird Vance, the state's Civil War governor: Simone Jasper, "Confederate Monument Honoring Former North Carolina Governor Will Be Destroyed," *Charlotte Observer*, March 25, 2021.

33. Victory Fiorillo, "The Battle Over the Frank Rizzo Statue Heads to Federal Court," *Philadelphia Magazine*, July 2, 2020; "Italian-American One Voice Coalition Files

Suit Against West Orange," September 16, 2020, https://www.tapinto.net/ towns/west-orange/sections/law-and-justice/articles/italian-american-one-voice -coalition-files-suit-against-west-orange.

34. Indeed, some neighbors of private landowners who have agreed to display relocated Confederate monuments immediately began to object to their presence: Ariana Kraft, "Chicod Community Has Mixed Emotions About Move of Confederate Monument to Neighborhood," WNCT, March 10, 2021, https://www.wnct.com/local -news/chicod-community-members-discuss-move-of-confederate-monument/.

35. Kate Beane, "A Conversation About Monuments and Memory with Mni Sota Indigenous Scholars," Minnesota Historical Society, July 30, 2020, https://www .youtube.com/watch?v=Sa7YTP5pRd8.

36. Molly Conger, Twitter Post, September 12, 2020, 8:41 AM, https://twitter.com/ socialistdogmom/status/1304762078977286145?s=20.

37. Robert Moran and Rob Tornoe, "Christopher Columbus Statue in Camden Taken Down, But Pieces Being Held in Protest by Residents," *Philadelphia Inquirer*, June 12, 2020; April Saul, "Camden's Columbus Statue Departs, But His Isn't the Only Name Activists Want Gone," June 13, 2020, WHYY, https://whyy.org/articles/camdens -columbus-statue-departs-but-his-isnt-the-only-name-activists-want-gone/.

38. My thinking about the "public secrets" held by monuments is indebted to Michael Taussig's *Defacement: Public Secrecy and the Labor of the Negative* (Stanford: Stanford University Press, 1999). A public secret is something "privately known but collectively denied": Jon Christopher Crocker, "Being and Essence: Totemic Representation Among the Eastern Bororo," in *The Power of Symbols: Masks and Masquerade in the Americas*, eds. N. Ross Crumrine and Marjorie Halpin (Vancouver: University of British Columbus Press, 1983), 158. One way of understanding many American monuments would be to interpret them as publicly celebrating the "American dream" of meritocratic success while viewers privately know that this dream of meritocracy is negated by a reality of structural racism that blocks certain Americans from success while granting it to others, distinguished merely by the accidents of their birth. Taussig points out that the maintenance of a public secret is possible only if it benefits those who uphold it: "you don't exactly 'keep' a public secret so much as know how to be kept by it": *Defacement*, 121. Taussig insists that merely exposing a public secret does nothing to destroy it, since so many observers remain interested in continuing to keep the secret. Thus, he believes, these secrets must be transformed through a desacralizing ceremony or a "revelation," which can include initiating a change in society that makes it no longer necessary to keep the secret.

Epilogue

1. Gary Hendricks, "Easter Sunrise: Faithful Brave Rain," *Atlanta Constitution*, March 31, 1975; Joe Ledlie, "Easter's Heroes Spent Weeks to Ensure That It's a Day of

Beauty for Others," *Atlanta Constitution*, April 15, 1979 (praising the park's director of special events as the hero in question).

2. Frank Wells, "Stone Mtn. Memorial Plans Listed," *Atlanta Constitution*, June 15, 1959. The Prison Camp was operated initially not by Georgia's Department of Corrections, but by the Stone Mountain Memorial Authority itself: Gene Stephens, "Work-Release Units Urged," *Atlanta Constitution*, December 30, 1969. The state did not take over the prison until 1971, changing its name to the Stone Mountain Correctional Institution. It became a probation boot camp for first-time offenders in 1991.

3. Jack Strong, "Stone Mountain to Echo Prison Choir's Song," *Atlanta Constitution*, November 24, 1960.

4. Freeman, *Carved in Stone*, 147.

5. When the number of prisoners at Stone Mountain tripled during the 1970s, this building was too small to hold them all. The rest slept in metal trailers in the prison's red-clay yard: Phil Hersh, "Prison Puts Lock on Ex-NFL Star Herron's Future," *St. Louis Post-Dispatch*, November 5, 1978. In 1959, the prisoners built themselves a chapel in their spare hours, using materials they took from a run-down building they were allowed to demolish. "We took it down as meticulously as if it was precious jewels," an unnamed prisoner told a journalist in 1960 while showing off the completed chapel, which included a pine pulpit "which formerly had been paneling around their sink": Strong, "Prison Choir's Song."

6. "Chain Gangs' Time Is Past," *Atlanta Constitution*, May 7, 1995; Jack Nelson, "Stone Mountain Unit's Operation Disgraceful, Ridiculous, Lane Says," *Atlanta Constitution*, August 18, 1964.

7. Freeman, *Carved in Stone*, 146, 148.

8. Sam Hopkins, "MacDougall Fires Warden Hoke Smith," *Atlanta Constitution*, March 8, 1972.

9. Rick Nelson, "It's Taken 14 Years to Clear His Name," *Colorado Springs Gazette-Telegraph*, February 6, 1978.

10. "Escapee Calling from Phone Booth Is Captured at Stone Mountain," *Atlanta Constitution*, April 11, 1963.

11. Craig R. Hume, "Four Prison Inmates Escape," *Atlanta Constitution*, August 16, 1976.

12. For bloodhounds tracking prisoners, see Charles Moore, "3 Escapees Here Outrun Hounds," *Atlanta Constitution*, August 2, 1960; "Prisoner Flees Detail at Stone Mountain," *Atlanta Constitution*, February 22, 1963; "Hounds Trap Burglar in Storm Here," *Atlanta Constitution*, September 29, 1960; "2 Scale 10-Foot Barbed Wire Fence to Flee Prison at Stone Mountain," *Atlanta Constitution*, April 24, 1964; "3 Escape Stone Mountain Work Detail on Monday," *Atlanta Constitution*, May 25, 1971.

13. "Golf Course Chase Nets Two Fugitives," *Atlanta Constitution*, July 21, 1971.

14. Beth P. Bolden, "Stone Mountain Prison Defines Real Meaning Behind the Walls," *Atlanta Voice*, April 27, 1984.

15. "Ontario Jails Minister Likes the Georgia Work-Gang System," *Leader-Post* (Regina, Canada), January 25, 1978.

16. "Park Officials Gear Up to Beat Biloxi Record," Associated Press, April 6, 1982; Jean Thwaite, "With Kids Awaiting Easter Hunts, Here's Your Total Egg-Preparing Kit," *Atlanta Constitution*, April 8, 1982.

17. For the Augusta monument and Black celebrations of Emancipation, see Kathleen Clark, *Defining Moments: African American Commemoration & Political Culture in the South, 1863–1913* (Chapel Hill: University of North Carolina Press, 2005).

18. *Augusta Constitutionalist*, April 28, 1870, quoted in Kathleen Clark, "Making History: African American Commemorative Celebrations in Augusta, Georgia, 1865–1913," in *Monuments to the Lost Cause: Women, Art, and the Landscapes of Southern Memory*, eds. Cynthia Mills and Pamela H. Simpson (Knoxville: University of Tennessee Press, 2003), 52.

19. Clark, "Making History," 51.

20. Clark, "Making History," 46.

21. *Augusta Constitutionalist*, July 6, 1866, quoted in Clark, "Making History," 53.

22. *Atlanta Constitutionalist*, July 5, 1868, quoted in Clark, "Making History," 54.

23. *Augusta Constitutionalist*, August 4, 1869, quoted in Clark, "Making History," 54.

24. Clark, "Making History," 46.

25. Friedrich Dieckmann, "Friedrich und Iljitsch—Zwei Berliner Monumente," quoted in Gamboni, *Destruction of Art*, 71.

26. Gamboni, *Destruction of Art*, 72.

27. On this monument, see Gamboni, *Destruction of Art*, 79–85.

28. Gamboni, *Destruction of Art*, 84.

29. Gamboni, *Destruction of Art*, 83.

30. "Giant Head from Lenin Statue Unearthed for Exhibition in Berlin," Reuters, September 10, 2015.

31. Murray, *Emancipation and the Freed*, xix.

32. Jabez Lamar Monroe Curry to Manley Curry, August 12, 1886, Curry Papers, Library of Congress, quoted in Foster, *Ghosts*, 71.

BIBLIOGRAPHY

Abbott, Karen. "'Murder Wasn't Very Pretty': The Rise and Fall of D.C. Stephenson." *Smithsonian*, August 30, 2012.

Abinanti, Abby et al. *'To' Kee Skuy' Soo Ney-Wo-Chek': I Will See You Again in a Good Way: A Year 1 Project to Report on Missing and Murdered Indigenous Women, Girls, and Two Spirit People of Northern California*. Eureka, CA: Sovereign Bodies Institute, 2020.

Adams, David. *Education for Extinction: American Indians and the Boarding School Experience, 1875–1928*. Lawrence: University Press of Kansas, 1995.

Albertson, Dean. "Portrait: Guy Stanton Ford." *American Scholar* 26, no. 3 (1957): 350–353.

Alderman, Derek H. "Surrogation and the Politics of Remembering Slavery in Savannah, Georgia (USA)." *Journal of Historical Geography* 36, no. 1 (2010): 90–101.

Alexander, Charles C. "Kleagles and Cash: The Ku Klux Klan as a Business Organization, 1915-1930." *Business History Review* 39, no. 3 (1965): 348–367.

Allmendinger, David F., Jr. *Ruffin: Family and Reform in the Old South*. New York: Oxford University Press, 1990.

Anderson, Eric. *Race and Politics in North Carolina, 1872–1901: The Black Second*. Baton Rouge: Louisiana State University Press, 1981.

Araujo, Ana Lucia. *Shadows of the Slave Past: Memory, Heritage, and Slavery*. London: Routledge, 2014.

Archuleta, Margaret Brenda Child, and Tsianina Lomawaima, eds. *Away from Home: American Indian Boarding School Experiences, 1879–2000*. Phoenix: Heard Museum, 2000.

Ater, Renée. "Commemorating Black Soldiers: The African American Civil War Memorial in Washington, D.C." In *Tell It with Pride: The 54th Massachusetts Regiment and Augustus Saint-Gaudens' Shaw Memorial*. Edited by Sarah Greenough and Nancy Anderson, 112–126. Washington, DC: National Gallery of Art (2013).

———. "Slavery and Its Memory in Public Monuments." *American Art* 24, no. 1 (Spring 2010): 20–23.

Autry, La Tanya S., and Mike Murawski. "Museums Are Not Neutral: We Are Stronger

Together." *Panorama: Journal of the Association of Historians of American Art* 5, no. 2 (2019).

Bahrani, Zainab. "Assault and Abduction: The Fate of the Royal Image in the Ancient Near East." *Art History* 18 (1995): 363–382.

Bailey, Fred Arthur. "The Textbooks of the 'Lost Cause': Censorship and the Creation of Southern State Histories." *Georgia Historical Quarterly* 75, no. 3 (1991): 507–533.

Ball, Thomas. *My Three Score Years and Ten: An Autobiography.* Boston: Roberts, 1892.

Beard, W. E. "The Confederate Government, 1861–1865." *Tennessee Historical Magazine* 1, no. 2 (1915): 120–128.

Beetham, Sarah. *Sculpting the Citizen Soldier: Reproduction and National Memory, 1865–1917.* PhD Dissertation, University of Delaware, 2014.

Bellion, Wendy. *Iconoclasm in New York: Revolution to Reenactment.* University Park: Pennsylvania State University Press, 2019.

Benjamin, Andrea, et al. "Set in Stone? Predicting Confederate Monument Removal." *PS: Political Science & Politics* 53, no. 2 (2000): 237–242.

Bennett, David H. *The Party of Fear: From Nativist Movements to the New Right in American History.* Chapel Hill: University of North Carolina Press, 1988.

Benton-Banai, Edward. *The Mishomis Book: The Voice of the Ojibway.* St. Paul: Red School House Publishers, 1988.

Berg, Scott W. *38 Nooses: Lincoln, Little Crow, and the Beginning of the Frontier's End.* New York: Pantheon, 2012.

Bergman, Teresa. *Exhibiting Patriotism: Creating and Contesting Interpretations of American Historic Sites.* Walnut Creek, CA: Left Coast Press, 2013.

Berlin, Ira, Leslie S. Rowland, and Joseph P. Reidy, eds. *Freedom: A Documentary History of Emancipation, 1861–1867: Series II, The Black Military Experience.* Cambridge: Cambridge University Press, 1982.

Bishir, Catherine W. "'A Strong Force of Ladies': Women, Politics, and Confederate Memorial Associations in Nineteenth-Century Raleigh." In *Monuments to the Lost Cause: Women, Art, and the Landscapes of Southern Memory,* edited by Cynthia Mills and Pamela H. Simpson. Knoxville, University of Tennessee Press, 2003.

Blight, David W. "'For Something Beyond the Battlefield': Frederick Douglass and the Struggle for the Memory of the Civil War." *Journal of American History* 75, no. 4 (1989): 1156–1178.

Brown, Thomas J. *The Public Art of Civil War Commemoration: A Brief History with Documents.* Boston: Bedford, 2004.

Browne, Nicholas A., and Sarah E. Kanouse, eds. *Re-Collecting Black Hawk: Landscape, Memory, and Power in the American Midwest.* Pittsburgh: University of Pittsburgh Press, 2015.

Carter, Chelsey R. "Racist Monuments Are Killing Us." *Museum Anthropology* 41, vol. 2 (Fall 2018): 139–141.

Casey, Robert, and Mary Borglum. *Give the Man Room: The Story of Gutzon Borglum.* New York: Bobbs-Merrill Company, 1952.

Cayton, H. R., and G. S. Mitchell. *Black Workers and the New Unions*. Chapel Hill: University of North Carolina Press, 1939.

Child, Brenda. *Boarding School Seasons: American Indian Families, 1900–1940*. Lincoln: University of Nebraska Press, 2000.

Christin, Olivier. "Les iconoclasts savent-ils ce qu'ils font? Rouen, 1562–1793." In *Révolution Fraçaise et "Vandalisme Révolutionnaire,"* edited by Simon Bernard-Griffiths, Marie-Claude Chemin, and Jean Ehrard, 353–365. Paris: Voltaire Foundation, 1992.

Cimprich, John, and Robert C. Mainfort Jr., "Fort Pillow Revisited: New Evidence About an Old Controversy." *Civil War History* 28, no. 4 (1982): 293–306.

Clark, Kathleen. *Defining Moments: African American Commemoration & Political Culture in the South, 1863–1913*. Chapel Hill: University of North Carolina Press, 2005.

———. "Making History: African American Commemorative Celebrations in Augusta, Georgia, 1865–1913." In *Monuments to the Lost Cause: Women, Art, and the Landscapes of Southern Memory*, edited by Cynthia Mills and Pamela H. Simpson. Knoxville: University of Tennessee Press, 2003.

Colletta, John Philip. "'The Workman of C. Mills': Carl Ludwig Richter and the Statue of Andrew Jackson in Lafayette Park." *Washington History* 23 (2011): 2–35.

Connelly, Thomas L. *The Marble Man: Robert E. Lee and His Image in American Society*. Baton Rouge: Louisiana State University Press, 1977.

Connor, R.D.W. "Canova's Statue of Washington." *Publications of the North Carolina Historical Commission* 8 (1910): 14–27.

Cooper, Michael. *Indian School: Teaching the White Man's Way*. New York: Clarion Books, 1999.

Coughlan, Robert. "Konklave in Kokomo." In *The Aspirin Age: 1919–1941*, edited by Isabel Leighton, 105–111. New York: Simon & Schuster, 1949.

Coulter, E. Merton. "A Name for the American War of 1861–1865." *Georgia Historical Quarterly* 36, no. 2 (1952): 109–131.

Coutu, Joan Michèle. *Persuasion and Propaganda: Monuments and the Eighteenth-Century British Empire*. Montreal: McGill-Queen's University Press, 2006.

Cox, Karen. *Dixie's Daughters: The United Daughters of the Confederacy and the Preservation of Confederate Culture*. Gainesville: University Press of Florida, 2003.

Cox, Karen L. *No Common Ground: Confederate Monuments and the Ongoing Fight for Racial Justice*. Chapel Hill: University of North Carolina Press, 2021.

Crair, Ben. "The Fate of a Leg of a Statue of Saddam Hussein." *New Yorker*, January 29, 2017.

Crocker, Jon Christopher. "Being and Essence: Totemic Representation Among the Eastern Bororo." In *The Power of Symbols: Masks and Masquerade in the Americas*, edited by N. Ross Crumrine and Marjorie Halpin. Vancouver: University of British Columbus Press, 1983.

Davis, Michael. *In Remembrance: Confederate Funerary Monuments in Alabama and Resistance to Reconciliation, 1884–1923*. MA Thesis, Auburn University, 2008.

Denson, Andrew. *Monuments to Absence: Cherokee Removal and the Contest over Southern Memory.* Chapel Hill: University of North Carolina Press, 2017.

Derry, Joseph T. *Confederate Military History: Georgia.* Atlanta: Confederate Publishing Company, 1899.

Deschamps, Bénédicte. "Italian-Americans and Columbus Day: A Quest for Consensus Between National and Group Identities, 1840–1910." In *Celebrating Ethnicity and Nation: American Festive Culture from the Revolution to the Early Twentieth Century,* edited by Jürgen Heideking, Genève Fabre, and Kai Dreisbach, 124–139. New York: Berghahn Books, 2001.

Domby, Adam H. *The False Cause: Fraud, Fabrication, and White Supremacy in Confederate Memory.* Charlottesville: University of Virginia Press, 2020.

Duhé, Bailey J. "Decentering Whiteness and Refocusing on the Local: Reframing Debates on Confederate Monument Removal in New Orleans." *Museum Anthropology* 41, no. 2 (2018): 120–125.

Eaton, John. *Grant, Lincoln, and the Freedman.* New York: Longman Green, 1907.

Eggleston, George Cary. *A Rebel's Recollections.* New York: Hurd & Houghton, 1875.

El-Mecky, Nausikaä. "Don't Call It Vandalism." *Image* (2000).

Emerson, Ralph Waldo. *The Complete Works of Ralph Waldo Emerson.* Edited by Edward Waldo Emerson. Boston: Houghton, Mifflin, 1903–04.

———. *The Letters of Ralph Waldo Emerson.* Edited by Ralph L. Rusk. New York: Columbia University Press, 1939.

Essex, Jamey. "'The Real South Starts Here': Whiteness, The Confederacy, and Commodification at Stone Mountain." *Southeastern Geographer* 42, no. 2 (2002): 211–227.

Estes, Nick. *Our History Is the Future: Standing Rock Versus the Dakota Access Pipeline and the Long Tradition of Indigenous Resistance.* New York: Verso, 2019.

Fabian, Ann. *The Skull Collectors: Race, Science, and America's Unburied Dead.* Chicago: University of Chicago Press, 2010.

Farrington, Lisa. *African-American Art: A Visual and Cultural History.* New York: Oxford University Press, 2016.

Fields, Mamie Garvin, and Karen Fields. *Lemon Swamp and Other Places: A Carolina Memoir.* New York: The Free Press, 1983.

Finn, Kathleen, et al. "Responsible Resource Development and Prevention of Sex Trafficking: Safeguarding Native Women and Children on the Fort Berthold Reservation." *Harvard Journal of Law and Gender* 40, no. 1 (2017).

Foner, Philip S., and Robert Branham, eds., *Lift Every Voice: African American Oratory, 1787–1901.* Tuscaloosa: University of Alabama Press, 1997.

Force, Peter, ed. *American Archives: Consisting of a Collection of Authentick Records, State Papers, Debates, and Letters and Other Notices of Publick Affairs.* Washington, DC: M. St. Clair Clarke and Peter Force, 1843.

Ford, Worthington Chauncey, ed. *Writings of George Washington.* New York: Putnam, 1889–93.

Forman, James. *Sammy Younge, Jr.: The First Black College Student to Die in the Black Liberation Movement*. Seattle: Open Hand Pub, 1986.

Forman Jr., James. "Driving Dixie Down: Removing the Confederate Flag from Southern State Capitols." *Yale Law Journal* 101, no. 2 (1991): 505–526.

Foster, Gaines M. *Ghosts of the Confederacy: Defeat, the Lost Cause, and the Emergence of the New South*. New York: Oxford University Press, 1987.

Frank, Tom. *The People, No: A Brief History of Anti-Populism*. New York: Metropolitan Books, 2000.

Frankfurter, Felix. *Felix Frankfurter Reminisces*. New York: Reynal, 1960.

Freedberg, David. *The Power of Images: Studies in the History and Theory of Response*. Chicago: University of Chicago Press, 1989.

Freeman, David B. *Carved in Stone: The History of Stone Mountain*. Macon, GA: Mercer University Press, 1997.

Fryd, Vivian Green. *Art and Empire: The Politics of Ethnicity in the United States Capital, 1815–1860*. Athens: Ohio University Press, 2001.

———. "Two Sculptures for the Capitol: Horatio Greenough's 'Rescue' and Luigi Persico's 'Discovery of America.'" *The American Art Journal* 19, vol. 2 (1987): 16–39.

Fuller, James. *Men of Color, to Arms!: Vermont African-Americans in the Civil War*. N.p.: iUniverse, 2001.

Gamboni, Dario. *The Destruction of Art: Iconoclasm and Vandalism since the French Revolution*. London: Reaktion Books, 1997.

Gilchrist, James P. *A Brief Display of the Origin and History of Ordeals: Trials by Battle; Courts of Chivalry or Honour; and the Decision of Private Quarrels by Single Combat: Also, a Chronological Register of the Principal Duels Fought from the Accession of His Late Majesty to the Present Time*. London: W. Bulmer and W. Nicol, 1821.

Glatthaar, Joseph T. *Forged in Battle: The Civil War Alliance of Black Soldiers and White Officers*. Baton Rouge: Louisiana State University Press, 1990.

Goulding, Francis R. *Sal-O-Quah; or Boy-Life Among the Cherokees*. New York: Dodd, Mead and Co., 1870.

Greene, Melissa Fay. *The Temple Bombing*. Cambridge, MA: Da Capo Press, 1996.

Greenough, Frances Boott, ed. *Letters of Horatio Greenough to His Brother, Henry Greenough*. Boston: Ticknor and Company, 1887.

Greenough, Horatio. *The Travels, Observations, and Experience of a Yankee Stonecutter*. Gainesville, FL: Scholars' Facsimiles & Reprints, 1958.

Grestle, Gary. *American Crucible: Race and Nation in the Twentieth Century*. Princeton, NJ: Princeton University Press, 2001.

Grover, Linda LeGarde. "From Assimilation to Termination: The Vermilion Lake Indian School." *Minnesota History* 58, no. 4 (Winter 2002–2003): 225–240.

Hahn, Steven. *A Nation Under Our Feet: Black Political Struggles in the Rural South from Slavery to the Great Migration*. Cambridge: Harvard University Press, 2003.

Hale, Grace Elizabeth. "Granite Stopped Time: The Stone Mountain Memorial and the

Representation of White Southern Identity." *Georgia Historical Quarterly* 82, no. 1 (1998): 22–44.

Harjo, Suzan Shown. "Threatened and Damaged: Protecting Sacred Places." *Expedition Magazine* 55, no. 3 (2013): 12–17.

Harris C. M., "Washington's Gamble, L'Enfant's Dream: Politics, Design, and the Founding of the National Capital." *William and Mary Quarterly*, 3rd ser., 56, no. 3 (1999): 527–564.

Hodder, Robert. "Redefining a Southern City's Heritage: Historic Preservation, Planning, Public Art, and Race in Richmond, VA." *Journal of Urban Affairs* 21 (2016): 437–453.

Hubner, Brian E. "Fort Anne, New York, Skirmish at (July 8, 1777)." In *The American Revolution 1775–1783: An Encyclopedia*, vol 1., edited by Richard L. Blanco, 555–556. New York: Garland, 1993.

Hutchinson, Peter Orlando, ed. *The Diary and Letters of His Excellency Thomas Hutchinson.* Boston: Houghton, Mifflin, 1884.

Ifill, Sherrilyn. *On the Courthouse Lawn: Confronting the Legacy of Lynching in the Twenty-First Century.* Boston: Beacon Press, 2007.

Jackson, Kenneth T. *The Ku Klux Klan in the City: 1915–1930.* Chicago: Ivan R. Dee, 1992.

Jacobson, Matthew Frye. *Whiteness of a Different Color: European Immigrants and the Alchemy of Race.* Cambridge: Harvard University Press, 1998.

Jarves, James Jackson. *Art Thoughts: The Experiences and Observations of an American Amateur in Europe.* New York: Hurd and Houghton, 1870.

Johnson, Joan Marie. "'Ye Gave Them a Stone': African American Women's Clubs, the Frederick Douglass Home, and the Black Mammy Monument." *Journal of Women's History* 17, no. 1 (2005): 62–86.

Jones, Martha S. *Vanguard: How Black Women Broke Barriers, Won the Vote, and Insisted on Equality for All.* New York: Basic Books, 2021.

Kim, Patricia Eunji. "(Un)making Monuments: Moving Towards Justice." *Caldera*, August 15, 2020.

Kubal, Timothy. *Cultural Movements and Collective Memory: Christopher Columbus and the Rewriting of the National Origin Myth.* New York: Palgrave Macmillan, 2008.

Landrieu, Mitch. *In the Shadow of Statues: A White Southerner Confronts History.* New York: Viking, 2018.

Lapsansky, Phillip. "Graphic Discord: Abolitionist and Antiabolitionist Images." In *The Abolitionist Sisterhood.* Edited by Jean Fagan Yellin and John C. Van Horne, 201–230. Ithaca, NY: Cornell University Press, 2018.

Larner, Jesse. *Mount Rushmore: An Icon Reconsidered.* New York: Thunder's Mouth Press/ Nation Books, 2002.

Lee, Susan P. *New School History of the United States.* Richmond, VA: B. F. Johnson, 1900.

Letwin, Daniel. "Interracial Unionism, Gender, and 'Social Equality' in the Alabama Coalfields, 1878–1908." *Journal of Southern History* 61, no. 3 (1995): 519–554.

Looney, J. Jefferson. ed. *The Papers of Thomas Jefferson.* Princeton: Princeton University Press, 2012.

Lutholtz, M. William. *Grand Dragon: D.C. Stephenson and the Ku Klux Klan in Indiana*. West Lafayette, IN: Purdue University Press, 1991.

Manning, Chandra. *Troubled Refuge: Struggling for Freedom in the Civil War*. New York: Vintage Books, 2017.

McAuliffe, Terry. *Beyond Charlottesville: Taking a Stand Against White Nationalism*. New York: Thomas Dunne Books, 2019.

McMichael, Kelly. *Sacred Memories: The Civil War Monument Movement in Texas*. College Station: Texas A&M University Press, 2013.

McPherson, James. *The Negro's Civil War: How American Blacks Felt and Acted During the War for the Union*. New York: Vintage Books, 1993.

Metzer, Jacob. "The Records of the U.S. Colored Troops as a Historical Source: An Exploratory Examination." *Historical Methods* 14, no. 3 (1981): 123–32.

Meyers, Frederic. "The Knights of Labor in the South." *Southern Economic Journal* 6, no. 4 (1940): 479–487.

Mills, Cynthia. "Gratitude and Gender Wars: Monuments to the Women of the Sixties." In *Monuments to the Lost Cause: Women, Art, and the Landscapes of Southern Memory*. Edited by Cynthia Mills and Pamela H. Simpson. Knoxville: University of Tennessee Press, 2003.

Minnesota History. "The Columbus Celebration." 13, no. 1 (1932): 83–85.

Murray, Freeman Henry Morris. *Emancipation and the Freed in American Sculpture: A Study in Interpretation*. Washington, DC: Murray Brothers, Inc., 1916.

Nimmo, Dan, and Clifton McCleskey. "Impact of the Poll Tax on Voter Participation: The Houston Metropolitan Area in 1966." *Journal of Politics* 31, no. 3 (1969): 682–699.

Northrup, Herbert R. "The Negro and Unionism in the Birmingham, Ala., Iron and Steel Industry," *Southern Economic Journal* 10, no. 1 (1943): 27–40.

O'Neill, Connor Towne. *Down Along with That Devil's Bones: A Reckoning with Monuments, Memory, and the Legacy of White Supremacy*. Chapel Hill, NC: Algonquin, 2020.

Painter, Nell Irvin. *The History of White People*. New York: W. W. Norton, 2010.

Pember, Mary Annette. "Death by Civilization." *The Atlantic*, March 8, 2019.

Phelps, Jess R., and Jessica Owley, "Etched in Stone: Historic Preservation Law and Confederate Monuments." *Florida Law Review* 71 (2019).

Pinheiro, Holly, Jr. *The Families' Civil War*. Athens: University of Georgia Press, 2022.

Rechtenwald, Miranda. "The Life of Archer Alexander: A Story of Freedom." *The Confluence* (Fall/Winter 2014).

Redman, Samuel J. *Bone Rooms: From Scientific Racism to Human Prehistory in Museums*. Cambridge: Harvard University Press, 2016.

Richardson, Heather Cox. *How the South Won the Civil War: Oligarchy, Democracy, and the Continuing Fight for the Soul of America*. New York: Oxford University Press, 2020.

Ridgeway, James. *Blood in the Face: The Ku Klux Klan, Aryan Nations, Nazi Skinheads, and the Rise of the New White Culture*. New York: Thunder's Mouth Press, 1996.

Roediger, David R. *Working Towards Whiteness: How America's Immigrants Became White*. New York: Basic Books, 2005.

Rutherford, Mildred Lewis. *Truths of History: A Fair, Unbiased, Impartial, Unprejudiced and Conscientious Study of History.* Athens, GA: n.p., 1920.

Ryback, Timothy, et al., eds. *Contested Histories in Public Spaces: Principles, Processes, Best Practices.* London: International Bar Association, 2021.

Savage, Kirk. *Monument Wars: Washington, D.C., the National Mall, and the Transformation of the Memorial Landscape.* Berkeley: University of California Press, 2009.

———. *Standing Soldiers, Kneeling Slaves: Race, War, and Monument in Nineteenth-Century America,* 2nd ed. Princeton: Princeton University Press, 2018.

Scull, Gideon Delaplaine, ed. *The Montresor Journals.* New York: New-York Historical Society, 1882.

Seraile, William. *New York's Black Regiments During the Civil War.* New York: Routledge, 2001.

Shaff, Howard, and Audrey Karl Shaff. *Six Wars at a Time: The Life and Times of Gutzon Borglum, Sculptor of Mount Rushmore.* Sioux Falls, SD: The Center for Western Studies, 1985.

Shannon, James P. *Catholic Colonization on the Western Frontier.* New Haven: Yale University Press, 1957.

Smith T. K. "Monumental Futures." *Art Papers* (Fall/Winter 2020): 26–31.

Smith, Laurajane. *Emotional Heritage: Visitor Engagement at Museums and Heritage Sites.* London: Routledge, 2020.

Smolenyak, Megan. "Philip Reed, the Slave Who Rescued Freedom." *Ancestry Magazine* (May/June 2009), 54–56.

Stannard, David E. *American Holocaust: The Conquest of the New World.* New York: Oxford University Press, 1992.

Stark, Christine. "Strategies to Restore Justice for Sex Trafficked Native Women." In *Palgrave International Handbook of Human Trafficking.* Edited by John Winterdyk and Jackie Jones, 1219–1240. London: Palgrave Macmillan, 2019.

Stewart, William H. "The Private Infantryman: The Typical Hero of the South." *Southern Historical Society Papers* 20 (1892).

Storch, Paul S. "Ten Years of Sculpture and Monument Conservation on the Minnesota State Capitol Mall." *Objects Specialty Group Postprints* 9 (2002): 14–40.

Strother, Logan, Spencer Piston, and Thomas Ogorzalek. "Pride or Prejudice?: Racial Prejudice, Southern Heritage, and White Support for the Confederate Battle Flag." *Du Bois Review* 14, no. 1 (2017): 295–323.

Sutherland, Daniel E. "Exiles, Emigrants, and Sojourners: The Post–Civil War Confederate Exodus in Perspective." *Civil War History* 31 (September 1985): 237–256.

Swiatek, Anthony, and Breen Walter. *The Encyclopedia of United States Silver & Gold Commemorative Coins, 1892 to 1954.* New York: Arco Publishing, 1981.

Taliaferro, John. *Great White Fathers: The Story of the Obsessive Quest to Create Mount Rushmore.* New York: PublicAffairs, 2002.

Taussig, Michael. *Defacement: Public Secrecy and the Labor of the Negative.* Stanford: Stanford University Press, 1999.

Taylor, Brian. *Fighting for Citizenship: Black Northerners and the Debate over Military Service in the Civil War*. Chapel Hill: University of North Carolina Press, 2020.

Tinker, Tink, and Mark Freeland. "Thief, Slave Trader, Murderer: Christopher Columbus and Caribbean Population Decline." *Wicazo Sa Review* 23, no. 1 (2008): 25–50.

Topaz, Chad M., et al. "Diversity of Artists in Major U.S. Museums." *PLoS One* 14, no. 3 (2019).

Trafzer, Clifford Jean Keller, and Lorene Sisquoc, eds. *Boarding School Blues: Revisiting American Indian Educational Experiences*. Lincoln: University of Nebraska, 2006.

Treuer, David. *The Heartbeat of Wounded Knee: Native America From 1890 to the Present*. New York: Penguin, 2019.

Trujillo, Michael L. "Onate's Foot: Remembering and Dismembering in Northern New Mexico." *Aztlan: A Journal of Chicano Studies* 33, no. 2 (2008): 91–119.

Tucker, Richard K. *The Dragon and the Cross: The Rise and Fall of the Ku Klux Klan in Middle America*. Hamden, CT: Shoe String Press, 1991.

Upton, Emory. *New System of Infantry Tactics, Double and Single Rank, Adapted to American Topography and Improved Fire-Arms*. New York: D. Appleton, 1867.

Vellon, Peter G. *A Great Conspiracy Against Our Race: Italian Immigrant Newspapers and the Construction of Whiteness in the Early 20th Century*. New York: New York University Press, 2014.

Wade, Wyn C. *The Fiery Cross: The Ku Klux Klan in America*. New York: Oxford University Press, 1998.

Wall, A. J. "The Statues of King George III and the Honorable William Pitt Erected in New York City 1770." *New-York Historical Society Quarterly Bulletin* 4 (1920): 37–57.

Ward, Robert Charles. "The Spirits Will Leave: Preventing the Desecration and Destruction of Native American Sacred Sites on Federal Land." *Ecology Law Quarterly* 19, no. 4 (1992): 795–846.

Ward, Robert David, and William Warren Rogers. *Labor Revolt in Alabama: The Great Strike of 1894*. Tuscaloosa: University of Alabama Press, 1965.

Warnke, Martin. *Bildersturm: Die Zerstörung des Kunstwerks*. Frankfurt am Main: Fischer-Taschenbuch, 1988.

White, Jonathan W., and Scott Sandage. "What Frederick Douglass Had to Say About Monuments." *Smithsonian*, June 30, 2020.

Willis, Deborah. *The Black Civil War Soldier: A Visual History of Conflict and Citizenship*. New York: NYU Press, 2021.

Wilson, Keith P. *Campfires of Freedom: The Camp Life of Black Soldiers During the Civil War*. Kent, OH: Kent University Press, 2002.

Witmer, Linda F. *The Indian Industrial School, Carlisle, Pennsylvania, 1879–1918*. Carlisle, PA: Cumberland County Historical Society, 2002.

Wolde-Michael, Tsione, Ayana Omilade Flewellen, Justin P. Dunnavant, Alicia Odewale, Alexandra Jones, Zoë Crossland, and Maria Franklin. "'The Future of Archaeology Is Antiracist': Archaeology in the Time of Black Lives Matter." *American Antiquity* 86, no. 2 (2021): 224–243.

Woodruff, George C. *The History of the Town of Litchfield, Connecticut.* Litchfield, CT: Charles Adams, 1845.

Work, Monroe N., et al. "Some Negro Members of Reconstruction Conventions and Legislatures and of Congress." *Journal of Negro History* 5, no. 1 (1921): 63–119.

Wright, Nathalia. *Horatio Greenough: The First American Sculptor.* University Park: University of Pennsylvania Press, 1963.

———. "Ralph Waldo Emerson and Horatio Greenough." *Harvard Library Bulletin* 12, no. 1 (Winter 1958): 91–116.

Wright, Nathalia, ed. *Letters of Horatio Greenough: American Sculptor.* Madison: University of Wisconsin Press, 1972.

Wyeth, Samuel Douglas. *The Rotunda and the Dome of the United States Capitol.* Washington, DC: Gibson Brothers, 1869.

INDEX